Masterpieces
East & West

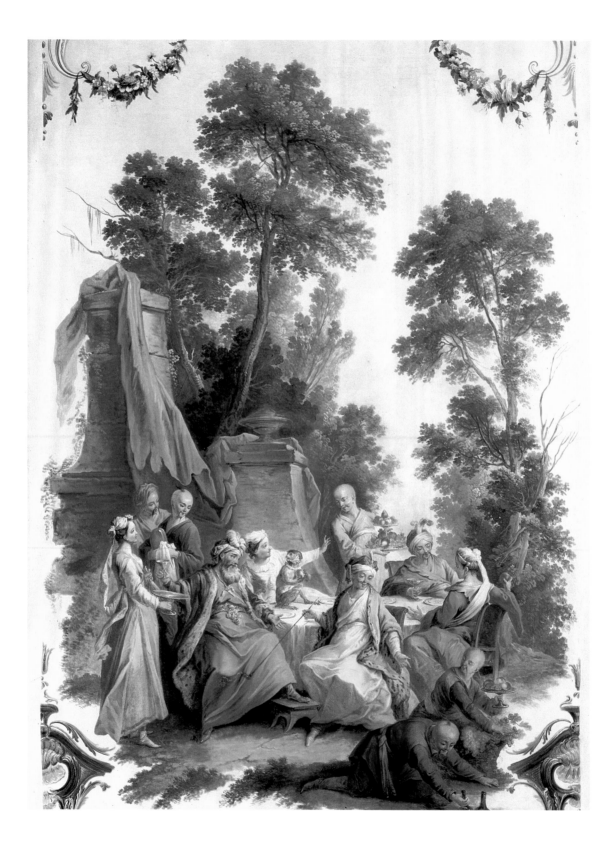

Masterpieces
East & West

from the collection of the
Birmingham Museum of Art

BIRMINGHAM, ALABAMA

Library of Congress Cataloging-in-Publication Data

Birmingham Museum of Art (Birmingham, Ala.)
 Masterpieces East & West : from the collection of the Birmingham
Museum of Art.
 p. cm.
 Includes index.
 ISBN 0–931394–38–4 (hardcover). -- ISBN 0–931394–37–6 (softcover)
 1. Art--Alabama--Birmingham--Catalogs. 2. Birmingham Museum of
Art (Birmingham, Ala.)-- Catalogs. I. Title. II. Title:
Masterpieces East and West.
N518.B36A62 1993 93-26353
708.161'781--dc20 CIP

ISBN softcover - 0-931394-37-6
ISBN hardcover - 0-931394-38-4

(Cover) Left: *Sakyamuni as an Ascetic*, China, Yuan dynasty
(1279–1368). Wood, fabric, lacquer, and pigment, 14 1/8 x
10 5/8 inches. Gift of Mr. and Mrs. William M. Spencer
III, 1979.316.
Right: *Hagar and Ishmael Saved by the Angel*, ca. 1727–
1728, Sebastiano Ricci (1659–1734), Italy, Venice. Oil on
canvas, 60 3/8 x 52 3/8 inches. Lent by the Art Fund, Inc.,
AFI 1.1993.
(Frontispiece) Detail, *La Boisson Froide (The Cold Drink)*,
ca. 1750, attributed to Christophe Huet (1700–1759),
France. Oil on canvas, 119 1/2 x 53 1/4 inches. Museum
purchase with funds provided by the Acquisitions Fund,
Inc. and the 1992 Museum Dinner and Ball, 1992.1.3.

Design and layout of this book was by Joan Kennedy; it
was edited by Cecilia Robinson. Photography by Harold
Kilgore, Robert Linthout, and Owen Murphy. Photo on
p. 30, © Justin Kerr. Color separations by Precision
Color, Inc., Capitol Engraving, and Color Unlimited,
Birmingham, AL; type output by Compos-It, Inc.,
Montgomery, AL, in Jansen Text with heads set in
Cochin; printed by EBSCO Media, Inc., Birmingham,
AL, on Frostbrite Matte 80 lb. text.

Contents

Acknowledgments

I wish to thank the curators for their hard work in choosing the objects and in preparing the entries for this catalog. They have been aided by numerous researchers, whose initials are listed at the end of each entry. We wish also to thank the following scholars for their help: Theodore Dell; Nicole Garnier, Curator of Painting, Musée Condé, Chantilly; Clare Le Corbeiller, Associate Curator, Department of European Sculpture and Decorative Arts, Metropolitan Museum of Art; James Parker, Curator Emeritus, Department of European Sculpture and Decorative Arts, Metropolitan Museum of Art; Dr. David Steel, Curator of European Art, North Carolina Museum of Art; Gillian Wilson, Curator of Decorative Arts, The J. Paul Getty Museum; Jane LaRose, Jim Stapleton, and the staff of the Inter-Library Loan Department, Birmingham Public Library.

The wonderful presentation of the works could not have been accomplished without the diligence of our publications department headed by Joan Kennedy. We wish also to thank EBSCO Media, Inc., for their help with the production of this book. Additional support for this publication has been provided by the National Endowment for the Arts.

Dr. John E. Schloder
Director

8

Directors of the Birmingham Museum of Art

Richard Howard
 January, 1951–April, 1975
David Farmer
 April, 1975–December, 1978
Richard Murray
 September, 1979–August, 1983
Gail A. Trechsel
 Acting Director
 September, 1983–March, 1984
 June, 1991–October, 1992
Douglas K. S. Hyland
 April, 1984–June, 1991
John E. Schloder
 November, 1992–present

Contributors

John E. Schloder, Introduction

Commentaries

EBA	E. Bryding Adams
TA	Tracey Albainy
DA	Donna Antoon
NAB	Nila A. Baker
WE	Walton Eagan
EFE	Ellen Friend Elsas
AF	Ann Friedman
MG	Mary Gover
SBH	Suzan B. Harris
CH	Carson Herrington
AH	Ann Hurley
PP	Pratapaditya Pal
KS	Kathleen Sarsfield
SS	Sue Scott
SVS	Suzanne V. Stevens
MMV	Mary M. Villadsen
JW	John Wetenhall
DAW	Donald A. Wood
JY	Jeffrey York

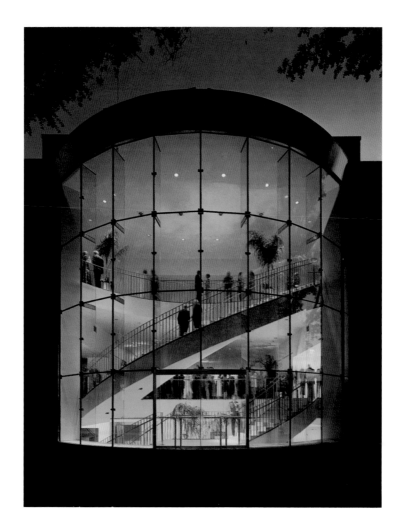

Introduction

The Birmingham Museum of Art is a relatively young museum. It was founded by the city in 1950 and initially occupied a few rooms in city hall. In 1959, through the generosity of Mr. and Mrs. Oscar Wells, a first museum building was erected, and in each succeeding decade a major addition has been added. This tradition continues today with the opening of the new wing designed by internationally acclaimed architect Edward Larrabee Barnes, in collaboration with K/P/S Group. Our latest building campaign not only added fifty thousand square feet of space to the museum but also included the total renovation of the previously existing wings and the creation of a sculpture garden the size of a football field. This new expansion is also a potent symbol of the extraordinary renaissance taking place in the cultural district of downtown Birmingham where the museum is located.

With this most recent addition, the Birmingham Museum of Art becomes the largest municipal art museum in the Southeast. Besides gaining much-needed gallery space to show its fine collection, it now has expanded offices, conservation and storage areas, art classrooms, a library, restaurant, museum store, and three-hundred-forty-seat auditorium. Its collections offer an introduction to world art history rivaling that of any museum in the South, and through these collections, exhibitions, and outreach programs the museum serves as an important educational and cultural resource for the state and region.

This publication will introduce a select group of treasures representing the range and quality of the

museum's collection. The one hundred thirty objects in this catalog are drawn from about fourteen thousand works of art and thus can give only the briefest overview of the collection. We hope, nonetheless, that they illustrate the breadth of material found in the museum today. Objects range from ancient to contemporary in date, East to West in origin, and pre-Columbian to Post-Modernist in style. By no means has the selection been easy. Everyone has a particular favorite. We have tried to include many that we believe to be popular as well as representative of the collection as a whole. Such practical considerations as the book's size, however, had to be taken into account. In every instance we have chosen objects of outstanding quality, but which, because their number is limited, can only suggest the grandeur of each civilization.

A major museum has many functions. It should speak for all times and all places. It should aim to show the highest expression of art. It should also make visitors see more and see differently, and explore areas of human achievement of which they may have been previously unaware. These discoveries can help us all better understand and appreciate other cultures so that we may live in harmony with them. Would it not be wonderful to see the diverse cultures of today exist as peaceably side by side—without ignorance, prejudice, and hatred—as these works of art do?

A museum should also be a place where ideas come bouncing off of every wall and out of every display case. We hope that the Birmingham Museum of Art is this kind of museum and that this publication will generate new ideas and new discoveries.

With this in mind, we have intermingled objects from Eastern and Western cultures by

putting them in chronological order. Various media are also intermixed, as they are in the museum galleries. This does not imply that there is a direct relationship between two successive objects, nor that one had any influence on the other, although in certain instances this may indeed be true.

What this arrangement does is allow the reader to better grasp the vast areas of civilization represented in the entire collection. It also creates some juxtapositions we hope will stimulate our readers to think about the differences between or similarities of the civilizations that created the objects simultaneously, and will entice them to visit the museum to see the art in person. The curators and I fully realize that some of the placements will be strange, and perhaps disquieting, but we hope that they will always be thought-provoking. It is fascinating, for example, to see here the fifteenth-century Ming dynasty fresco (p. 52–53) near the early Renaissance painting of the *Seven Virtues* by Pessellino (p. 58), or to compare Rodin's nude figure of *Jean d'Aire* (p. 190) to the African Songye power figure (p. 192), or Frank Lloyd Wright's window and chair (pp. 216 and 218) with a silver punch bowl of the same time period but of a very different style (p. 221).

For those who are interested in a particular area of art history, we have included two indexes that we hope will be of help. The first index lists the objects in this publication by department and within each department by country or culture, so that one can easily find his or her area of interest. The second index lists in alphabetical order artists whose work is included in this book.

Readers may want to expand their overview of the collection by consulting *The Handbook of the Collection*, published in 1984, which also contains a

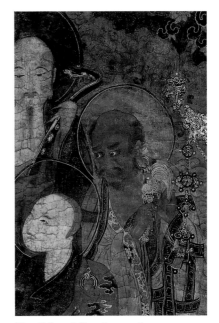

Detail from Ming dynasty fresco.

Detail of Justice from the Seven Virtues.

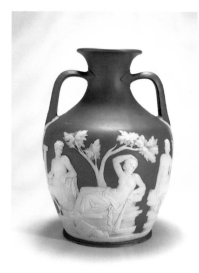

Slate blue Portland vase copy, ca. 1791. Jasper ware, 9 ³/₄ x 4 ¹⁵/₁₆ inches. Gift of Dwight and Lucille Beeson. One of the most important pieces in the Wedgwood Collection, published in the 1984 Handbook.

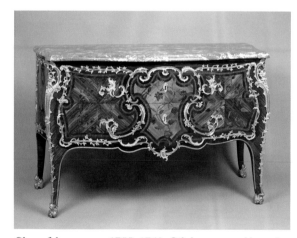

Chest of drawers, ca. 1755–1760. Gilt bronze, marble, and oak veneered with kingwood, bois satiné, *and purplewood, 34 x 56 ¹/₂ x 25 ³/₄ inches. Eugenia Woodward Hitt Collection. One of the many fine objects in the eighteenth-century French collection that, due to space constraints, could not be included in this catalog.*

history of the museum. By comparing the earlier catalog with this one, one realizes the great extent to which the collection has grown in less than a decade. Of course, certain items of outstanding quality—Bierstadt's awesome presentation of Yosemite Valley (p. 175), the mythological representation of *Perseus Armed by Mercury and Minerva* by the Mannerist Italian artist Paris Bordone (p. 68), the Chinese gilded wood figure of Sakyamuni from the Yuan dynasty (p. 45)—are found in both. These are undeniable masterpieces in the collection and therefore have also been included here. But it is amazing to see the number of works that have not been duplicated in the new publication because the collection has grown so extensively in quality during these nine years. Only about one-quarter of the objects represented in this book were also in the 1984 *Handbook*.

A number of masterpieces have been added recently, starting with the Jomon jar from Japan (p.19), which is the oldest work in the present catalog. It was acquired in 1989, as was the unbelievably beautiful Tang ceramic horse (p. 27). The recent purchase of a large Baroque painting, *Hagar and Ishmael Saved by the Angel* by Sebastiano Ricci (p. 93), adds another great work to our Venetian eighteenth-century collection, and the *Britannia Triumphant* figurine (p. 140) is a major addition to our Wedgwood Collection, the largest outside England. Certainly the remarkable bequest by Eugenia Woodward Hitt in 1991 of two thousand objects has made French eighteenth-century decorative arts one of the strengths of the museum, establishing Birmingham's museum as unique among the museums in the Southeast. In large part this catalog is a tribute, therefore, to the vigorous collecting the museum has pursued over the past few years.

In the forty-three years of its existence, the Birmingham Museum of Art has changed dramatically from the institution that opened its doors in 1951. The reasons for this evolution may be found in the wellspring of public and private generosity that created a series of buildings culminating in the new addition, as well as in the exceptional acquisition of individual works of art and entire collections that reflect the munificence of benefactors whose names will forever be associated with the museum.

To a significant degree, the names of many Alabamians who have made it all possible appear in the credit line accompanying each object. Their names indicate that they want to leave the city better than they found it; not simply bigger, or richer, or more imposing, but better. Nowhere is that more evident than in their devotion to the Birmingham Museum of Art. Their boundless generosity and the enthusiastic support of the museum's board of trustees have enabled a perceptive curatorial staff to create the great collection we have today—and will ensure its growth in the future.

Dr. John E. Schloder
Director

Jar

Jomon period (ca. 4500–200 B.C.)
Japan
Earthenware
22 x 16 inches
Museum purchase
1989.61

 The art tradition of Jomon period, or Neolithic Japan, is one of great variety. Lasting over eight thousand years and permeating most of modern Japan, the Jomon culture of the Neolithic period was rich in tools, jewelry, figures, and pottery. It is probable that most households of this period had their own artisans, resulting in great diversity of form and decoration in the works produced. The Birmingham Museum of Art jar is an outstanding example of the pottery tradition from this time. From the Middle Jomon period dating to about 3500–2500 B.C., the piece was excavated in 1969 in Aomori prefecture in northern Japan.

 Jomon pottery is low-fired earthenware with a coarse, polished, burnished, or painted surface. Many of the pots are characterized by cord-impressed designs that range from simple incised zones of decoration to dense, circuitous markings and carved spiral patterns near the rim. The work of the Middle Jomon period is particularly plastic, with sculpted rim decorations in elaborate shapes that project into space.

 During the Jomon period pots were used primarily for boiling or storing food, although steamers, lamps, hearth linings, and burial jars are also known. Many of these items have been discovered in the shell-mounds, or kitchen-middens, of Jomon settlements. Over two thousand such sites have been reported in Japan, filled with kitchen refuse and broken and unusable objects. The remains of deer, wild boar, badger, hare, wild birds, fish, and bivalves of all kinds that also litter these sites indicate a rich variety of food stuffs. The economic stability that was provided by such abundance allowed for the provocative and imaginative development of the pottery tradition typified by the Birmingham Museum of Art jar.

DAW

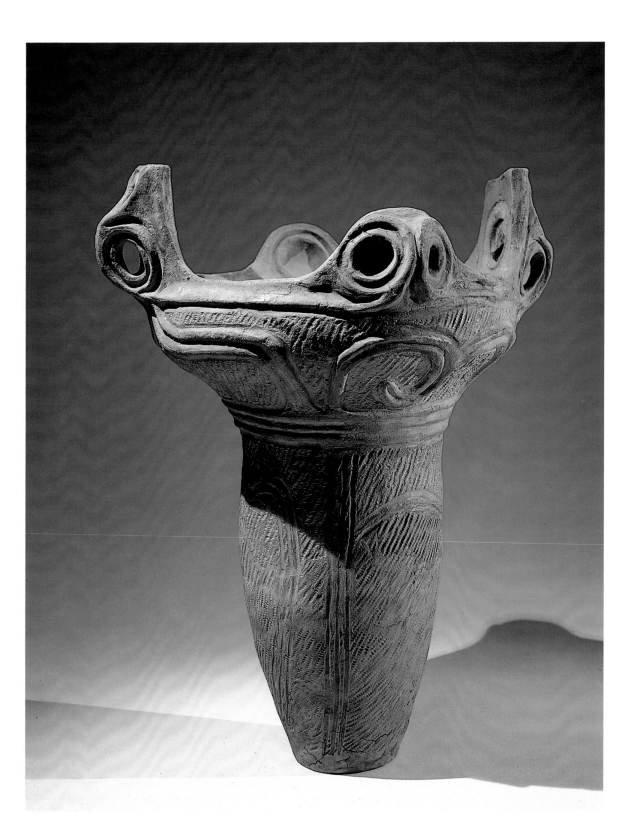

Female figure

500 B.C.–A.D. 250
Jalisco culture, Ameca style?
Western Mexico, State of Jalisco
Fired clay and slip
17 1/2 x 14 x 5 1/2 inches
Museum purchase with funds provided by Mr.
 and Mrs. E. M. Friend, Jr.; Mrs. James D. Foster;
 and Mrs. Sidney B. Finn, by exchange; and the
 Traditional Arts Acquisition Fund
1987.5

Among the liveliest of pre-Columbian arts are the shaft tomb figures from western Mexico. The Ameca group, from northern Jalisco, is a subtype of the large hollow terra-cotta figures produced by the hundreds during the Late Preclassic period (approximately 300 B.C.–A.D. 100). They are immensely popular with connoisseurs, the abstract forms inspiring many contemporary artists. They were used in antiquity as burial goods, but their whimsical nature belies the funerary function.

The female figure in this collection is representative of the type, yet its unique details demonstrate subtle diversity within the Ameca range. The overriding diagnostic of all western Mexican figures is anatomical disproportion; bodies seem to be inflated rather than obese, heads are long and angular. Ameca statues are characterized by greyish-buff clay—many are painted red and mottled black—and by enormously large, stubby hands and feet, with incongruously long, well-defined nails.

The heels of the figure project from the back, enabling an otherwise unstable, top-heavy piece to stand alone. The head is small in proportion to the body and shows evidence of cranial deformation. Ameca eyes are clay pellets set into oval rimmed sockets. Noses are long and thin. Mouths were made with considerable detail, not easily seen by cursory observation. The tongue rests on small incisions that represent teeth.

The wide-legged stance of this figure is distinctive, as many Ameca figures were formed in sitting or kneeling positions with palms pushing forward from extended arms. Unlike most Ameca figures, this one wears neither clothing nor ornament, although it does have the usual close-fitting cap.

The tombs, like the figures they contained, are unique to western Mexico. They are described as shaft tombs, having a long vertical entrance, usually with one to three chambers. Unfortunately archaeological work has not kept pace with the destruction of the shaft tombs, leaving the figures to be studied and appreciated in museum and private collections.

SS

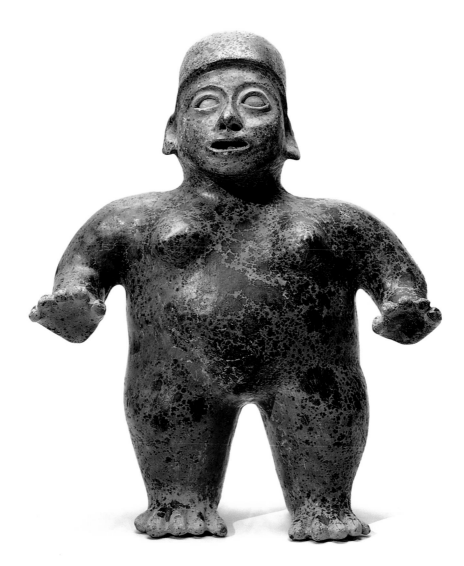

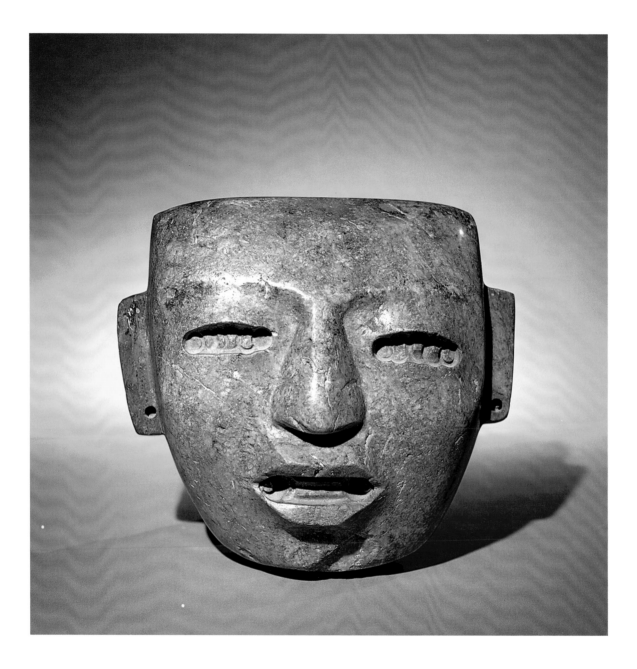

Stone face

Period III–IV (ca. 250–650)
Teotihuacan culture
Mexico, central highlands region
Carved stone
6 ¼ x 4 ⅜ x 3 inches
Gift of Gay Barna
AFI 25.1982

Serene and unsmiling, this face of a Teotihuacan personage is sculpted in stone. Slightly smaller than life-size, stone faces are one of the most usual and yet most enigmatic of all artifacts from the ancient city. It has been estimated that hundreds, perhaps thousands, of these items have been found at Teotihuacan, most of which are now in museum and private collections. Only a few have been recovered in archaeological excavations, and none in contexts that would suggest how they were used. It is thought they were first made in the Early Classic period (ca. 200) and continued in use until the collapse of Teotihuacan (650).

The highly developed stone carver's art of this culture produced human likenesses by working a hard, dense stone. The features were shaped by smoothing surfaces to indicate eyebrows, indentations around the eye sockets, and cheekbones. The top of the head was cut straight across, giving the idea of a mask, hence the term. An uneven surface at the top left smoothed but unfinished could mean it was covered and not seen. The eye sockets and mouth inside the lips were drilled with small round tubes, perhaps of bone, approximately one centimeter in diameter. These unfinished areas would have been inlaid with shell, obsidian, or pyrite to depict the eyes and teeth. The lips retain traces of a red substance that may be cinnabar. Seen in profile, the face seems a striking example of cranial deformation. The long, rather flat nose is particularly distinctive; the nostril flares are simple incised lines.

The Teotihuacan countenance is thought to be an idealized conception and not intended to represent a particular person. Close examination of many carved faces and terra-cotta figurine heads of similar configuration reveals subtle differences that may represent the products of several artists, or perhaps the portraits of several individuals.

It is highly doubtful that these Teotihuacan faces were worn as masks; they are extremely heavy and lack perforations for eyes, nose, and mouth. They have been regarded as masks because of the flattened head, or because of perforations on the reverse, permitting attachment by cord or fiber. It has been suggested that they were tied onto mummy bundles, but there is not a shred of evidence to support the theory of that practice. Entire stone figures of comparable proportion are known at Teotihuacan, and Esther Pasztory reasons that these faces were part of a larger figure made from a perishable material and richly adorned.[1]

Representations of humans in other Teotihuacan art forms—mural and vase painting, censors, and figurines—are shown wearing lavish clothing, jewelry, and headdresses. It is highly likely that stone masks were decorated with equally sumptuous attire. Certainly this face would have worn earspools and probably a headdress. A U-shaped section was carved on the reverse, leaving a three-centimeter rim around the sides and lower back. It is functional, rather than decorative; in size and shape it would have served to brace a headdress support. No headdresses have survived the centuries at Teotihuacan, but are depicted as large and elaborate and fitted on the head just above the eyebrows.

Today we admire this work of art for its harmony and simplicity of line, its controlled strength of countenance.

SS

1. Esther Pasztory, "A Reinterpretation of Teotihuacan and Its Mural Painting Tradition," in *Feathered Serpents and Flowering Trees*, ed. Kathleen Berrin (San Francisco: The Fine Arts Museums of San Francisco, 1988).

Buddha

7th–8th century
Dvaravati school
Thailand
Limestone with traces of polychrome
13 x 7 1/2 x 7 1/2 inches
Gift of Mr. Robert Utterback, Sr., in memory of his
 mother, Katherine Flournoy Utterback
1989.152.1

Dvaravati is the term used to describe a king-dom of the Mon people who ruled the region between U Thong and Nakhon Pathom in Thailand between the sixth and eleventh centuries. In the later part of this period, Dvaravati came under the political influence of Srivijaya to the south, but managed to maintain its own cultural identity. The chief cities of Dvaravati were centers of refinement and learning where a distinctive artistic style evolved. Lacking direct references to Indian prototypes, the sculpture of the Mon people is the first truly original form of Buddhist art to appear in Southeast Asia. The head of the Buddha in the Birmingham Museum of Art is a classic example of this indigenous expression.

The stone available to the Dvaravati sculptors was a brittle limestone riddled with internal fault lines. The friable cracks within such stone are clearly visible in the Birmingham head. The very nature of the stone prescribed a somewhat heavy figure type that has broad facial features with a wide, flat nose and thick lips. The eyebrows are defined with a substantial ridge that joins in the center to form a bow and the head is usually covered with thick, heavy curls. The physiognomy of this imagery is thought to directly reflect that of the people who created them.

It is impossible to say whether the Birmingham image originally came from a standing or a seated figure. Both types were within the oeuvre of the Dvaravati school. Statuary such as this was usually part of an overall architectural scheme in which images adorned either the inside of a building or formed part of the exterior decoration in niches. Gilded and painted, these statues were an essential element of the overall iconographical plan of a structure. The influence of the Dvaravati style and iconography spread far beyond the supposed confines of the kingdom, providing inspiration and innovation for many of the artistic traditions of Southeast Asia.

DAW

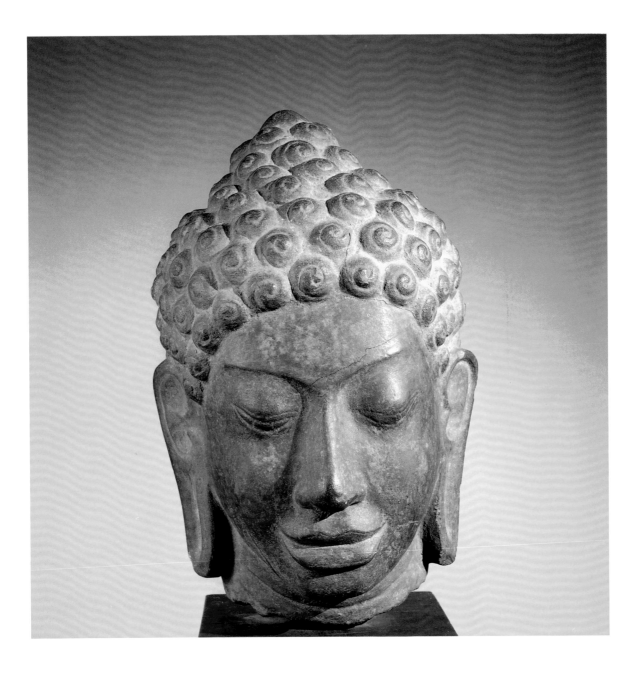

Horse

Tang dynasty (618–906)
China
Glazed pottery
25 x 26 x 7 inches
Partial gift of Dr. and Mrs. M. Bruce Sullivan and
 museum purchase with funds provided by the
 1988 Museum Dinner and Ball
1989.51

Archaeological excavations have verified the practice described in ancient Chinese texts in which the entire retinue of a deceased ruler was sacrificed in order to accompany the master into the next world. This practice included family members, retainers, soldiers, slaves, and animals of all kinds. By the second century B.C., this immolation came to be replaced by ritual observance in which figurines of wood or clay were commonly interred. By the Tang dynasty (618–906), the production of these tomb figurines in China had reached an artistic zenith. The horse in the Birmingham Museum of Art is an outstanding example of this legacy.[1]

Horses were of tremendous importance to the ancient Chinese. Invested with sanctity by tradition and revered as a relative of the dragon, the horse became an instrument of military and diplomatic policy as well as a status symbol by the Tang dynasty. Imported from various parts of Central Asia and even further afield, foreign horses of many breeds were represented in Chinese art during this period of prosperity and power.

Strict sumptuary laws, based on class distinctions, regulated the types of tomb figures that could be buried with an individual. Hundreds of tomb figurines have been discovered in royal tombs of the Tang dynasty, depicting court officials and ladies, foreigners, musicians, dancers, and a wide diversity of animals. Of this varied retinue, the horses of the early eighth century are particularly spirited. The Birmingham Museum of Art horse, with its great size and elaborate caparison, would most likely have been part of a much larger grouping intended for the tomb of an individual of the highest social station.

The body of this horse was made in a mold from a soft white clay. The legs, tail, ears, and delicate saddle trappings were all individually fashioned from a similar clay and then luted to the body. The whole figure was then carefully covered with chestnut-, straw-, cream-, and green-colored glazes and fired.

DAW

1. This figure was exhibited in A Thousand Years of Chinese Tomb Sculpture, EPCOT Center, Orlando, Florida, 1983.

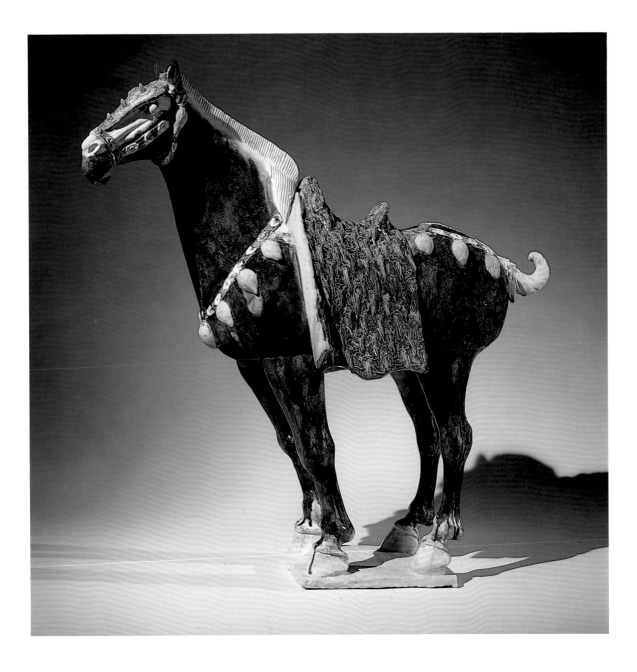

Buddha

United Silla period (668–918)
Korea
Gilt bronze
7 3/8 x 2 1/4 inches
Anonymous gift
1988.64

Traditionally Buddhism was introduced into Korea from China during the Three Kingdoms period (first century B.C.–A.D. 668). As a vehicle of higher civilization the new religion received widespread support in conjunction with the native Shamanist beliefs. The influx of material culture that ensued provided the impetus for an artistic florescence in the three kingdoms of Koguryo, Paekche, and Silla.

The following United Silla period (668–918) saw the influence of the international Tang dynasty (618–906) style from China take hold in Korea as it did throughout much of Asia. The round full form, the rather stern expression of the face, and the drapery that clings to the body of the Birmingham Museum of Art figure are all hallmarks of the Tang style. Within this style, however, elements of the native Korean propensity for an indigenous stylistic orientation are clear and pronounced. As seen in this statue, this native aesthetic prefers a blocklike conception of spacial development with little desire to expand into space. There is also a constrained linear schematization of the drapery and a strict sense of bilateral symmetry that is not common to Tang dynasty prototypes.

The identity of the Birmingham Museum of Art statue is unclear. A similar figure exhibited at the Yamato Bunkakan in Nara, Japan, in 1982 is identified simply as *Nyorai*, or Buddha.[1] Lacking any of the distinguishing attributes of a specific Buddha, a comparable generic designation is perhaps appropriate for this particular figure. Like the Yamato Bunkakan figure, the Birmingham Museum of Art image is cast in the half-round with tenons on both feet for insertion into a base. The transmission and intermingling of ideas and style represented by such work as this statue are indicative of the rich diversity of influences that distinguish the arts of Korea.

DAW

1. Yamato Bunkakan, *Kudara to Shiragi no Kondo Butsu* (Tokyo: Nihon Shashin Insatsu Kabushiki Kaisha, 1982), 29, fig. 36.

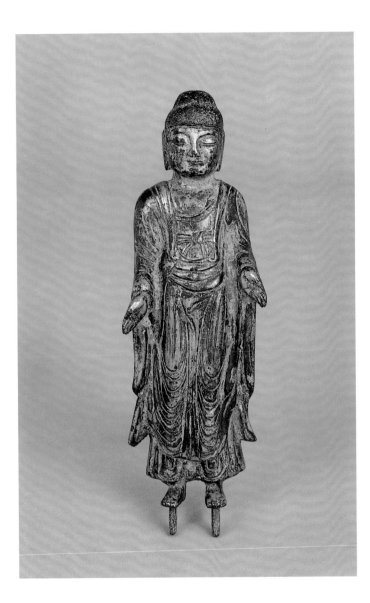

Cylindrical vessel

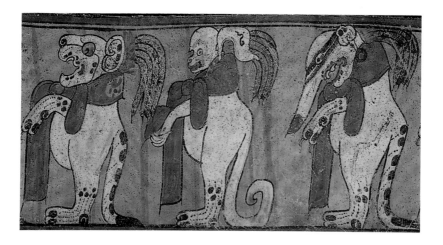

Late Classic period (ca. 700–800)
Maya culture
Guatemala, Peten region
Fired clay and slip
6 ½ inches; diameter: 4 ¼ inches
Museum purchase with funds provided by the
 Committee for the Traditional Arts and the
 Traditional Arts Acquisition Fund
1991.781

The Maya culture flourished from ca. 200 B.C.–A.D. 1000 in regions of southern Mexico, Belize, Guatemala, El Salvador, and Honduras. Although best known for their complex social organization and remarkable achievements in architecture, astronomy, and hieroglyphic writing, perhaps their greatest level of artistic sophistication is illustrated in their ceramic wares deposited in burials.

Depicted on this vase are a monkey, a coatimundi, and a jaguar. The figures advance from right to left, the direction of the night sun's journey through the underworld. Each wears a red scarf, a symbol often associated with death. The spots on the figures' hands and feet may also refer to death and the afterlife; a recent tomb excavation has revealed an individual wearing jaguar-paw mittens.[1] The animal processional motif is fairly common. This was thought to take place in Xibalba, the Land of the Dead. However, new studies of glyphs have proven that many such depictions actually represent spirit beings who coexist with the living.[2] The figures on this vase are thought to be such spirits.

Many Mesoamerican cultures believe that everyone possesses a parallel being or "co-essence"[3] in the spirit world. The Maya glyph referring to this supernatural twin translates as *way* (pronounced "why"). The *way* entity may assume the form of an animal, bird, or a natural occurrence with characteristics that mirror those of its "owner." Although generally benevolent beings, *way* usually exhibit odd behavior or unusual features. Often dormant, they sometimes roam while their counterparts sleep. The coatimundi and jaguar have bloodshot eyes, the unequivocal identifying trait of a co-essence.[4]

Recent translations of the Maya writings have revealed much about the original context of such vessels. Vases such as this were also used as containers for a frothy drink made from cacao, a beverage important in rituals.

MMV

1. Jennifer T. Taschek and Joseph W. Ball, Lord Smoke-Squirrel's Cacao Cup: The Archaeological Context and Socio-Historical Significance of the Buenavista 'Jauncy Vase,' vol. 3 of *The Maya Vase Book: A Corpus of Rollout Photographs of Maya Vases* (New York: Justin Kerr, Kerr Associates, 1992), 494.
2. Stephen D. Houston and David Stuart, *The Way Glyph: Evidence for "Co-essences" among the Classic Maya* (Washington, D.C.: Center for Maya Research, December 1989).
3. "Co-essence" is a term introduced by John Monaghan in an unpublished paper. Houston and Stuart, *The Way Glyph*, 1–2.
4. David Stuart, "Hieroglyphs on Maya Vessels," vol. 1 of *The Maya Vase Book*.

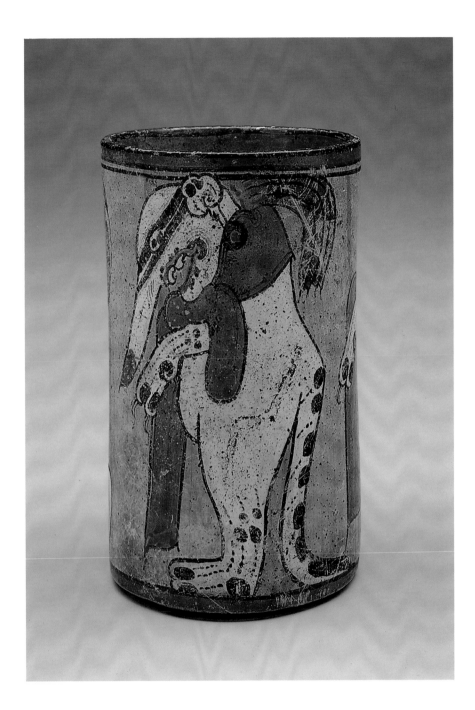

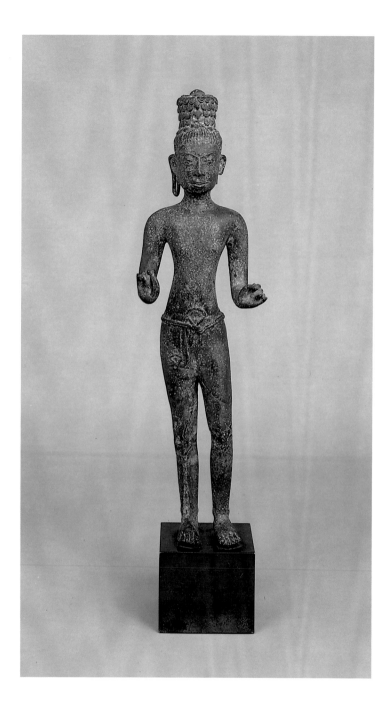

Avalokitesvara

Pre-Angkor period (9th century)
Thailand
Bronze
15 1/8 x 4 1/2 x 3 1/2 inches
Gift of Dr. and Mrs. M. Bruce Sullivan in honor of
 Douglas and Tita Hyland
1991.958

Images of Avalokitesvara from the pre-Angkor period in Thailand are among the most beautiful ever produced in Southeast Asia. Distinguished by light and graceful forms, these images are a reflection of Indian styles as transmitted through the Cambodian tradition of the Chenla period (550–802).

The Birmingham Museum of Art image is clearly identified as Avalokitesvara, the personification of compassion, by the small seated image of Amitabha Buddha at the base of the elaborate hairstyle. As the spiritual son of Amitabha, the Buddha of Infinite Light, Avalokitesvara is the most popular of the Mahayana Buddhist deities. Introduced to Thailand some time during the seventh century, Mahayana Buddhism emphasizes the concept of salvation and redemption through the direct assistance of Avalokitesvara. Rescue from the perils of travel, the curing of illness, and protection from thieves and wild animals and other dangers are all within his powers.

The most famous of the pre-Angkor period Buddhist bronzes come from a group discovered in the village of Prakonchai in Buriram province of Thailand in 1964.[1] While similar in style and overall appearance, slight differences in the hairstyle and the overall patination of the Birmingham Museum of Art piece suggest a comparable time frame, but perhaps a site other than Prakonchai.[2]

DAW

1. Emma C. Bunker, "Pre-Angkor Period Bronzes from Pra Kon Chai," *Archives of Asian Art* XXV (1971–1972), 67–76; and Robert D. Mowry, "An Image of Maiterya and Other Pre-Angkor Prakonchai Bronzes," *Orientations* (December 1985): 33–41.
2. Metalurgical analysis of the Birmingham Museum of Art piece was conducted at the Metropolitan Museum of Art and was found to be consistent with other known pre-Angkor examples.

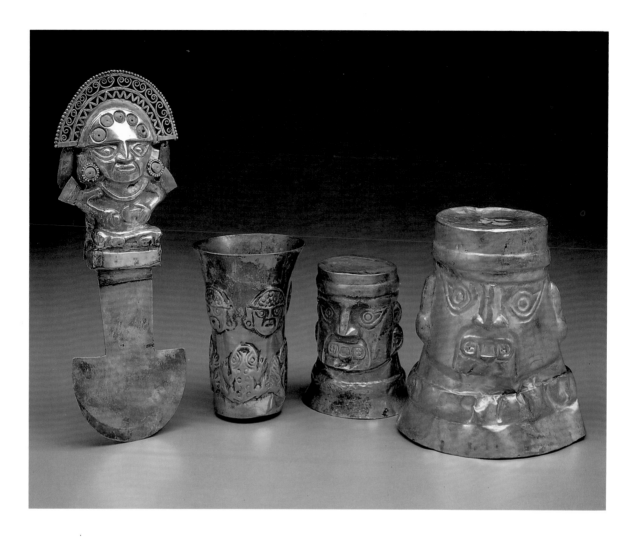

Ceremonial knife (tumi) and vessels

Ca. 1000–1050
Middle Sicán culture
Peru, northern coast, Lambayeque region, La Leche
 Valley, Batán Grande complex
Tumbaga and turquoise
Knife: 13 5/8 x 5 1/4 x 1 1/2 inches
Two larger vessels: 7 15/16 x 6 3/4 inches,
 6 5/16 x 4 1/2 inches
Museum purchase
1964.92, 1964.94, and 1964.100
Smallest vessel: 5 1/2 x 4 1/2 inches
Gift of Mary R. Belcher in memory of her son,
 Charles Donald Belcher
1986.652

Long before the Spanish conquest, Native Americans had developed the art of metalworking to a highly sophisticated level. Peru, southern Colombia, and Ecuador constitute the region where metallurgy was first practiced in the New World.[1] This *tumi* (ceremonial knife) and these vessels are from the Sicán culture of Peru.

The anthropomorphic depictions on the ceremonial knife and the vessels represent the principle deity, the Sicán Lord. Characteristic motifs are the comma-shaped eyes and, on the "upside-down" vessels, the fanged mouth. On the *tumi*, the Sicán Lord is seated with left leg crossed over right. He is holding a *tumi* in one hand and an unidentified round object in the other.

These pieces are composed of thinly hammered *tumbaga*, an alloy of gold and copper that has a melting point considerably lower than pure gold or pure copper. Objects made of this alloy were given an exterior of solid gold by removing the surface copper with an acidic or saline solution, a process known as depletion-gilding, or through oxidation. The surface was then consolidated by burnishing, giving the illusion of a solid gold mass. Designs were raised by hammering and embossing over forms made of wood or some other dense yet elastic material.[2]

Nearly two hundred objects of *tumbaga* and other precious metals have been found in a single Sicán elite burial. The beakers were usually stacked approximately ten high in groups according to size and shape.[3] The quantity of objects interred and the time and labor required to make them suggests that they were not all manufactured just to be buried. Obviously not of a common utilitarian nature, they were probably indicators of status and used during rituals throughout life, perhaps in internment ceremonies.[4] There is evidence that such objects were often painted or covered with mosaic patterns of iridescent feathers that concealed the gold surfaces.[5] Residue of a thick coating of cinnabar, possibly from the vessel it was stacked upon in the tomb, still exists inside another beaker in the collection of the same type as the one in the far right in the photograph. The objects may have been gathered and painted red to connote death in preparation for internment. Most *tumbaga* objects in museums and private collections have been cleaned of any traces of applied surface decoration in a misguided effort to accentuate the gold color.[6] It is apparent that gold or the red-gold color of *tumbaga* held a deep significance to pre-Columbian peoples, very different from the Western aesthetic. Many New World cultures considered gold to be the "sweat of the sun," and its presence, even when invisible, may have been necessary in such ritual objects.[7]

MMV

 1. Heather Lechtman, "Issues in Andean Metallurgy," in *Pre-Columbian Metallurgy of South America*, ed. E. P. Benson (Washington, D.C.: Dumbarton Oaks, 1979), 344.
 2. Ibid., 8–9, 29, 372–73; and Warwick Bray, "Ancient American Metallurgy: Five Hundred Years of Study," in *The Art of Precolumbian Gold: The Jan Mitchell Collection*, ed. E. P. Benson (New York: Metropolitan Museum of Art, 1985), 77, 79–80.
 3. Paloma Carcedo Muro and Izumi Shimada, "Behind the Golden Mask: Sicán Gold Artifacts from Batán Grande, Peru," in *The Art of Precolumbian Gold*, 72.
 4. Ibid., 73–4.
 5. Ibid., 65.
 6. Ibid., 74.
 7. Lechtman, "Issues in Andean Metallurgy," 9–10, 31–2.

Ganesha

Angkorian period (11th–13th century)
Cambodia
Sandstone
28 ³/₈ x 17 x 10 ¹/₂ inches
Gift of Mr. and Mrs. Charles B. Crow and Mr. and
 Mrs. William Grant, Jr.
1978.73

Being one of the most ubiquitous of Indian gods, images of Ganesha can be found by the roadside, in household shrines, temples, and shops, and on the frontispieces of books. Ganesha, who both places and clears away all obstacles, is the patron of merchants and the god of wealth and well-being. He is the son of the Hindu gods Shiva and Parvati and is always shown with the body of a potbellied dwarf and the head of an elephant.

Legends about the unusual appearance of this god abound in Hindu mythology. One of the most common recounts how Parvati ordered her son to stand guard and not let anyone near her while she bathed. When Shiva approached and demanded passage, a fight ensued during which he cut off the head of the boy. In order to pacify the heartbroken Parvati, Shiva ordered the other gods to retrieve the first head they could find. The gods returned with the head of an elephant, attached it to the decapitated body, and brought the youth back to life. Parvati took her son to Shiva where the boy apologized and was forgiven by Shiva and the other gods. Much pleased, Shiva then adopted the boy as his own son and gave him the name Ganesha.

The Birmingham Museum of Art image of Ganesha is from Cambodia. Carved from a solid block of sandstone, the god wears the royal attire of the Khmer people: a *sampot* (lower garment), elaborate jewelry, and a crown. Both the crown and the *sampot* are tied with intricate knots in back, with the *sampot* in the characteristic butterfly knot of Khmer art. Ganesha is portrayed seated, holding his usual attributes of a *modaka* (sweet-meat) in his left hand and part of his broken tusk in his right hand. The elephantine nature of the deity is aptly emphasized by the architectonic solidity of the composition.

DAW

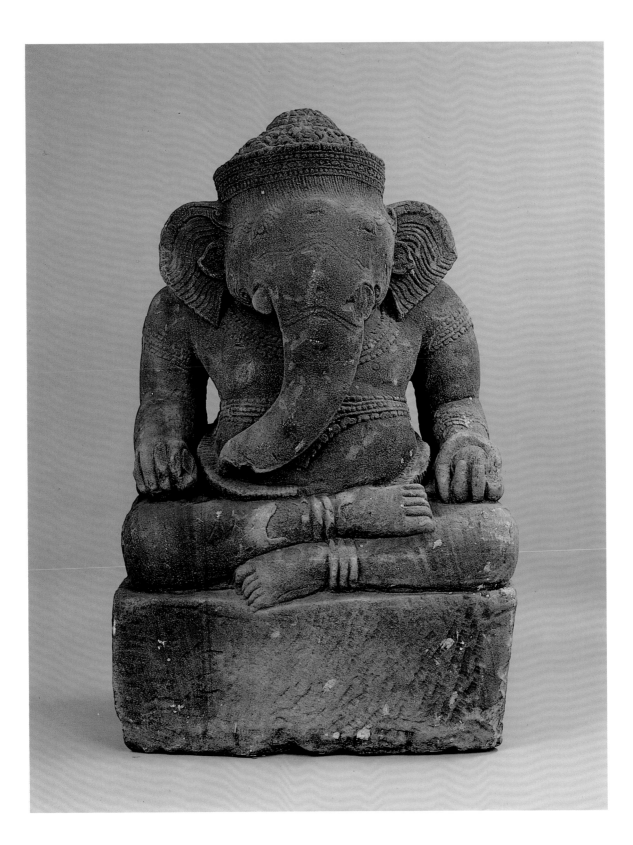

Uma-Mahesvara (Shiva and Parvati)

12th–13th century
India, Halebid region, Karnataka
Chloritic schist
38 1/2 x 23 1/2 x 11 inches
Museum purchase with funds provided by the
 1990 Museum Dinner and Ball
1990.109

Hindu culture flourished in southern India during the twelfth to fourteenth centuries when the powerful Hoysala dynasty ruled the Karnataka area of the Deccan. Master builders, the Hoysalas constructed a number of distinguished Hindu temples in the area of Halebid (Dorasamudra, the Hoysala capital). Many of these temples were never finished, lacking towers and roofs, attesting to the rapid political and economic changes of the time. The Birmingham Museum of Art statue of Uma-Mahesvara is from the Halebid region, Karnataka, where the largest and most famous of these temples were built.[1]

Uma-Mahesvara is the combined imagery of Mahesvara, the Great Lord Shiva, and his wife, Uma, the Great Goddess Parvati. A symbol of release within the spiritual and physical unity of divine love, the image of Uma-Mahesvara was a popular form in the hierarchy of Hindu iconography. The Birmingham Museum of Art image is a superb representation of the divine couple seated in *lalitasana* (pose of royal ease), with Shiva's bull vehicle, Nandi, and Parvati's iguana below their feet. Their sons Ganesha, on his rat, and Karttikeya, perched on his peacock, are depicted in the lower left and right, respectively.

The stone carvers of the Hoysala dynasty were masters in the rendition of fine detail. The chloritic schist stone that was so readily available to these artisans permits the very fine carving that characterizes work such as the Birmingham piece. The smooth, heavy limbs of the figures form a stark contrast with the deep carving of the various accoutrements that encase the gods within a rigid mass of opulent detail. Heavily jeweled and beaded dhotis, necklaces, crowns, and rhizome spitting *kirttimukha* (demons) combine to form a sumptuous surface play of light and dark on the grey stone. The sense of depth created by these details, along with the deep undercutting of the figures themselves, is further heightened by the pierced surface of the stele. The rich orchestration of component details and surface decorations found in the Birmingham stele represent the full flowering of the continuing Indian love of stonework.

DAW

1. Further references can be found in J.C. Harle, *The Art and Architecture of the Indian Subcontinent* (Middlesex 1987), 266–67, ill. 208; Stella Kramrisch, *Manifestations of Shiva* (Philadelphia: 1981), ill. 53; Pratapaditya Pal, *The Sensuous Immortals, A Selection of Sculptures from the Pan-Asian Collection* (Los Angeles: 1977), ill. 87.

This statue was exhibited at the Denver Art Museum, 1968–1977, and at the Los Angeles County Museum of Art, 1977–1982.

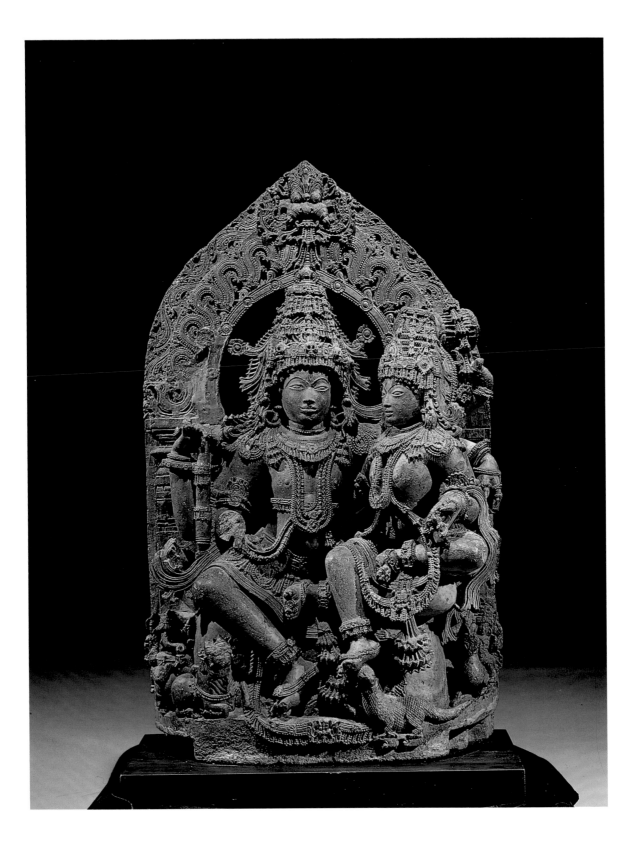

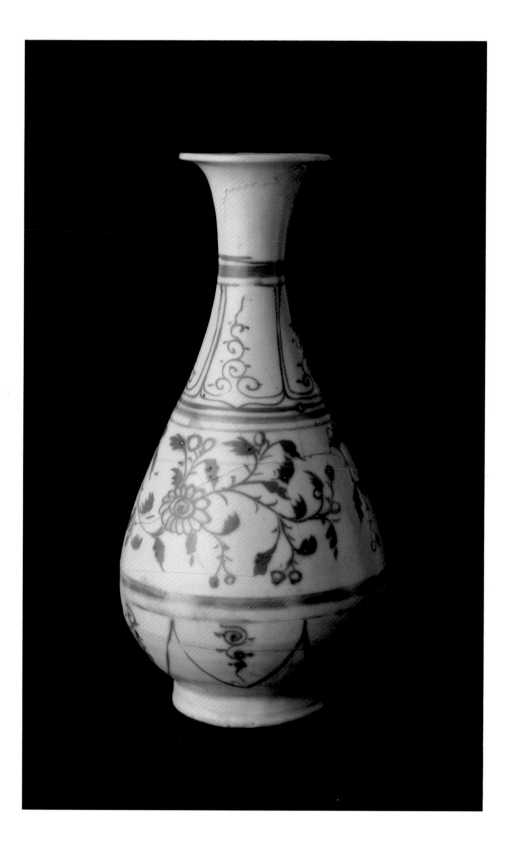

Yuhuchun bottle

Yuan dynasty (1279–1368)
China
Porcelain decorated in underglaze copper red
7 ¹/₂ x 3 inches
Gift of Mr. and Mrs. William M. Spencer III
1979.351

The systematic use of underglaze copper oxide as a colorant on porcelain began at the Jingdezhen kilns in Jiangxi Province, China, during the Yuan dynasty. Contemporaneous to the perfection of underglaze cobalt blue decoration, copper oxide was much more difficult to control in the kiln and tended to burn to a faded grey. The red color of the Birmingham Museum of Art bottle is unusually deep and rich, denoting a completely successful firing.

The name of the bottle shape, *yuhuchun*, is translated as "jade-vessel spring." Taken from a Yuan dynasty play in which the beautiful heroine composes a poem of the same title, the shape became a standard one in Jingdezhen production during the fourteenth century.[1] How the name came to be associated with these pear-shaped bottles is still unclear.

The embellishment of *yuhuchun* bottles is usually spare and restrained. The Birmingham Museum of Art bottle by comparison is decorated with a complex design of chrysanthemum patterns, floral petals, and lotus panels. The various motifs were rapidly brushed on in lines of varying thickness and density. The white glaze on the Birmingham bottle has a pale blue-grey tint, and the exposed clay in the foot ring has burned a rusty buff color. Comparable examples in other collections are adorned with incised, carved, appliquéd, or painted underglaze blue and red designs and show similar characteristics of glaze and clay types.

DAW

1. Mary Ann Rogers, *In Pursuit of the Dragon: Traditions and Transitions in Ming Ceramics* (Seattle: Seattle Art Museum, 1988), 65.

Plate

14th century
Yuan dynasty (1279–1368)
China
Wood, hemp, and lacquer
1 ³/₈ x 13 ³/₄ inches
Gift of Mr. and Mrs. William M. Spencer III
1986.811

The covering of vessels with lacquer originated in the prehistory of China. Used for everyday and ceremonial pieces, lacquer not only enhances the appearance of an object but also gives it added strength and makes it impervious to liquid. Lacquer is derived from the sap of the lacquer tree (*Rhus verniciflura*) and like varnish is an irritant in its unrefined state. The manufacture of the best lacquerware can require as much as ten years, with the number of layers of lacquer on some pieces numbering several hundred. Lacquer can be applied directly to the body of an object, or more commonly, to an intermediary layer of cloth. Lacquer can also be colored while still in its liquid state by the addition of cinnabar, cassia juice, or other colorants.

The Birmingham Museum of Art plate belongs to an important group of early Chinese lacquerware known as "two-bird" plates that date to the Yuan dynasty. Decorated with deeply carved parrots frolicking amidst peonies in full bloom, the plate is typical of this type in which parrots, cranes, herons, or phoenixes are depicted with a variety of foliage in red, black, or like this plate, a deep dark-brown color.

The parrot is a symbol of fidelity to the Chinese. Because of its ability to mimic human speech, it was thought the perfect companion for a woman whose husband was away, informing him of her activities during his absence. The peony is also regarded as an emblem of female virtue in China. In full bloom it is a token of love, affection, and feminine beauty.

Plates such as this were usually built around a lathe-turned wooden core that was refined in shape and size by the addition of narrow wooden strips. The whole was then covered with a coarse-weave fabric to help reinforce the plate and give it further definition. After numerous coats of lacquer were applied, the plate was finally carved. Warpage and lifting are common to all of the plates in this group due to fluctuations in temperature and humidity over the intervening centuries.

DAW

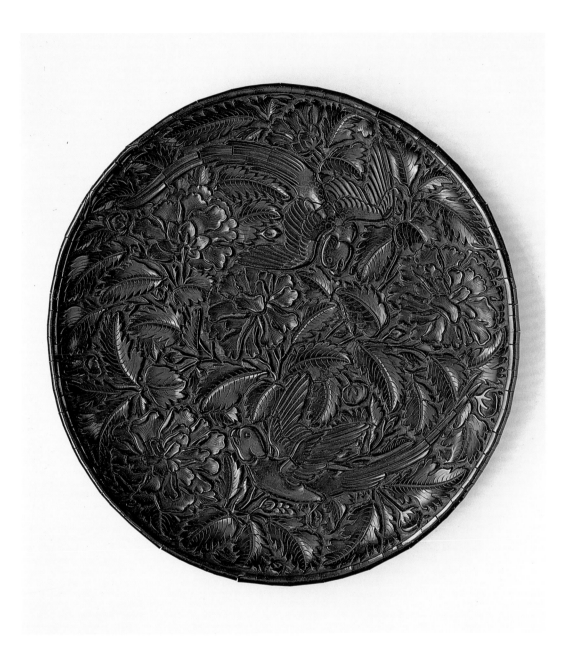

Sakyamuni as an Ascetic

Yuan dynasty (1279–1368)
China
Wood, fabric, lacquer, and pigment
14 1/8 x 10 5/8 inches
Gift of Mr. and Mrs. William M. Spencer III
1979.316

The first Buddhists looked upon Sakyamuni, the historical Buddha, as a great teacher and model on whose ideal they could base their lives. Sakyamuni placed great importance on the value of self-help in his teachings, and his followers strove to emulate his doctrine of renunciation of desires and enlightenment attained through meditation. Through Chan Buddhist practices in the Song dynasty (960–1279), representations of Sakyamuni practicing ascetics and images of Sakyamuni departing from this way of life assumed a position of essential religious importance. By the Yuan dynasty, such imagery was conventional and had entered the mainstream of Chinese Buddhist art.

The Birmingham Museum of Art statue depicts that time in the life of Sakyamuni when he is in the midst of these religious austerities. So intent was he in these eremitic practices that after six years his strength was reduced greatly and his mien became that of death. Legend repeats that his mother was so worried about his health that she came down from the heavens to plead with him to give up these extreme practices. Sakyamuni relented, retreated to a river where he bathed and accepted food, and soon retired to a grove of trees where he eventually attained the ultimate awakening.

Sakyamuni as an Ascetic was carved from a single piece of wood that was hollowed out from the bottom. The resulting chamber originally would have held sutras or other relics to sanctify the image. However, this cavity also facilitated the drying of the block of wood. Wood that has not been hollowed out will crack from the outside in, whereas wood that has been hollowed out will dry much more evenly. The whole of this image was then covered with lacquered cloth and finally gilded and painted. Traces of blue and red pigment remain that highlight the hair and other features of the figure. The result is an introspective figure that well befits the last advice of Sakyamuni to his followers: "All composite things must pass away. Strive onward vigilantly."

DAW

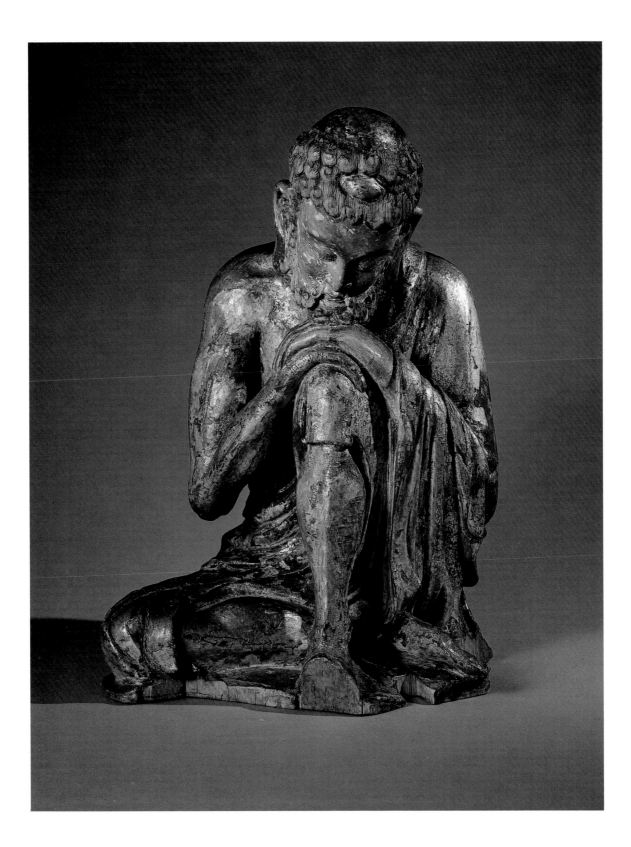

Madonna and Child with Four Saints

Ca. 1310–1315
The Goodhart Ducciesque Master
 (active first quarter 14th century)
Italy (Siena)
Tempera on panel
29 1/2 x 76 1/2 inches
Gift of the Samuel H. Kress Foundation
1961.104

During the latter half of the thirteenth century, the dominant motif of God as a stern judge gave way to a gentler, more humane theme of Virgin and Child with its attendant ideals of compassion, intercession, and hope. Tuscan art evolved accordingly as the stiff, remote, hieratic conventions of the Byzantine style yielded to the more sensitive, tender naturalism that would become the hallmark of Renaissance religious art.

The "Goodhart Ducciesque Master" is an attributed name for the unidentified painter of a stylistically unified body of work, characterized by an unusually subtle and skillful handling of light and shadow that renders a delicately rounded contour to faces, imparting human qualities to divine subject matter.[1] This treatment is considered remarkably expert and original for its time and place.

No longer a remote figure of awe, the Virgin gazes at the spectator with tender solicitude, a faint smile playing on her lips. She seems scarcely aware of the child who gently tugs at her veil. This natural, innocent gesture, which adds an additional human touch, was first used by Sienese master Duccio di Buoninsegna in 1302 and is a nascent example of Renaissance concern with humanity and naturalism. Conversely, her remoteness to the child who appears to float in the air are characteristics of the Byzantine tradition. The star on her shoulder, a common iconographical motif in early Italian art, refers to her as Star of the Sea, the heavenly guide to the port of salvation.

The goldfinch held by the infant Christ, rare in Sienese painting, may have derived from contemporary Florentine painters. Frequently seen among thistles and thorny plants, the goldfinch alludes to the crown of thorns and conceptually relates the Passion to the Incarnation. Also, a legend explains the bird's red spot as a drop of blood acquired while drawing a thorn from the brow of Christ on the road to Calvary.

The arrangement of saints on either side of the central panel follows Byzantine hierarchy, the most important personages occupying the spaces closest to the center. To the left of the Virgin and Child is John the Baptist, bearing a scroll with the inscription "Ecce Agnus Dei. Ecce qui tollis peccata mundi" (Behold the Lamb of God. Behold [Him] who takes away the sins of the world). The Archangel Michael, his sword ready to defend the faithful, occupies the space immediately to the Virgin's right. The outer panels are occupied by unidentified saints, a bishop on the far left and a biblical figure, perhaps an apostle or prophet, on the right. Among these peripheral saints are significant differences in drapery treatment, suggesting either that the Goodhart Master may have adopted his figures from borrowed models or that other artists may have collaborated with him.

The current framing of this altarpiece is a modern reconstruction. Originally, a triangle-shaped pinnacle containing a half-length figure of an angel or saint probably topped each compartment.

DA/JW

1. On the Goodhart Ducciesque Master, see James Stubblebine, *Duccio di Buoninsegna and His School* (Princeton: Princeton University Press, 1979), 106–110. In 1940, Richard Offner identified the unique qualities of the Goodhart Master in a panel included in the A. E. Goodhart Collection of the Metropolitan Museum of Art, New York City. In a written opinion in the Birmingham Museum's files, Professor Hayden B. J. Maginnis of McMaster University in Hamilton, Ontario, Canada, dates this polyptych 1315–1320 on stylistic grounds.

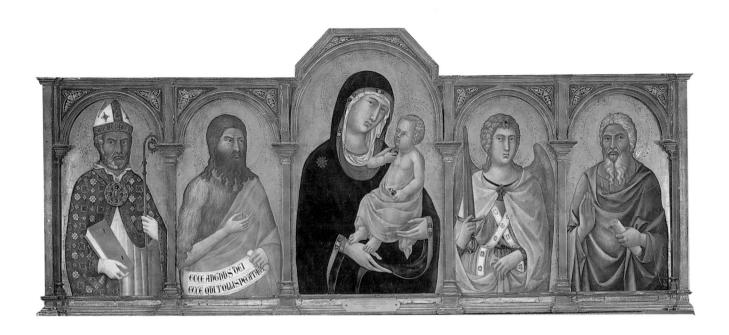

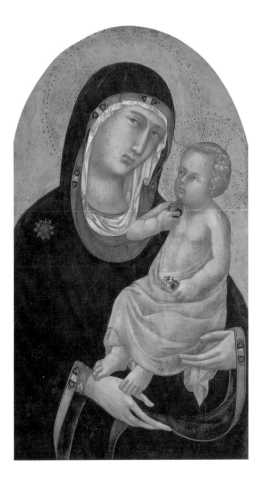

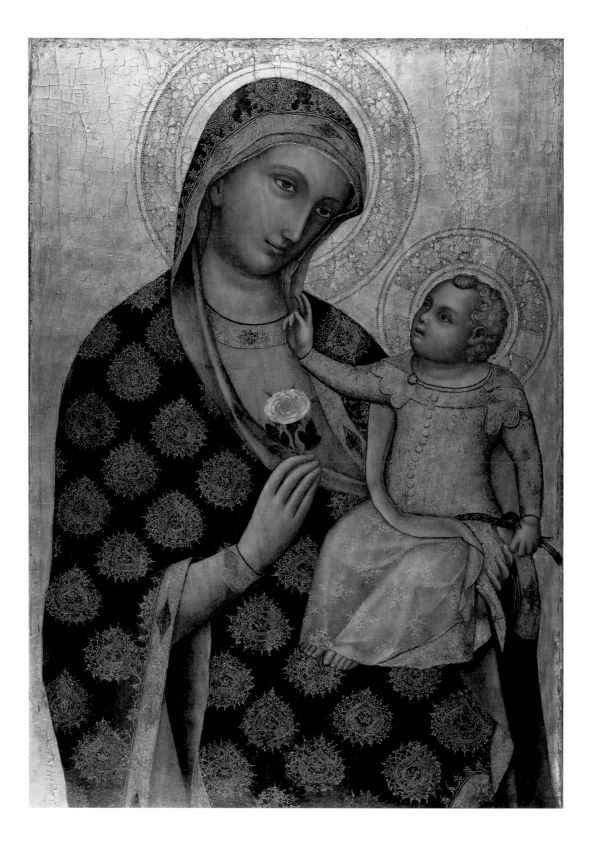

Madonna and Child

Ca. 1370
Lorenzo Veneziano (active 1357–1379)
Italy (Venice)
Tempera on panel
33 3/4 x 24 1/4 inches
Gift of the Samuel H. Kress Foundation
1961.100

The art of Lorenzo Veneziano stands between the Byzantine tradition and the dawning humanism of the Renaissance, reflecting as well a period when Italy was beginning to absorb the International Gothicism of northern Europe. *Madonna and Child* is, as well, a manifestation of the Venetian love of vibrant color.

Remnants of the Byzantine style—associated with the Greek Christianity of the East—appear in the heavy gold background and the intricately tooled halos about the heads of the Virgin and Christ Child. Byzantine too are the stylized facial structure of the Madonna and the attenuated anatomy of both figures.

While Byzantine influence would dominate Venice through the fourteenth century, Veneziano's travels to such cities as Bologna and Verona introduced him to the humanistic attitudes then developing across the rest of Italy. Renaissance fascination with nature appears in such naturalistic renderings as the goldfinch and the rose, fluidly modeled with a noticeable regard for earthly reality. Human emotion radiates on the face of the Christ Child; his gentle gesture of blessing almost becomes a caress. Drapery flows in a far more graceful manner than stiff Byzantine formalism ever would have allowed.

Other elements hint at the advent of the International Gothic movement, a cosmopolitan style favored by the European nobility and characterized by courtly elegance. Gilded decorative detail is delicately complex, as in the gold embroidered medallion on the Virgin's veil, which has its origins in Near Eastern art. The Christ Child's stylish garment comes from contemporary courtly attire, and the swaying posture of the Madonna mirrors the S-curves of Northern Gothic sculpture.

Veneziano employed an exacting symbolism common in religious art of the era. The Virgin's pale pink rose alludes to the prophecy of Isaiah 35:1— "The desert shall rejoice, and blossom as the rose"—that presaged coming of the Lord. The Christ Child holds a goldfinch in his left hand, a reference to the Passion.[1]

MG/DA/JW

1. Although larger, Birmingham's *Madonna and Child* bears strong stylistic resemblance to Lorenzo Veneziano's *Madonna and Child* in the Louvre.

The Pure Land of Amitabha

15th century
Ming dynasty (1368–1644)
China
Polychrome, gilding, and gesso on plaster
126 x 127 ½ inches
Museum purchase with funds provided by the
 1987 Museum Dinner and Ball
1987.34

This mural was originally from a Chinese Buddhist temple of the Ming dynasty. It is made of mud mortar bound with chopped straw and rush and covered with a layer of cloth and fine plaster, and the two sections together measure ten feet five inches by ten feet six inches and weigh approximately one ton.

Buddhism was introduced to China during the Han dynasty (206 B.C.–A.D. 220). Although public and official support of the religion fluctuated over the centuries, Buddhism experienced a resurgence in popularity during the Ming dynasty when the arts received widespread patronage. The Birmingham Museum of Art mural is an especially beautiful example of this artistic renewal. Serving as backdrops for sculptural groupings, murals such as this have formed an integral part of temple iconography throughout the history of Buddhism in China. This mural is among only a handful of such works preserved in Asian and Western collections.

The Birmingham Museum of Art has two parts of what must have been a much larger composition of the Sukhavati Paradise of Amitabha Buddha. Amitabha is the Buddha of Infinite Light, the most widely venerated of the transhistorical Buddhas, who presides over the Sukhavati, or Western, Paradise where he receives the faithful after death. The *Sukhavativyuha-sutra* describes this paradise as a land of endless beauty, peopled with many gods and men. It is rich in a diversity of flowers and fruits, and adorned with jewel trees, which are frequented by flocks of various birds. These jewel trees are of many colors and are embellished with the seven treasures: gold, silver, beryl, crystal, coral, red pearls, and emeralds. Amitabha created this Paradise out of his boundless love for all sentient beings and vowed that anyone who has absolute faith in him will be reborn in the Sukhavati Paradise.

Thirty-three figures are depicted in these panels, along with an assortment of flora and fauna. Musicians, arhats, monks, and possibly several donor portraits crowd around the central figures of Amitabha Buddha in the upper portions of the mural, while two of the four Guardian Kings, perhaps Virudhaka and Vaisravana, with their attendants appear below. The hands of Amitabha Buddha on the right are shown in the *Abhayamudra*, or the "Have No Fear" gesture, while those on the left are portrayed in the *Dharmacakramudra*, or the "Turning of the Wheel of the Law" gesture. Easily understood by the followers of Amitabha Buddha, murals such as this were created to give concrete shape to the apparitional visions of paradise described in the Buddhist texts.

The mural bears no inscription or date. Stylistically, however, details such as the vari-colored radiating design of the aureoles of the Buddhas, the elaborate jewel trees, and the raised gesso work in the details correspond with fifteenth-century Chinese and Korean Buddhist materials.[1]

DAW

1. *The Pure-Land Mandala* (Nara, Japan: Nara National Museum, 1983), 105, pl. 70; Lokesh Chandra, *Buddha in Chinese Woodcuts* (Delhi: Jayved Press, 1973), figs. 1 and 80; and Aschwin Lippe, "Buddha and the Holy Multitude," *Metropolitan Museum of Art Bulletin* 23 (May 1965): 329.

Right: details from The Pure Land of Amitabha.

 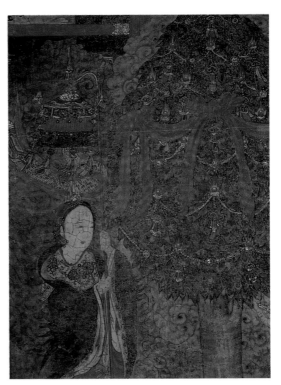

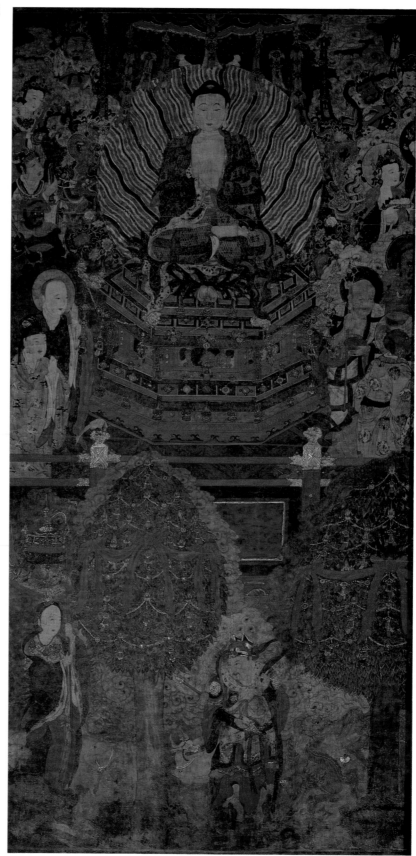

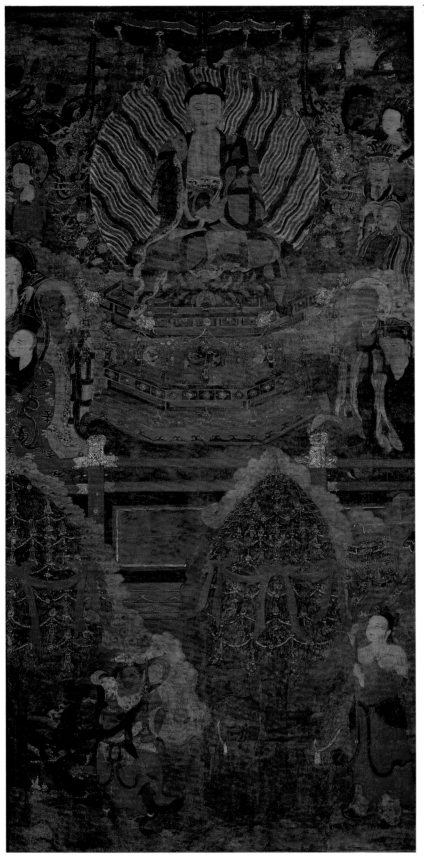

Kasuga Deer Mandala (Kasuga-Shika Mandala)

15th century
Muromachi period (1392–1573)
Japan
Ink, color, and gold on silk
40 x 15 inches
Museum purchase with funds provided by Dr. and
 Mrs. Austen L. Bennett III, Dr. and Mrs. Thomas
 A. S. Wilson, Dr. and Mrs. Thomas W. Mears,
 Dr. and Mrs. Lawrence J. Lemak, and Dr.
 Richard H. Cord, by exchange
1993.15

The deer that roam the grounds of the Kasuga shrine in Nara, Japan, are believed to be messengers of the Shinto gods that inhabit the shrine and the surrounding mountains. Founded in 709 by Fujiwara Fuhito (659–720), the shrine is one of the most ancient and most venerated in Japan.

By the eleventh century the Japanese believed that their native Shinto gods had universal counterparts among the imported Buddhist deities. Buddhist art forms were accordingly adapted to Shinto practices to represent this synthesis, including the making of ritual paintings, or mandala. Within this tradition, paintings of a white saddled deer represent the Kasuga shrine. Descending from the mountains on a cloud, the deer carries a large mirror supported by the branches of a flowering *sakaki* tree (*Cleyera japonica*), both sacred emblems of Shinto. Seated in the mirror are five Buddhist deities, Sakyamuni Buddha, Ekadasamukha Avalokitesvara, Ksitigarbha, Bhaisajyaguru Buddha, and Manjusri, the transformed manifestations of the Shinto gods of the Kasuga shrine.

The shrine itself is depicted above and behind the mirror by six small buildings set in a mist-filled landscape. The distinctive crossed roof beams of the Kasuga shrine buildings peek through the stylized bands of mist, while a full moon looms over the low rolling hills of Mt. Mikasa dotted with flowering cherry trees. The landscape element of this painting is significant in that it depicts an actual place in a style that appeals to the indigenous Japanese aesthetic.

The reverse of the Birmingham Museum of Art mandala bears an inscription that translates, "Painted by Rokkaku Jakusai." A member of the *Edokoro* (Office of Painting), Jakusai (1348?–1424) painted for the imperial court in the Japanese style known as *Yamato-e*. Based on a purely Japanese aesthetic, paintings of the *Yamato-e* school were most popular with the aristocracy. While it is unlikely that Jakusai painted this *Kasuga Deer Mandala*, the association of his name with a painting of native religious subject matter done in a native style is not inappropriate.

DAW

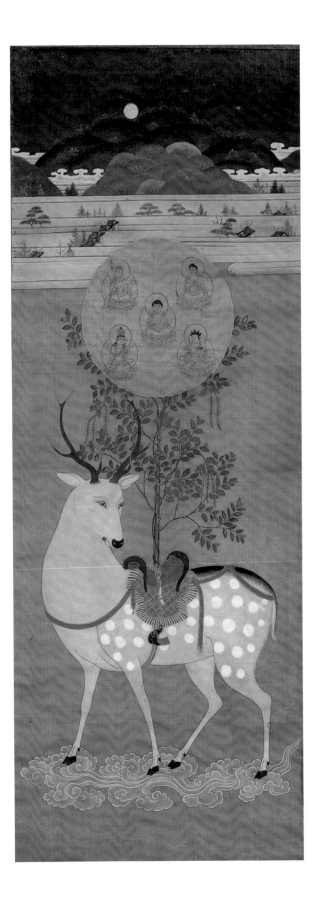

Sculpture in the form of the deity Quetzalcoatl

Last half of the 15th century
Aztec culture (1325–1521)
Mexico, Tenochtitlan (present site of Mexico City)
Carved basaltic stone
8 x 5 x 7 ¾ inches
Museum purchase with funds provided by Dr.
 and Mrs. Keith Merrill, Jr.; Mr. and Mrs. F.
 Dixon Brooke, Jr.; the bequest of Mrs. G. F.
 McDonnell; Mrs. Margaret Steeves; Mr. and
 Mrs. Charles Grisham; Mr. and Mrs. Hugh Jacks;
 the Hess Endowed Fund; and the Acquisition
 Fund, Inc.
1989.144

The Aztec were the last of a long line of highly developed pre-Columbian culture groups that inhabited the region now known as Mexico. This carving represents Quetzalcoatl, one of the most revered of the many Aztec deities. *Quetzalcoatl* literally means "plumed serpent" in the Aztec or Nahuatl language. Appropriately the body of the Birmingham Museum piece is in the form of a startlingly naturalistic knotted snake, complete with rattles and delicately carved quetzal bird feathers in place of scales. The sculpture is unusual in that it has a human head attached directly to the serpent body instead of emerging from the open jaws of the snake. Characteristic of depictions of Quetzalcoatl are the undulating headband with knot at front center and the large circular earplugs with fringe and curved pendants of shell. The mouth and the deeply hollowed eyes once held inlays of shell or precious stone, and there are traces of red pigment and stucco in the pores of the stone.[1] According to Spanish accounts many Aztec "pagan idols" were originally brightly ornamented and painted.[2] Sculptures representing such important personages as Quetzalcoatl were reserved for the elite or served as ritual altarpieces in major temples. The Spanish considered such images idolatrous and destoyed all they encountered; they are consequently extremely rare.[3]

The legend of Quetzalcoatl is based on both myth and history. As a deity, he participated in the creation of the world and exercises a continuing role in the conception of human beings. As a human being, Quetzalcoatl was the king of the Toltecs who ruled the Valley of Mexico before the arrival of the Aztecs. He was a benevolent ruler of the priest class who did not sanction human sacrifice, and he was said to have spread knowledge of the calendar and arts and crafts among his followers. Quetzalcoatl was tricked into a major trangression by the jealous warlike deity Tezcatlipoca, and Quetzalcoatl was then exiled from the Valley of Mexico. He left for the Gulf Coast where, by some accounts, he sailed away on a raft of serpents, promising to return in the year 1 Reed, or 1519 by our calendar.[4] Motecuhzoma resorted to this legend to account for the arrival of the Spaniards in 1519, and the fact that Cortes was initially mistaken for a god was a major factor in the Spanish conquest of the Aztecs.

MMV

1. Peter David Joralemon, Letter of authentication, July 1, 1989.
2. Bernal Diaz del Castillo, *The Discovery and Conquest of Mexico: 1517–1521*, edited from the original by Genaro Garcia, translated by A. P. Maudslay, with an introduction by Irving A. Leonard (New York: Farrar, Straus and Cudahy, 1956), 219–20.
3. Esther Pasztory, *Aztec Stone Sculpture* (New York: Center for Inter-American Relations, 1976), 8.
4. John Bierhorst, ed., *Four Masterworks of American Indian Literature* (New York: Farrar, Straus and Giroux, 1974), 3–105; and Esther Pasztory, *Aztec Art* (New York: Harry N. Abrams, Inc., 1983), 20.

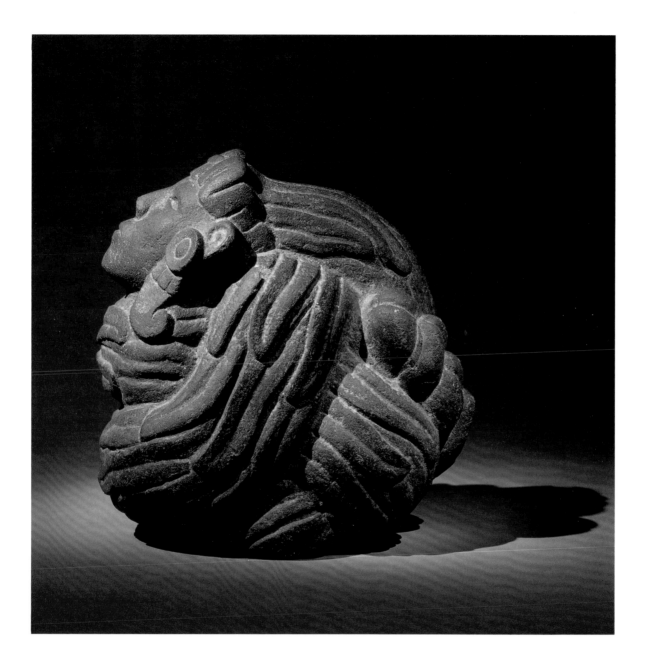

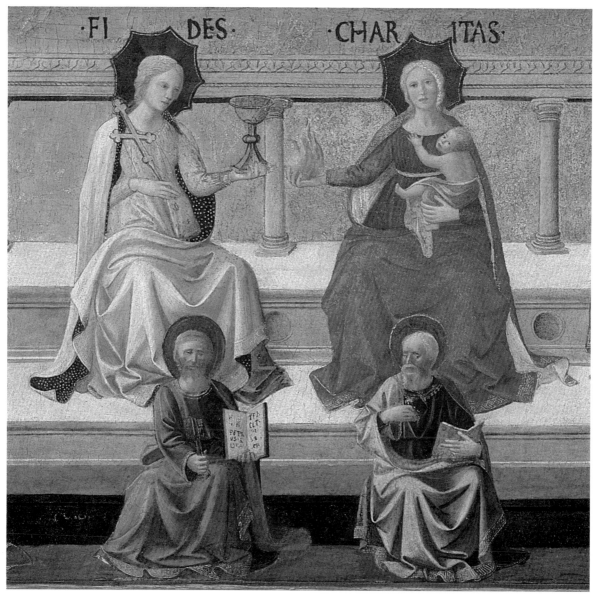

Detail from Seven Virtues

60

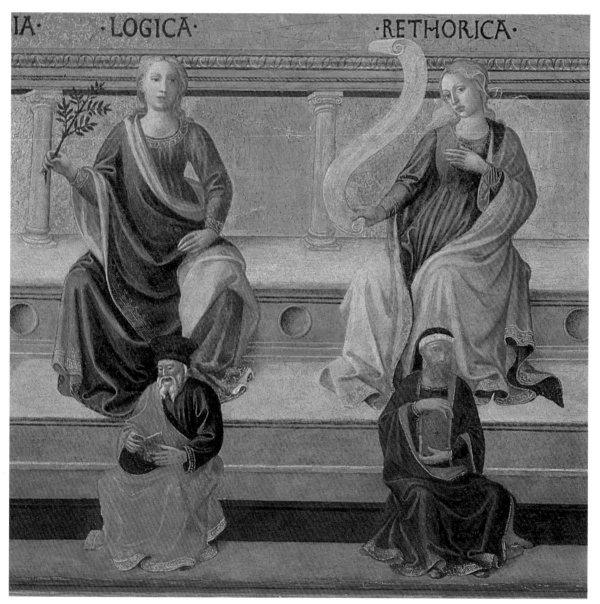

Detail from Seven Liberal Arts

Enthroned Madonna and Child with Female Martyr, Saint Agatha, and Angels

Ca. 1500
The Stratonice Master (active last quarter of the
 15th to early 16th century)
Italy, Tuscan School
Tempera on panel (poplar)
55 3/4 x 43 1/4 inches
Gift of the Samuel H. Kress Foundation
1961.124

Accompanied by an entourage of angels resembling young Renaissance courtiers, the Madonna stands in front of a throne, Florentine in design, holding the infant Christ. He leans forward to crown and bless the unidentified female saint kneeling before him. On the right attends St. Agatha, recognizable by her veil and bearing the attributes of her martyrdom: her severed breast, a pair of shears, and a martyr's palm. She serves as the patron or sponsor at this heavenly coronation.

To the fifteenth-century viewer, this painting functioned on a variety of symbolic levels, some of them still uncertain. In an age of idealized portraiture, the suffering shown on the honored saint's face is unusual. She carries the palm of martyrdom, identifying her as one who suffered and died for her faith. The book to which she gestures may refer to her intellectual attainments, her writings, or, if she were the foundress of a religious community, its Rule. We may assume from her costume that she was either a nun or a holy widow, notwithstanding the diaphanous veil (a secular garment) worn by both martyrs. The veil could be associated with the Legend of St. Agatha, whose veil was preserved after her death in A.D. 251 and which was reputed to have had miraculous powers.

Angels bear flowers of purity symbolizing the Annunciation (the lily) and the Nativity (the white rose). The throne is garlanded with gold, symbolic of pure light—the dwelling place of God. Jewels are associated with the splendor and omnipotence of the Supreme Deity, green stones with the triumph of life over death. Pearls not only call to mind purity but are also special attributes of Christ and the Virgin (the ancients believed that oysters "gave birth" to pearls through a form of virginal generation). Draped below the fire are strands of red coral, used at this time in Italy as protection against evil, particularly the evil eye. The fire could allude to any of the following: celestial light or wisdom, self-sacrifice (because it consumes itself to light the world), the saint's burning love of God, or the wise virgins in the biblical parable. The crown is the symbol of the glory of martyrdom, or the emblem of victory and reward due to virtue.

Together, all these symbols offer intriguing testimony to the life and accomplishments of the saint depicted here.[1] While scholars are still unable to determine her name with certainty, one has proposed that she might be St. Ursula and that the altarpiece may have been painted for the Church of St. Agatha in the Via San Gallo, Florence.[2] The nuns of St. Ursula were incorporated with the cloister of St. Agatha in 1435.

DA/JW

1. Exhibited in 1877 as Italian School, fifteenth century, this altarpiece, then in the collection of Mrs. Austin, Horsmonden, (Kent) England, was exhibited again at the New Gallery Exhibition of 1893–1894 under the name of Fra Filippo Lippi. The attribution persisted until 1931 when Bernard Berenson recognized it as the work of the Master of the Stratonice Cassone, now in the Huntington Gallery, San Marino, California (*Dedalo*, April 1931, 11: 738; *International Studio*, March 1931, 40).
2. A clue to the identity of the saint is offered by Fern Rusk Shapley in *Paintings from the Samuel H. Kress Collection, Italian Schools XIII–XV Century* (New York: Phaidon Press for the Samuel H. Kress Foundation, 1966).

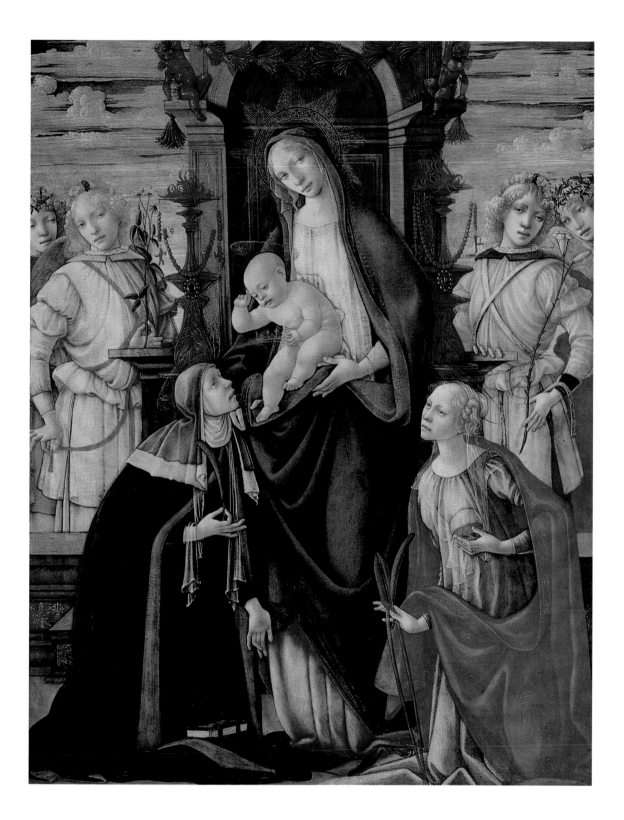

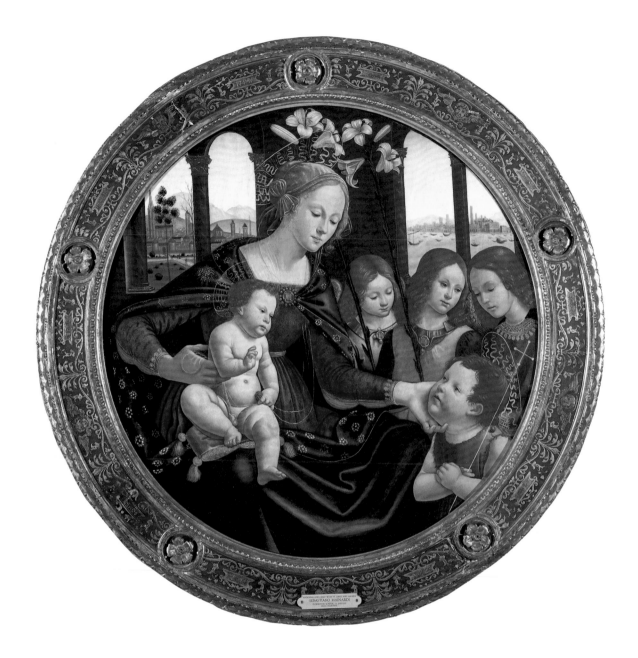

Madonna and Child with Saint John and Three Angels

Ca. 1500
Sebastiano Mainardi (ca. 1460–1513)
Italy (Florence)
Tempera on panel
33 3/4 x 33 3/4 inches
Gift of the Samuel H. Kress Foundation
1961.97

An evolution in the painterly depiction of the Madonna and Child paralleled humanistic development in Renaissance thought, developing from flat, decorative, iconic renderings to realistic portrayals of actual people with plausible feelings. So it is with the Birmingham Madonna—a contemporary noblewoman, albeit idealized, in a contemporary setting. She leans forward to gently caress the face of young John the Baptist, as her child, Jesus, blesses him and youthful members of the Lady's court, three beautiful angels, look on. Beyond the loggia is an early-sixteenth-century Italian city with its crowded, bustling harbor; in the distance rise the misty blue hills of Tuscany. Deep, rich color gives the entire scene a splendid opulence.

Symbols augment the meaning of the painting. For instance, the cross held by John the Baptist prefigures the Passion. Jesus holds a bunch of pomegranate seeds, symbolic of the unity of the church. Lilies stand for the Virgin Mary's purity and the Annunciation, an event recalled in the frame. Translated from the Latin, the inscription repeats the words of the Angel Gabriel, "Hail Mary, full of grace, the Lord is with thee," and the words spoken at the Visitation, "Blessed is the fruit of thy womb, Jesus."

The *tondo*, or circular form, was popular in the late fifteenth century and the early sixteenth century. In Renaissance thought, the circle was widely understood as the poetic analogy to eternity, heavenly harmony, and perfection. Circumscribed by this formal allusion, Mainardi's composition depends on a complex geometry. An inner circle within the broader *tondo* can be traced from the Madonna's face through her right arm to her child and then (following a highlighted fold in her gown) to John the Baptist. The inward inclination of the head of the far-right angel leads to the window, the lilies, and back to the face of the Madonna. Formally balanced windows in the background give stability, enhanced by the horizontal line of faces across the center of the picture. Everything is tied together by the triangle formed by the three protagonists in the drama.

Sebastiano Mainardi, born in San Gimignano, studied and worked in the workshop of his brother-in-law, Domenico Ghirlandaio, assisting him in decorating the Sistine Chapel in Rome. Most of his works remain in San Gimignano.[1]

DA/JW

1. Numerous versions of this painting, some by Mainardi, others by assistants, exist (a listing can be found in Everett Fahy, *Some Followers of Domenico Ghirlandaio* [New York and London: Garland, 1976]). That the Birmingham example is either the original or an early version by Mainardi is evidenced by comparison with examples in the Louvre and in Naples. The Birmingham faces are much more sensitively modeled, as though taken from life rather than formalized. Furthermore, examination of under-painting reveals that the eyes of the Birmingham Madonna appear to have been altered, suggesting that the artist had changed his mind during creation of the work—something less likely to happen if he were working from a previously painted model.

St. Jerome in His Cell

1514
Albrecht Dürer (1471–1528)
Germany
Engraving
9 ¹/₂ x 7 ¹/₄ inches
Bequest of Mr. and Mrs. Oscar Wells
1957.81

Albrecht Dürer's engraving *St. Jerome in His Cell* is considered one of his masterpieces. It was executed during an important period in Dürer's career as an engraver; in 1513 and 1514 he made not only this image of St. Jerome but also *Melancholia* and *Knight, Death, and the Devil.* These works are connected by their themes: Each one explores the defining characteristics or personality traits of individuals and demonstrates how these different types confront philosophical truths and moral issues such as the struggle with good and evil. This work also reflects the emergence of printmaking as a form of visual art that is especially accessible because the nature of the medium allows for the production of multiple originals. Indeed, this image was widely circulated and became well known in its own day.

During the period when this image was produced, Dürer, a German, was attempting to reconcile his knowledge of Italian art with his Northern stylistic traditions. Although he had gone to Italy and studied the works of his contemporaries as well as the wonders of ancient Rome, he never completely adopted an Italianate style. Instead, Dürer took from Italian art its sense of balance and order and its interest in a rational understanding of the world, and he combined these principles with the Germanic, or Northern, tendency toward detailed study of the world and its mysteries. In *St. Jerome*, these Northern characteristics are manifested in the attention to detail and the subtle play of light that combines both realism and mysticism. The Italian characteristics are most obvious in the carefully controlled illusionistic space of the room and the sense that everything is in its place.

In *St. Jerome in His Cell* the saint sits thoughtfully at his writing desk while a lion sleeps in the foreground. St. Jerome had tamed the lion by pulling a thorn from his paw. The lion appears as docile as the dog that sleeps beside him. The setting is an orderly room that is detailed in its capturing of all of the necessities for peaceful existence, yet, as pleasant as the room appears, it does not boast of luxury and every object is precisely and purposefully placed. Along the left wall are arched windows that transmit a patterned, diffused light through the stained glass. This natural light casts shadows in the room, yet a glow of holy light outlines the saint's head. Like the use of lighting, the choice of objects in the room serve a dual purpose, containing both descriptive information and symbolic meanings. For example, the hourglass in the background and the skull in the windowsill are symbols typical of *vanitas* tableaux that remind the viewer of the temporal nature of human existence. This depiction of St. Jerome is meant to serve as a model of the scholar-saint—kind, thoughtful, and wise—who demonstrates the artist's view of a well-balanced life.

SVS

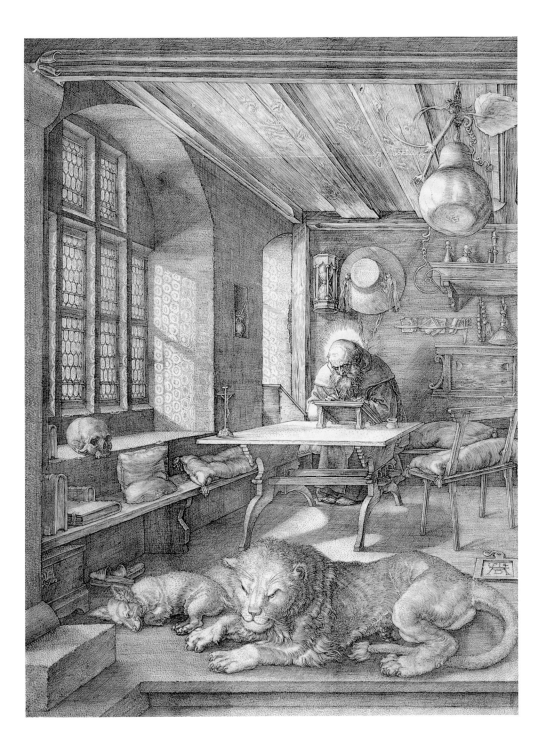

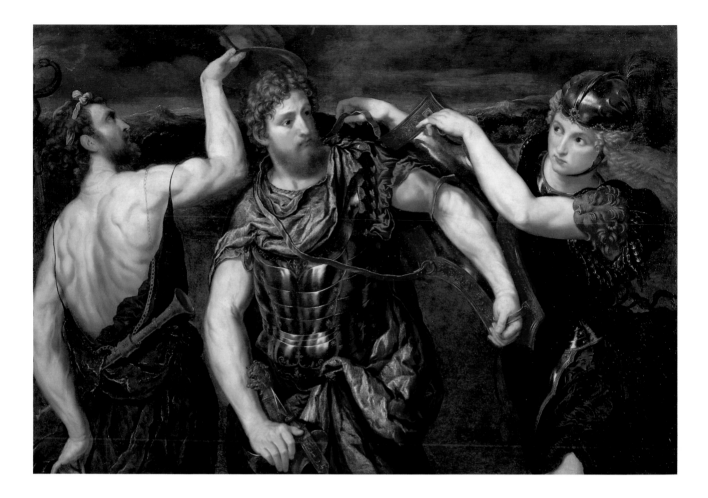

Perseus Armed by Mercury and Minerva

Ca. 1545–1555
Paris Bordone (Paris Paschalinus) (1500–1571)
Italy (Venice)
Oil on canvas
40 ½ x 60 ¼ inches
Gift of the Samuel H. Kress Foundation
1961.117

Under a dark, threatening sky, the hero Perseus prepares for battle. The Goddess of Wisdom, Minerva, straps her shield on his arm while he receives the helmet of invisibility from Mercury, Messenger of the Gods. With such supernatural aid, Perseus would slay the fearsome monster Medusa, the snake-haired gorgon whose visage had the power to petrify anyone who dared to look directly at her. Able to see Medusa's reflection on the polished surface of his shield, Perseus would cut off her head, place it in a pouch, and later use its fatal power to turn the tyrant Polydectes into stone.

This painting exemplifies the luxurious, florid style characteristic of the mature work of Paris Bordone. The sophisticated arrangement of figures, stressing elegantly interlocking curves, is a self-conscious display of his technical mastery of drawing and composition. Affected, unnatural poses such as Mercury's (almost a mirror image of Perseus), accentuated by the boneless, serpentine rendering of the arms, form echoing visual rhythms. The result is a rhythmic frieze of dynamic movement that sweeps across the canvas.

This highly stylized preciosity typifies Mannerism, a stylistic and ideological reaction against the perfection, balance, and restraint of the High Renaissance. Mannerism stressed intellectual overrefinement, artificiality, and displays of technical virtuosity. Venetian Mannerists especially reveled in color, evident in this painting's sumptuous reds, greens, and blues highlighted by a vibrant treatment of tactile surfaces, as in the shining armor of Perseus and the restless, rippling draperies. Venetian brushes, much finer than those used elsewhere, allowed Bordone to carefully apply paint in thin transparent layers, enlivening the surface with shimmering richness and resonant depth.

There is disagreement over the allegorical relevance of this painting. In the sixteenth century, portraits were commonly inserted into mythological or allegorical contexts: A patron might be embodied in Perseus, setting forth on a quest fortified by the powers of eloquence (from Mercury, God of Communication) and wisdom (from Minerva). Scholars have speculated that Perseus might be either Ottavio Farnese or Allessandro Farnese, grandsons of Pope Paul III.[1] If true, the painting would relate to the Farnese family's defense of Papal interests, possibly commemorating Ottavio's appointment in 1546 to the command of Papal forces in Germany. Another scholar has theorized that Perseus is based upon a French model, reasoning that Perseus's facial type departs significantly from other Bordone figures, therefore it must be a portrait—although of whom, and to what purpose, is unclear.[2] For now, lacking more precise evidence, these interpretations must remain conjecture.

DA/JW

1. J. C. Robinson, *Memoranda No. 19* (London: 1868); and L. Bailo and G. Biscaro, *Della Vita e delle Opere di Paris Bordone* (Treviso: 1900). Unsigned documents in the files of the Birmingham Museum of Art disagree with this thesis, stating that the iconographical evidence presented by Robinson, Bailo, and Biscaro is unconvincing.
2. Sylvie Béguin, "Paris Bordon en France," *Paris Bordon e il Suo Tempo: Atti del Convegno Internazionale di Studi* (Treviso: October 28–30, 1985) Edizioni Canova, 1987.

The Judgement of Paris

1590
Hans von Aachen (1552–1616)
Germany
Oil on copper
11 x 15 inches
Gift of the *Birmingham News* and the 1979 Beaux
 Arts Committee
1979.18

As celebrated in Homer's Iliad, the Trojan War began with a fateful beauty contest around 1200 B.C. Eris, or Discord, had thrown a golden apple inscribed "For the Fairest" among three powerful, vain goddesses—Hera, Athena, and Aphrodite. Each claimed the apple. Zeus decreed that a mortal should decide and so dispatched his messenger Hermes to appoint Paris, son of King Priam of Troy. Hera, the wife of Zeus and Goddess of Marriage and Maternity, bribed Paris with a great kingdom in Asia if only he would choose her. Athena, the Warrior Goddess of Wisdom, promised victory in battle. Aphrodite, Goddess of Love and Beauty, offered the most beautiful woman in the world, Helen, wife of Menelaus of Sparta. Awarding the golden apple to Aphrodite, he chose love over power and glory, married Helen, and became prince of Troy. But the losers conspired in revenge to start the ten-year Trojan War, a bloody conflagration that would claim the life of Paris and bring about the ruin of Troy.

The glowing opalescent color, agitated composition, and attenuated figures of Aachen's painting derive from the far-reaching influence of Mannerism, a movement that began in early-sixteenth-century Florence and Rome in the work of Michelangelo and the later paintings of Raphael. As a reaction against the idealized beauty and equilibrium of the High Renaissance, Mannerism tended toward the irrational, favoring unnatural forms and strident colors to express artistic virtuosity. The movement sprang from an erosion of faith in the ideals of the early Renaissance fueled by political and moral instability—wars, plague, and economic upheavals sweeping through Europe, culminating with the sack of Rome in 1527. Deprived of their traditional patrons in the Church and Italian courts, artists wandered through Europe seeking new commissions and, in the process, spreading the Mannerist taste for aesthetic refinement beyond the borders of Italy.

At the beginning of the last quarter of the sixteenth century, Hans von Aachen left his native Cologne for Italy, where he assimilated the Mannerist influences into his own sensuous style. Around 1592, his work came to the attention of Holy Roman Emperor Rudolph II who summoned him to his court in Prague, which, by the late sixteenth and early seventeenth centuries, had become a mecca for International Mannerism. (The emperor also supported the two great astronomers of the time, Johannes Kepler and Tycho Brahe.) Aachen was appointed court painter and, in 1594, a noble of the empire. He made his home at the imperial court, concentrating on courtly and mythological subjects, a genre ideally suited to his porcelain-like female nudes and the perfect vehicle for his elegant brand of urbane eroticism.

DA/JW

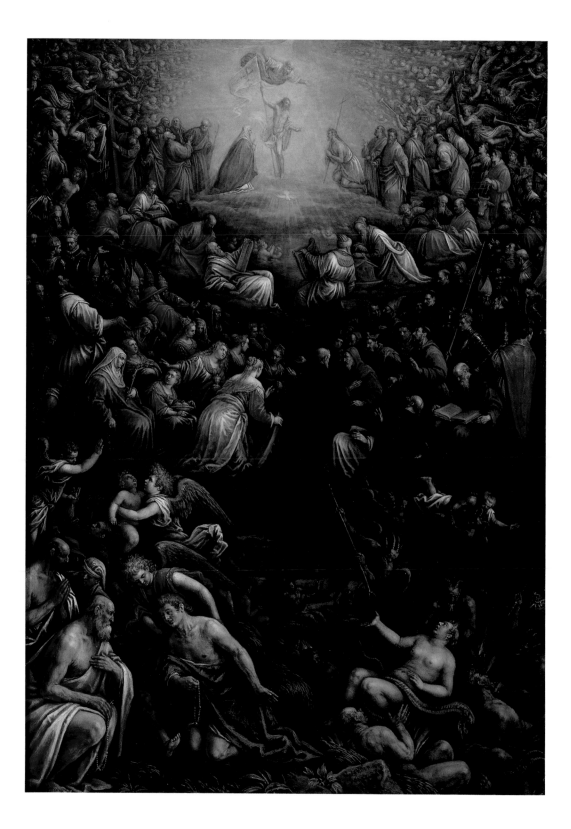

The Last Judgement

Ca. 1596–1605
Leandro Bassano (1557–1622)
Italy
Oil on copper
27 ½ x 19 ½ inches
Gift of the Samuel H. Kress Foundation
1961.114

Since as long ago as the fourth century, artists have rendered the biblical prophecy of Judgement Day, the end of the world when Christ would reward the good with eternal life in paradise and punish the guilty with banishment to hell. Leandro Bassano's *Last Judgement* recalls Michelangelo's vast masterpiece of 1534–1541 in the Sistine Chapel in Rome. Christ, surrounded by the blessed, provides the axis around which the composition revolves. In the lower left, the newly risen elect make their way to heaven while sinners are thrust into eternal torment in the lower right. However, while Michelangelo's *Last Judgement* is monumental in size, emotion, and power, Bassano's is exquisitely small and refined, the emotion understated.

To reproduce this vast cosmic drama in miniature, Bassano arranged his actors in an amphitheater of successive tiers that surround the blinding light emanating from the Holy Trinity (God the Father, Christ the Judge, and the Holy Spirit in the form of a dove). Bassano's stage suggests infinite space: From the knee in the lower-left corner that projects into the viewer's space, figures diminish in size as they seemingly recede into the distance, leading back to the nearly microscopic heads of the faraway angelic multitude assembled behind the Godhead. The illusion is enhanced through light, figures in the distance glowing with heavenly radiance while those in the foreground receive little more than daylight.

Many of the blessed are identifiable through iconographic attributes; real portraits (including Bassano's own) have been carefully rendered. The most renowned of the saints are grouped closest to the Trinity. The Virgin Mary kneels to the immediate left of Christ; behind her, St. Joseph (carrying a flowery staff) and apostles around St. Peter (holding keys). St. John the Baptist kneels on Christ's right, attended by more apostles, including St. Paul (holding sword and book).

The four evangelists and figures from the Old Testament occupy the tier closest to the Trinity. Included are St. Mark (lion), Moses (tablets of the law), David (harp), and St. Luke (ox). The lower tier, from the far left, begins with the Doge of Venice Grimani in front of St. Sebastian (in loincloth). Bassano's self-portrait appears just to the left of Grimani, wearing black and the decoration of knighthood bestowed upon him by the Doge.[1] Continuing to the right are Doctors of the Latin Church, bishops and popes, followed by the holy women and virgin martyrs. Next are founders and chief saints of the religious orders, recognizable by their distinctive habits, followed by soldier saints. Other saints, not fitting any particular category, occupy the outer left and right perimeters.

MG/DA/JW

1. The painting is inscribed on the stone in the lower-right portion of the image with the signature "LEANDER A/ PONTE BASS/EQUES." Such an identification indicates that the painting was executed following Bassano's 1596 appointment to knighthood but prior to his 1605 move to Prague and the court of Emperor Rudolph II, at which time he began signing his works "LEANDER BASSANENSIS FECIT PRAGAE." A very similar composition, though unsigned, is at the Trafalgar Galleries, London. In the eighteenth century, this painting was in the collection of Philip, Duc d'Orleans, Palais Royal, Paris (ca. 1737), and later in the collection of Louis-Philippe Egalité (until 1792).

Kitchen Interior

Mid-17th century
Attributed to Hubert van Ravesteyn (1638–1691)
Netherlands
Oil on panel
31 ³/₄ x 26 inches
Museum purchase with funds provided by the
 1976 and 1977 Beaux Arts Committees
1976.303

By the seventeenth century, the United Provinces of the Netherlands had become the world's leading sea power, fostering a burgeoning economy based on international commerce. This emergent nation stood apart from Europe in its combination of democratic government and Protestant religion, a form of Calvinism that permeated every aspect of daily life. Calvinist teachings prompted a renunciation of luxury and ostentatious display, including the rejection of theatrical religious tableaux of the Catholic Counter-Reformation and grand manner portraiture patronized elsewhere in Europe by the secular nobility. Wealth from manufacture and international trade had turned the Dutch bourgeoisie into collectors, creating a middle-class commercial market economy for art.

No longer dependent upon private patronage, artists sold their works from their studios, through dealers, or at fairs. In most cases, the new clientele preferred small, unpretentious scenes from everyday life (genre), particularly those that contained a moral lesson. To accommodate this demand, some painters became specialists, working in such narrowly defined subjects as landscapes, interiors, or still lifes. Sometimes artists worked collectively, painting particular elements within a scene: figures, backgrounds, or specific objects. It was possible, then, for a single Dutch painting to comprise a collaboration of several experts.

Domestic tasks offered a rich source to Dutch genre artists. The Calvinist ethic had made family life the foundation stone of society, familial duty the highest of virtues. The well-run household of the hard-working father, virtuous wife, and obedient children replaced Catholicism's Holy Family as the Protestant ideal of familial perfection.

Kitchen Interior offers a quiet, intimate glimpse of a woman at work beside the family hearth. Objects in the room, lovingly depicted in precise detail, celebrate the rare beauty to be discovered in ordinary things, deriving from the technique of such northern Renaissance masters as Hubert and Jan van Eyck, Robert Campin, and Hugo van der Goes.[1] Sunlight streaming through the window falls upon the woman like a benediction, raising her mundane occupation to the level of a secular sacrament.

DA/JW

1. The files of the Birmingham Museum of Art contain numerous witten opinions speculating on the painting's possible attribution. Clyde Newhouse, Seymour Slive, and John Walsh have suggested Hubert van Ravesteyn (Walsh proposing that a different artist painted the figure and background). Peter Sutton agreed that it may be a collaboration, possibly by a follower of Gerrit Dou, Pieter Cornelis van Slingelant, or Isaac Koedijk. Ronni Baer proposed Pieter van den Bosch, an attribution supported by Paul Boerlin. Also proposed are Harmon van Steenwyck and Abraham du Pape.

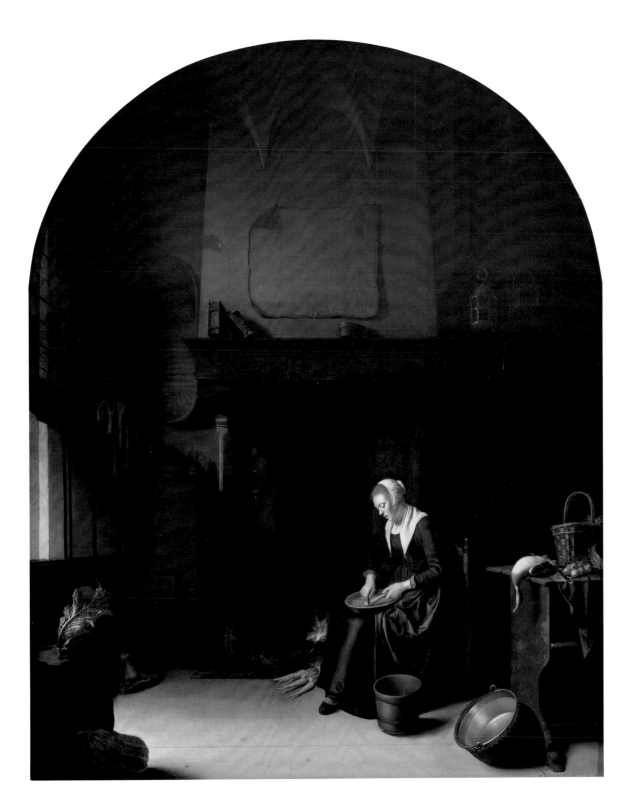

75

Gros point lace

Ca. 1660
Italy (Venice)
Linen
63 x 51 inches
Gift of Coleman Cooper in memory of his
 mother, Olive Bryan Cooper
1984.195.9

Needlepoint lace is one of the earliest forms of lace thought to have been developed in Italy in the sixteenth century as a natural transition from drawn thread work and cutwork. The buttonhole stitch, of which there are over 240 variations, distinguishes needlepoint lace from other laces in that it is made with a single needle and thread versus bobbins on a pillow. Each piece is composed of two main parts, the solid clothwork and the open ground, which joins the clothwork together. The connecting fibers of the open ground are called brides and are often embellished with small loops called picots. A thick, raised edge called gimp or cordonnet outlines much of the clothwork, creating a relief border on the lace. Cordonnets were separate pieces usually of a fifty-thread strand that was covered with the buttonhole stitch and sometimes picots.

Venetian gros point lace first appeared about 1650 and immediately became fashionable throughout Europe. The sculptural quality of the relief border was largely produced in Italy, and it was very arduous work. The French did copy the lace, but Venetian gros point lace is easily discernable from the French counterpart by a horizontal layout of the foliated scrolls and flowers and a haphazard spatial design of the elements. The French lace tended to be centered on a vertical plane with more definition to the design.

As the century progressed, the clothwork ground became more elaborate with decorative stitches of chevrons, diamond-shaped panes, stripes, holes, and point d'esprit. The picoted brides became more numerous, foreshadowing the net grounds of lace at the end of the seventeenth century and Venetian point de neige lace with its snowlike appearance.

As seen in this example, the lace has a sculptural effect particularly suited to masculine clothes. Men worn the lace as a rabato (two knotted rectangles at the chin), cuffs, a rhingrave (a short skirtlike band of lace over the breeches), and as garters, which forced the wearer to walk slightly bowlegged. Ladies use the lace for berthas at the shoulder, as headdresses, and as petticoats. The lace was also used as curtains.

The design source of this lace is the Baroque style with its expressive shapes and vigorous contours, but there is also an Oriental influence in the plantlike ornate theme. The lace was made in small workshops where the individual elements of the lace such as the leaves, flowers, and cordonnets were sewn by individual specialists. The pieces were then assembled and laid out by another worker according to an original drawing. The brides and picots were added to connect the lace together. This lace in a smaller format is often called rose point, a nineteenth-century term. Made of very fine flax or linen, the lace has a sheen that gives the effect of carved ivory.

EBA

78

Chest with Drawer

Ca. 1640–1670
England
Primary wood: oak and walnut; secondary wood:
 rosewood, ebonized wood, mother-of-pearl,
 and bone inlays
35 x 55 x 25 inches
Museum purchase with funds provided by Alan H.
 Woodward, Jr.; Eugenia W. Hitt; Martha Webb;
 and Anne Lundbeck, by exchange
1987.2

This chest, with its use of exotic woods and bold architectural design, illustrates the highest style of English joined furniture of the mid-seventeenth century. The geometric design typifies the continental influence on fashionable London-made furniture made by joiners just before the age of the cabinetmaker. The chest was probably made around Southwark on the south bank of the Thames in London, by either a Dutch immigrant or an English craftsman under the influence of the new Dutch style.

The chest has a lid that lifts and one long drawer at its base. The appearance of drawers in English furniture first occurred in the mid-seventeenth century, which eventually progressed into the chest of drawers by the late seventeenth century. Although this chest has no inscribed date, similar examples bear dates between 1647–1667. The feet may have originally been bun feet in the front, with longer stiles to accommodate the height in the back.

The front of the chest, similar to an architectural wall, is composed of three panels. In the center is an applied molding in octagonal shape framing a circular turned molding inset with four keystones. On either side of this central panel are two applied Romanesque arches. Four sets of heavily turned split-spindles separate all three panels. These turnings and other moldings may have been ebonized at one time. This type of chest was made to be colorful, as witnessed by the various inlays of mother-of-pearl and bone. The bone inlay is incised with flowers and geometric patterns. The carcass of the chest is mortise and tenon joined with chamfering on the interior stiles. The side-hung dovetailed drawers in place of the usual nailed drawers of this period are consistent with other known English examples. Triangular bosses are missing over the end drawer pulls.

The decorative vocabulary and construction of this piece were transferred to Boston, Massachusetts, with the immigration of three craftsmen from London to Boston in the mid-seventeenth century. This chest is attributed to the joinery shop of Ralph Mason (1599–1668/69) and Henry Messinger (?–1681) and the turner shop of Thomas Edsall (1588–1676), the three English woodworkers who eventually settled in Boston. Five American examples of this form of chest are known to exist, showing a gradual simplification of the style as time passed.[1] The American chests bring to conclusion the transmission of a style and construction by migrating craftsmen from country to country, the first being Holland to England and the second being England to America.[2]

EBA

1. Brock Jobe and Myrna Kaye, *New England Furniture: The Colonial Era* (Boston: Houghton Mifflin Company, 1984), 115–20; and Jonathan L. Fairbanks and Robert F. Trent, *New England Begins: The Seventeenth Century* (Boston: Museum of Fine Arts, 1982), vol. 3, 522–24, 536–38.
2. For more information about the actual English craftsmen in Boston, see Benno M. Forman, "The Origins of the Joined Chest of Drawers," *Netherlands Yearbook for History of Art* (Amsterdam: Foundation for Dutch Art, 1981), vol. 32, 169–83.

Christ Presented to the People

1655
Rembrandt van Rijn (1606–1669)
Netherlands
Drypoint
13 ⁷⁄₈ x 17 ¹¹⁄₁₆ inches
Bequest of Mr. and Mrs. Oscar Wells
1957.97

When Rembrandt applied his artistic genius to printmaking, he not only created images of beauty and emotional power but also increased the possibilities of the medium far beyond what had previously been imagined. Constantly searching for the visual means to convey emotional intensity, Rembrandt often changed aspects of a picture during the creative process. He printed many state proofs that helped him decide what to do next, states that now help us understand his working method.

Christ Presented to the People is one such print, existing in eight states that include a major alteration.[1] It depicts Pontius Pilate and Jesus before the people. Pilate asks, "Will you have this man released?" The crowd responds that another prisoner, Barabbas, should be released, and Jesus crucified.

Rembrandt peopled this large print with astutely observed individuals, each character portrayed with expressive gestures and facial features, with distinctive poses and attire, together creating a rich panoply of human reaction. Through composition and lighting, Rembrandt emphasized the importance of Jesus. He stands near the center of the image, the black archway and shadow by his legs throwing him into bold relief. Though Pilate is similarly positioned, the detail in his garments links him to the other figures, leaving the bare-chested, bare-legged Jesus standing out both visually and morally. The strong verticals and horizontals of the architectural framework further accentuate the focal point. The three walls seem to close in on the participants, intensifying the feel of these grim proceedings.

The monumentality of the buildings suggests the power of the governing authorities, the weighty order hinting at legal rigidity and lack of compassion.

By thoughtfully arranging the contrasts between dark and light, between areas filled with linear detail and broader areas of tonal treatment, Rembrandt created visual drama and emotional focus. That Rembrandt considered these dynamic contrasts to be essential is clearly evident in state proofs. In the early states, the crowd of onlookers extends across almost the entire bottom third of the image. By the sixth state, Rembrandt had scraped away this distracting group, and by the seventh state he had replaced them with two dark arches. Thus, the platform's black base dissolves into a white that highlights Jesus and his captors. The darkness below conveys a sense of ominous mystery, suggesting an abyss, a chasm, and death.

This print exemplifies Rembrandt's ability to manipulate all aspects of the printmaking medium for expressive ends. Developing a vast repertoire of line, texture, tone, and surface treatment, he brought to printmaking a previously unimaginable variety and visual richness. His innovations changed the course of printmaking, and his images continue to move viewers with their skillful drawing, emotional content, and visual beauty.

AF/JW

1. Among the numerous catalogue raisonnés of Rembrandt's prints, many list seven states for *Christ Presented to the People*. However, in his 1952 catalogue, Ludwig Münz described a state between states one and two, calling it state 1a. Recently this state has been catalogued as state two, thus bringing the total number of states to eight (Christopher White, *Rembrandt as an Etcher: A Study of the Artist at Work* [University Park and London: Pennsylvania State University Press, 1969], 87–92; Christopher White and Karel G. Boon, *Rembrandt's Etchings: An Illustrated Critical Catalogue* [Amsterdam: A. L. van Gendt, 1969], 41–2). Numbered in this way, the state before the elimination of the foreground figures, represented here by a print from the Art Institute of Chicago, is considered the fifth state.

Winter Landscape

Ca. 1660
Jacob van Ruisdael (1628–1682)
Netherlands
Oil on canvas
14 x 12 ½ inches
Gift of Mr. William M. Spencer
1968.43

Jacob van Ruisdael came from a family of Haarlem landscape painters. Even in his earliest work, he exhibited precocious artistic maturity and, after receiving training from his father and uncle, became an independent master at the age of eighteen. On his paintings, he signed his family name (Ruysdael) with an "i," probably from his desire not to have his work confused with that of this relatives. About 1657 he moved to Amsterdam, then the largest city in the Netherlands and center of the flourishing Dutch overseas trading empire. (Presumably he left Haarlem for the more populous, cosmopolitan city where a thriving middle class of merchants had paintings in their shops and homes and even blacksmiths were known to hang them by their forges.) Ruisdael spent the rest of his life in Amsterdam, specializing in landscapes that captured the myriad moods of nature in all of her majesty.

It is the mood of the season, rather than human activity, that is paramount in Ruisdael's paintings. Although quite small, *Winter Landscape* projects monumentality by his having combined boldly massed forms with a highly detailed rendering of individual elements. A low horizon makes prominent the spectacular cloud formation that dominates the composition with darkened grandeur. The relative minuteness of the human figures offers a metaphor for the insignificance of the human condition compared with the eternal, inexorable rhythm of nature's seasonal change. This and Ruisdael's emphasis on mood, atmosphere, and the drama of light and shade would foreshadow the Romantic movement of the late eighteenth through mid-nineteenth centuries.

The chill silvery-grey atmosphere of Birmingham's *Winter Landscape* is warmed by touches of color in the brick red sail and tower gate and in the sunlit edges of the heavy clouds overhead. On the left, fishing boats nestle up to the shore of the frozen river estuary. A light dusting of snow covers the ground. The landscape extends toward the distant horizon to meet with an infinite blue sky nearly obscured by the winter clouds.

Snowy leaves of the foliage, especially on the gnarled trees in the foreground, create a fragile, feathery contrast to the solid bulk of the gate and the lowering sky overhead. A flock of birds in flight beneath the clouds and the human figures on the earth below lend scale to the hushed, slightly melancholy mood of this late-afternoon scene. The roughly textured fallen logs and the withered vegetation at the water's edge suggest the passing of nature, aging, and death, reminding the viewer of human mortality—the forces of nature's regeneration surrounding people as they go quietly about their daily lives.

DA/JW

Allegory of Charles I of England and Henrietta of France in a Vanitas

1669–1677
Simon Renard de Saint-André (1613–1677)
France
Oil on canvas
56 ½ x 46 inches
Museum purchase with funds provided by Martee
 Woodward Webb; Mr. and Mrs. Edmund
 England; Dr. and Mrs. Rex Harris; Mrs. William
 McDonald, Jr.; Mr. and Mrs. Stewart M. Dansby;
 and Mrs. Pauline Tutwiler
1988.28

Obsession with human mortality played an important role in seventeenth-century piety, meditations on the hereafter being considered a means to spiritual perfection. A form of still life, the *vanitas* developed to impart moral lessons relating to life, death, and resurrection through the microcosm of diverse objects bearing symbolic meanings. In the Netherlands, the *vanitas* developed as a genre designed to appeal to the sober, sensual, materialistic sensibilities of the bourgeoisie, while in France, it served the aristocracy. Ingenious and subtle, French *vanitas* were tailored to the taste of an elite clientele of intellectuals acquainted with ancient myths and fond of interpreting obscure symbols.

The portraits of King Charles I of England and his widow, Henrietta Maria, figure prominently in this array as examples par excellence of the suddenness of death and the vanity of earthly power and glory—Charles having not only lost his kingdom but also his head at the hands of his former subjects. A victim of the Puritan Rebellion, he was found guilty of treason and beheaded by Cromwell's mob in 1649 (Henrietta Maria was exiled and lived the remainder of her life in seclusion in France). The jawbone separated from the skull and the overturned candlestick with smoke drifting sideways refer directly to Charles's violent death.

A common feature of the *vanitas*, the skull, placed amid attributes of power, science, and pleasure, is the traditional reminder of the vain and transitory nature of all earthly pursuits. But the message here is moderated by symbols of hope and redemption. For example, while the skull by itself carries connotations of finality, crowned with laurel it becomes the promise of victory over death—resurrection.

The ancient Romans used the bubble as the symbol of ephemeral human life. Associated with the putto, it refers to the fleetingness of earthly love. The map of the New World, shown prominently on the globe resting on an atlas, represents the discovery of new lands and the growth of empire, and the two classical busts allude to the impermanence of political power by calling to mind great civilizations of the past now extinct. A blank parchment stands ready to record one's earthly deeds, while the spectacles allow the user to see clearly through illusion. Sealing wax reminds viewers that man is an imperfect imprint of the heavenly original, and the seals are symbols of divine protection. The coral branches placed on the plain wooden box promise protection from evil at the hour of death; the empty shells signify the cast-off mortal body and, through their association with regenerating waters, foretell resurrection.

DA/JW

Dish

Edo period (1615–1868)
Ogata Kenzan (1663–1743)
Japan
Glazed stoneware
6 ½ x 6 ⅝ inches
Gift of Mr. and Mrs. Elton B. Stephens
1985.32

Ogata Kenzan belonged to a distinguished, cultured merchant family that dealt in luxury textiles for the aristocracy of Kyoto. He was distantly related to the famed Rimpa school artist Hon'ami Koetsu (1558–1637), and his elder brother, Ogata Korin (1658–1716), was also an eminent painter of this same school that sought creative response in the indigenous art forms of classic Japan. Finding inspiration in this heritage, Kenzan was to become known as a literary scholar, a skilled painter and calligrapher, and above all, as a master potter.

Unlike his flamboyant elder brother, Kenzan led a quiet life of introspection in which he studied Zen and Chinese and Japanese literature. Once established as a potter, he pursued his career with diligence, often collaborating with his brother who painted or provided designs for the pottery that Kenzan made. The result was a ceramic tradition that provided impetus and direction for the wares of Kyoto for generations.

Kenzan produced a wide variety of work, consisting primarily of high-fired stonewares decorated with iron oxide and underglaze and overglaze colors. His work also encompasses a broad range of shapes, ranging from simple square or round plates to more imaginative floral-shaped bowls and dishes such as the Birmingham Museum of Art piece. Originally from a set of five,[1] this dish captures not only the rich colors of the peony design but also, through the shape of the dish, an actual sense of the flower. The dish is made from a dense dark clay to which a layer of white slip was applied before the final design was painted on and fired. The underside of the dish is decorated with a simple grass pattern and bears the signature "Kenzan". Kenzan was the first Japanese potter to sign his work with a brush. Although he often relegated the actual throwing and firing of his work to assistants, it was through his talent as a designer and decorator that Japanese ceramics were elevated from a craft to an art.

DAW

1. A shard of identical shape to the Birmingham Museum of Art dish was excavated at Korin's kiln by Dr. Richard Wilson of Rice University. Richard Wilson, *Ogata Kenzan: Zen sakuhin to sono keifu* (Tokyo: Yuzankaku Publishers, 1992), vol. 1, pl. 51, 40.

Perfume fountain

Ca. 1710
France (Paris)
Porcelain: China (Ming dynasty),
 late 16th–mid-17th century
Mounts: France (Paris), ca. 1710
Porcelain with underglaze blue decoration and
 gilt bronze
17 1/16 inches; diameter at base: 10 5/8 inches
Eugenia Woodward Hitt Collection
1991.22

In Europe, the practice of setting Oriental porcelain in metal mounts dates at least from the Middle Ages. Like other small exotic objects such as ostrich eggs, nautilus shells, and coconuts, porcelains were fitted with mounts of precious or semiprecious metals both for their protection and as a tribute to their extreme rarity. From the mid-seventeenth century, when the Dutch East India Company opened a systematic trade with the Far East, hundreds of thousands of pieces of Chinese and Japanese porcelain entered Europe annually. Despite the greater availability, Europeans continued to set large numbers of Oriental ceramics in metal mounts, although their fascination now lay in the decorative possibilities of the ensemble rather than in the porcelains themselves.

Potpourris and perfume jars represent a popular type of mounted porcelain in eighteenth-century France. This perfume fountain is composed of three pieces of Chinese blue and white porcelain—two lids and the body of a jar—from the late Ming dynasty (1368–1644). An enterprising Parisian merchant presumably salvaged these pieces from three lidded jars and commissioned the gilt bronze mounts to join them together. As in this example, the metal mounts often served a practical role in combining odd porcelain elements into imaginative objects for the luxury market.

Nonetheless, the primary motivation for mounting Oriental porcelains was to moderate their exotic character and, in turn, bring them into line with contemporary interior design. During the early decades of the eighteenth century in France, gilding assumed an ever-greater role on *boiseries*, furniture, and a variety of decorative objects such as wall clocks, barometers, and firedogs. In response to this trend, French craftsmen set an increasing number of Oriental porcelains in gilt bronze, instead of the silver or silver-gilt mounts favored in earlier centuries. The gilt bronze mounts, like their silver antecedents, yielded singular objects of unparalleled fantasy and novelty that blended seamlessly into the unified interiors of eighteenth-century France.

TA

Pair of firedogs (feux)

Ca. 1710–1720
France (Paris)
Gilt bronze
1991.37.1: 13 5/8 x 8 15/16 x 4 5/8 inches
1991.37.2: 13 7/8 x 8 15/16 x 4 5/8 inches
Eugenia Woodward Hitt Collection
1991.37.1 and 1991.37.2

Into the nineteenth century, the fireplace was the primary source of heat and light in the domestic interior and, as such, provided a symbolic as well as an architectural focus to the room. Architects and designers accordingly lavished attention on the carving of the marble mantelpiece, its decorative gilt bronze mounts, and especially the firedogs, the most striking feature of the wood-burning fireplace.

Pairs of firedogs stood in the hearth of the fireplace, linked at back by a wrought-iron grill that held the burning logs. Since the Renaissance, firedogs had provided an ideal vehicle for the sculptor's art. By the early eighteenth century, firedogs often resembled miniature sculptures on pedestal bases and were equipped with a second, purely functional pair of brass or iron firedogs to support the log grill. Iron tongs and pincers (*pelles* and *pincettes*) with gilt bronze knobs completed the set of coordinating fireplace equipment.

Bronze firedogs in the form of rearing horses were popular throughout the eighteenth century. At least eight other eighteenth-century pairs of firedogs after this model are known, each with variations in the base and sometimes having a saddlecloth and a shield supporting the horses' forelegs. Of the known examples, only the Birmingham Museum's pair has gilded, rather than patinated, bronze horses. The fully gilded surface, with its luxuriant detail and high finish, implies the exorbitant expense and technical skill required in the fabrication of these firedogs. Given that the status of a room determined the richness of its furnishings, these firedogs were undoubtedly intended for the most formal room of a grand Parisian *hôtel particulier*, if not a royal residence.

TA

Hagar and Ishmael Saved by the Angel

Ca. 1727–1728
Sebastiano Ricci (1659–1734)
Italy (Venice)
Oil on canvas
60 ⅜ x 52 ⅜ inches
Lent by the Art Fund, Inc.
AFI 1.1993

In the Bible's twenty-first chapter of Genesis, Abraham's jealous wife, Sarah, forced him to repudiate his concubine, Hagar, by whom he (at Sarah's suggestion) had a son, Ishmael. Cruelly thrust out of the household with only some bread and a little water, Hagar and her young son wandered alone in the desert. When their water was gone, she laid the child down, raised her voice, and wept. Suddenly an angel appeared saying, "Lift up the boy and hold him fast with your hand for I will make a great nation of him." Then the angel revealed the location of a well of water. Thus, Ishmael survived and, according to ancient tradition, became the father of the Arab people.

Hagar and Ishmael Saved by the Angel captures the moment when a radiant, angelic messenger miraculously intervenes to rescue the despairing mother and her dying son. The empty water jar lying useless on the ground, the tear on Hagar's cheek, Ishmael's weak glance toward the viewer, and the dark, subdued colors serve to encourage the spectator's emotional involvement in the pathos of this desperate situation. Ricci heightened the drama by concentrating the three figures into a strongly lit, tightly interlocking group that fills the pictoral space. Their diagonal arrangement creates a dynamic upward flow, enhancing the dramatic tension of the miraculous scene. This operatic, softly sensual approach is characteristic of eighteenth-century Italian religious and historical art.

Thanks to the Grand Tour, the fame of Venetian artists had spread beyond the borders of Italy to the rest of Europe, and many, among them Sebastiano Ricci and Antonio Canaletto, received invitations to work abroad. Ricci, in addition to numerous commissions for historical paintings, was invited to paint murals in the Schönbrunn Palace in Austria and in several of the great aristocratic houses of England. In 1718, as he made his way back to Italy through Paris, he was elected to the French Royal Academy. After his triumphal return to Venice, he was instrumental in establishing the elegant Venetian Rococo style, which would reach its ultimate glory in the work of Giambattista Tiepolo (1696–1770).

The Birmingham painting contains a significant iconographical departure.[1] Traditional depictions of the story follow the biblical text in which Hagar places the child some distance away. In this version, however, Ricci placed Ishmael against his mother to make a tighter, more powerful composition. This innovation was later adopted by several of Ricci's Venetian contemporaries, most notably Tiepolo in his treatment of the same subject in the Scuola di San Rocco, Venice (ca. 1732).

DA

1. Ricci painted another version of *Hagar in the Desert*, employing the traditional iconography, in the Palazzo Reale, Turin (1723).

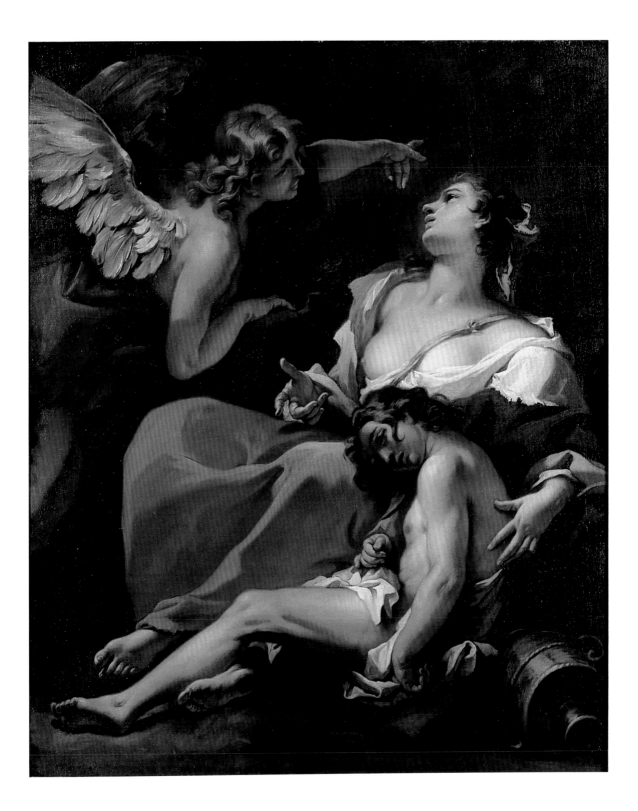

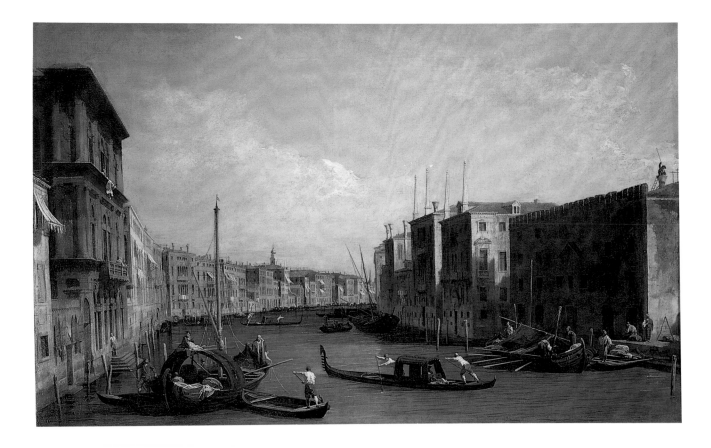

94

View of the Grand Canal, Venice

Ca. 1730
Canaletto (Antonio da Canal) (1697–1768)
Italy
Oil on canvas
23 ½ x 39 ¼ inches
Gift of the Samuel H. Kress Foundation
1961.121

The Enlightenment, which swept through Europe in the eighteenth century, ignited a growing interest in science, a curiosity about foreign lands, and an appreciation for the wellsprings of European civilization, ancient Greece and Rome. Rising prosperity and relative peace in Europe meanwhile made this an age of travel. From these circumstances came the grand tour, a year-long voyage in which a young gentleman with his tutor would visit the leading cities and historical sites of Europe, not only for academic knowledge but also for refinement and sophistication. The experience was considered by many equivalent to a university education. With its cultural riches, Italy became the prized destination for these travelers, most of whom came from England, then the wealthiest country in the western world.

A demand for souvenirs soon arose, giving birth to the portrait of a place, or *vedute* (view painting). *Vedute* became the picture postcards of their day, and Venice soon became the capital of the genre. Despite the waning of its international power, "La Serenissima" retained its Byzantine splendor, touched by an aura of worldly decadence. Still the gateway to the East, it was a city of gold, jewels, spices and silks, of masked balls and Giacomo Casanova.

A vivid drama of life was played out daily on the Venetian canals, watery thoroughfares teeming with barges, gondolas, and other vessels essential to water-borne transportation and commerce.

Bisecting the city in two great sweeping curves, the Grand Canal, for centuries the "main street" of Venice, is lined with Gothic and Renaissance palaces. Interspersed among them are warehouses that, in the eighteenth century, still contained the exotic trade goods that made the city great.

In painting his scenes of Venetian life, Canaletto captured the pristine shimmer of light and atmosphere caused by the special blending of sunlight, water, and mist so unique to his native city. In this view, we are on the Grand Canal looking southeast toward the Palazzo Michiel dalle Colonne.[1] On the right, Levantine merchants unload their wares at a warehouse, while on its roof a chimney sweep busily cleans the building's flue. On the opposite bank, figures watch the activity below from the windows and balcony of the sixteenth-century Palazzo Vendramin-Calergi. The canal is crowded with boats, from heavy merchant barges to swift, graceful gondolas. Around the curve in the far distance looms the Rialto, the business heart of eighteenth-century Venice.

DA/JW

1. W. G. Constable lists this painting as #249 in *Canaletto: Giovanni Antonio Canal 1697–1768* (Oxford: Clarendon Press, 1962), 292. A similar view (Constable, #248, 291) shows less of the Deposito del Megio and no chimney sweep; the boats and figures also differ.

Pair of console cabinets

Master of the Reticulated Mounts
 (active ca. 1730)
France (?)
Oak and pine veneered with *bois satiné*, gilt bronze,
 and *brèche d'Alep* marble
30 1/4 x 23 3/4 x 12 1/8 inches
Eugenia Woodward Hitt Collection
1991.88.1 and 1991.88.22

The exaggerated curves of these bombé cabinets express the animated spirit and invention of early-eighteenth-century furniture. During the first decades of the century, artists, craftsmen, and designers invented the Rococo style, or what they called the *goût modern* (modern taste). Curved lines and contours freed furniture forms from the architectonic rigidity characteristic of the late seventeenth century and invoked an era of fantastic innovation.

These cabinets resemble an unusual form specific to this period—the *commode en tombeau*, or sarcophagus-shaped chest, in vogue between 1700 and 1730. This novel form appeared in the first decade of the century as a startling alternative to the straight lines and architectural models of late Baroque furniture. Numerous permutations evolved during the early eighteenth century, with descriptive appellations such as "S-shaped commodes" and "bridge-shaped commodes" (having a large void at bottom center). The Birmingham Museum cabinets represent a late interpretation of the form, wholly sculptural and with the boldly curved profile continuing across front and sides.

The distinctive gilt bronze mounts of these cabinets, and particularly the reticulated moldings, are atypical of Paris production in the early eighteenth century. Their uniqueness suggests that the craftsman responsible for their design was either working in a provincial French center or was a foreign cabinetmaker working in Paris. These mounts appear only on this pair of cabinets and a *commode en tombeau* now in a private French collection. Their remarkable individuality inspired the eponym for the unknown craftsman.

Many gilt bronze mounts on eighteenth-century French furniture were standard models, produced by bronze casters for a number of cabinetmakers working in a major center. The pronounced curvature of much eighteenth-century furniture, however, often made the customizing of mounts a necessity. In this instance, the cabinetmaker worked closely with the bronze caster, who made templates directly from the wood carcase. In such a collaboration, the cabinetmaker could not only determine the shape and fit of the mounts but also initiate novel designs. The originality and quality of the mounts on these cabinets, together with their exuberant forms, distinguish the limited oeuvre of this unidentified cabinetmaker as one of exceptional invention.

TA

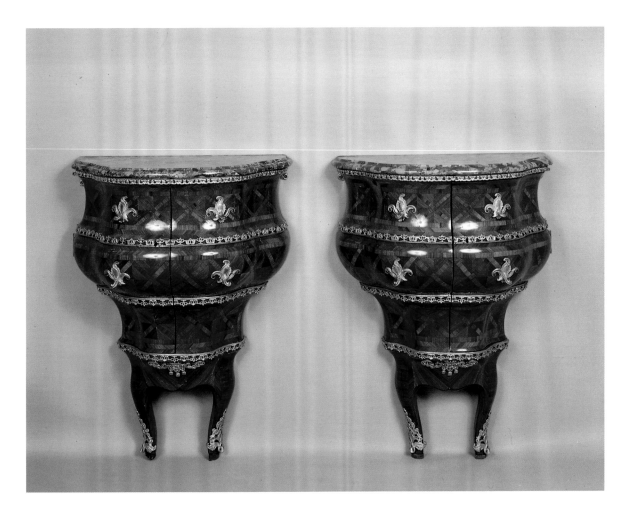

The Bathers

Ca. 1730–1735
Jean-Baptiste-Joseph Pater (1695–1736)
France (Paris)
Oil on canvas
51 ¾ x 38 ¼ inches
Eugenia Woodward Hitt Collection
1991.248

The subject of female bathers was a specialty of Jean-Baptiste-Joseph Pater, who painted more than fifty versions of it during his short but prolific career. Pater typically depicted the bathers in an outdoor pool at twilight, with fanciful baroque architecture and fountain sculpture in the foreground and a country village and mountains in the distance. His light, animated brushwork and preference for luminous colors such as pink, mauve, and blue heighten the sensual poetry of these works.

A pupil and close follower of Antoine Watteau, Pater throughout his career exploited the genre of the *fête galante* (gallant party) invented by his teacher. The *fête galante* celebrated the idle pleasures of love and gallantry in fictive, though vaguely recognizable, park settings. In his depictions of bathers, however, Pater discovered a more personal idiom, superficially linked to the *fête galante* through the dreamlike pastoral settings, but erotically charged. Female bathers, in provocative poses and stages of undress, splash in the pool, mindless of the viewer's gaze.

For Pater and his audience, the subject of bathers offered a barely veiled pretense for showcasing the female nude. This painting nonetheless retains vestiges of a traditional mythological theme, namely Diana, Goddess of the Hunt, with her nymphs resting by a forest pool after the hunt. Although Pater has stripped this composition of overt mythological references, he subtly alludes to the theme of Diana and her nymphs in the prominent figure seated beneath the red canopy at right center with her attendants.

The provocative subject matter together with the sparkling color and lively brushwork embodies the unabashed sensuality of much mid-eighteenth-century French painting. It is not surprising that Pater was called upon to repeat this successful formula for an avid international clientele.

TA

Charger from the Swan Service

Ca. 1737–1741
Modeled by Johann J. Kändler (1706–1775)
 and Johann Friedrich Eberlein (w. 1735–1749)
Germany (Meissen)
Meissen factory
Hard-paste porcelain
Diameter: 16 5/8 inches
Museum purchase with funds provided by Mrs.
 Morris W. Bush; Mrs. Catherine Collins;
 Thomas L. Fawick; Mrs. Horace Hammond;
 Chester H. Huck; Col. and Mrs. George Knight;
 Miss Frances Oliver; Nan L. Phillips; Floyd
 Railey; William Spencer, Sr; Elizabeth S. Steiner;
 Dr. Bruce Sullivan; Helen Verplanck; and Pauline
 Tutwiler, by exchange
1989.126

The Swan Service charger was part of the
largest and most magnificent dinner, tea, coffee,
and chocolate service ever produced at the Meissen
factory. It was commissioned in 1737 by Count
Heinrich Graf von Brühl (1700–1763), prime
minister to the court of Augustus III and director
of the Meissen factory. The occasion for the
commission was his marriage to Grafin Franziska
von Kollowrat-Krakowsha, and the service
remained in the family until the end of World
War II. The dual coat of arms of the Brühl-
Kollowrat families impaled appears on the flange
of over twenty-four hundred pieces of the service.

The service was modeled by Johann Joachim
Kändler, assisted by Johann Friedrich Eberlein.
Kändler began working at Meissen in 1731 and
was appointed master modeler in 1733. Consid-
ered the greatest and most famous of all Meissen
modelers, Kändler is known for his porcelain court
figures that were used as table decorations as well
as exquisite dinner services. His work is expressive
of the Rococo style, exploiting the fluid yet
malleable properties of the porcelain body, as
seen in this service with tureens and sauceboats
in the shape of swans.

In decorative relief in the center of the
charger, two swans swim and a crane feeds
among undulating rushes while a second crane
flies overhead. This design was conceived as a
play upon the idea of water, because the name
Brühl literally means "swampy meadow" or
"marshy ground" in German. The scene of the
swans (see figure below) was probably derived
from a painting by of Francis Barlow (ca. 1626–
1702), later etched by Wenceslaus Hollar (1607–
1677) for publication in a book of birds by Peter
Stent in 1654 in London. The Brühl-Kollowrat
coat of arms and scattered, Japanese-style flowers
in the manner of Sakaida Kakiemon were painted
in enamel and gilt on the flange of the charger,
with a fine gilt border on the scalloped rim.

EBA

Wenceslaus Hollar after Frances Barlow, Two Swans, *London,
England, 1654. Etching. Photograph courtesy of The Metropolitan
Museum of Art, Harris Brisbane Dick Fund, 1917.*

Allegory of Winter and *Allegory of Spring*

Ca. 1742–1743
Nicolas Lancret (1690–1743)
France (Paris)
Oil on copper
Winter: 10 ½ x 14 inches
Spring: 11 x 14 inches
Eugenia Woodward Hitt Collection
1991.249.1 and 1991.249.2

These pendants belong to a cycle of *The Four Seasons* painted by Lancret shortly before his death. The allegories of summer and autumn are known only through engravings made after the series by Nicolas Larmessin IV (1684–1753) and exhibited at the Paris Salon of 1745. According to the entry in the Salon catalogue, Larmessin's

engravings reproduced Lancret's last works. The paintings in this series, among his rare works on copper, bear the hallmarks of Lancret's late style, most importantly the new internal proportions created by fewer, more robust figures set apart from the landscape.

Following a long tradition, Lancret exemplified each season by a characteristic outdoor activity, such as flower gardening in the spring and ice-skating in the winter. In the two lost allegories, summer is represented by figures cutting wheat and tending chickens and autumn by the grape harvest. With charming fidelity, Lancret documented a rustic way of life through its manners and amusements. The

paintings make little suggestion of the physical labors normally associated with the different times of year. Instead, the pastoral subjects offer an appealing escape from the harsh realities of daily life. The passage of time is here an analogue for the stages in an idyllic romance between a pair of peasant lovers, who indulge in mild flirtations within each picturesque, seasonal landscape.

Although a painter of contemporary society, Lancret simultaneously idealized it, transposing the agreeable leisure of the Parisian upper classes to the simpler pleasures of the country. If not an accurate picture of rustic life, this *Four Seasons* cycle nonetheless chronicles the gentility of the eighteenth-century world. With such lively and inventive narratives, Lancret helped to establish genre painting as a legitimate subject in eighteenth-century French art and ensured its long-lasting popularity across Europe.

TA

Basket

1740–1741
Paul de Lamerie (1688–1751)
England
Silver
10 inches
Bequest of Frances Oliver Estate
1972.287

Stand

1820–1821
Paul Storr (1771–1844)
England
Silver
Diameter: 16 ¼ inches
Bequest of Frances Oliver Estate
1972.288

Paul de Lamerie holds the preeminent position of a master of silversmithing in the English Rococo style. Born in Holland, he was brought by his Huguenot parents to London in 1689 and apprenticed to the highly accomplished Pierre Platel, another Huguenot. In 1713 Lamerie registered his first of four marks at the Goldsmith's Hall. His early work reflects the restraint and simplicity of the Queen Anne and Huguenot styles. His talent soon became known and through shrewd business acumen at the sign of the Golden Bull, Lamerie prospered. In 1716 he was appointed goldsmith to the king. In the early 1730s, Lamerie and other English silversmiths were highly influenced by French regency silver and adopted the Rococo style, pioneering its development and predating its use in other media such as furniture. The flamboyancy of the Rococo is seen in Lamerie's work from approximately 1737 to 1746, when the extraordinary sculptural quality of these magnificent objects pervades each piece entirely.

Lamerie is credited with bringing pierced baskets for holding breads, cakes, and dates to popular use in the 1740s. The Birmingham Museum silver basket is typical of his work, with its intricate piercing and engraving of floral motifs and scrolls and cast sculptural innovations. This oval basket has tapering sides and a projecting rim with a cast overlay of shells, wheat sheaves, and dancing cherubs. The cast handle is encrusted with shells and leaves supported by two caryatids. The lacelike sides, with sinuously engraved, curving leaves, were cut with a fretsaw. The foot-rim is cast with leaves, cartouches, and demi-masks of four females each adorned with a three-feather headdress, and supported by beautifully fashioned feet in the form of lions' heads with splayed whiskers, all reminiscent of the ormolu mounts found on contemporary French furniture.

Upon his death, the *London Evening Post* of August 3–5, 1751, recognized Lamerie's accomplishments in their obituary: "Last Friday . . . died Paul D'Lamerie, Esq; an eminent Goldsmith in Gerard Street Soho; . . . [He] was particularly famous in making fine ornamental Plate, and has been very instrumental in bringing that Branch of Trade to the Perfection it is now in."

Complementing this remarkable basket is a stand by Paul Storr made eighty years after the basket. Why the stand was commissioned and by whom are questions that might have been answered by a coat of arms in the interior of the basket, but unfortunately it has been erased. The stand was made of a heavy-gauge silver and was punched out with a downfall press rather than cut with a jeweler's saw, as is the basket. The engraving on the pierced work, the putti, and the entwined leaves relate the stand beautifully to the decorative elements of the basket, creating the impression of a single object crafted by one hand.

EBA

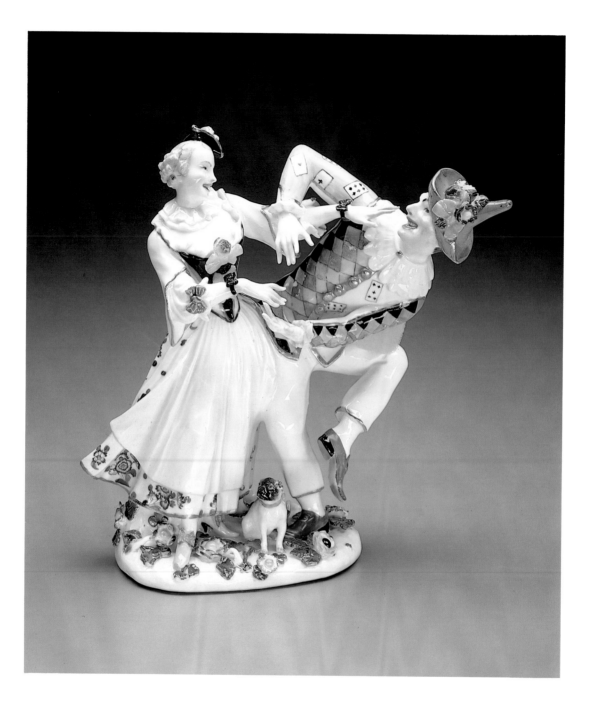

Harlequin and Colombine Dancing

Ca. 1744–1750
Model by Johann Joachim Kändler (1706–1775)
Meissen factory
Germany (Meissen)
Hard-paste porcelain with gilding and colored
 enamel decoration
8 3/16 x 7 3/4 x 3 3/8 inches
Eugenia Woodward Hitt Collection
1991.313

Harlequin and Colombine were among the most important characters in the Italian *Commedia dell'Arte*. An itinerant theater form, the *Commedia dell'Arte* flourished throughout Europe, especially in France and Germany, in the eighteenth century. The improvised comic skits usually centered on a feud between two aristocratic families, based on an impossible romantic liaison and fueled by servants' intrigues. Equipped only with the bare outlines of the plot, the actors ad-libbed each performance with bawdy jokes, acrobatic tricks, music, and monologues prepared for any improvised situation.

The Meissen factory introduced small-scale figures after the *Commedia dell'Arte* as early as 1710, probably to commemorate a performance by a troop in Dresden the previous year. Commercial and artistic success followed later when, beginning

about 1735, Master Modeler Johann Joachim Kändler reinterpreted the characters in highly theatrical, baroque guises. Kändler captured the burlesque nature of the *Commedia dell'Arte* through vivid colors, vigorous modeling, highly expressive features, and active gestures. The model of *Harlequin and Colombine Dancing*, first recorded in factory records in 1744, epitomizes the frenzied animation and exaggerated postures of Kändler's figures.

The porcelain figure sculpture produced at Meissen and at other European factories was primarily intended as decoration for the dessert table. Porcelain figures succeeded the ephemeral sugar sculpture, or *trionfi*, introduced earlier at the European courts from the Middle East. Permanent and more colorful alternatives to the sugar sculptures, Meissen figures rapidly gained popularity as dessert decorations in early-eighteenth-century Europe. The most extravagant dessert centerpieces comprised dozens of porcelain figures, spaced in garden parterres—contrived of colored sand or sugar with artificial flowers—and set on shaped silver or gilt bronze trays.

The dessert decorations mirrored the thematic program of the court festivities. To accommodate any occasion, Meissen produced a wide range of small-scale sculptures, including opera singers, dancers, peasants, hunters, Freemasons, miners, soldiers, and sultans. Dramatic groupings of *Commedia dell'Arte* figures would have mimed actual performances and anticipated that evening's entertainment. For the modern audience, these Meissen sculptures provide an entrancing historical document of the customs and fashions of court society in eighteenth-century Europe.

TA

Set of four wall panels: *The Hot Drink, The Cold Drink, The Picnic in the Park,* and *The Hunt Picnic*

Ca. 1750
Attributed to Christophe Huet (1700–1759)
France (Paris)
Oil on canvas
First two: 119 1/2 x 53 1/4 inches
Last two: 119 1/2 x 44 1/4 inches
Museum purchase with funds provided by the
 Acquisitions Fund, Inc. and the 1992 Museum
 Dinner and Ball
1992.1.1–.4

This set of four panels originally formed part of a complete painted room decoration in a fashionable Paris residence. Additional smaller canvases painted with the same bright palette and whimsical motifs would have filled the remainder of the walls, hanging over the windows, doors, and chimneypiece, on the doors, and under the chair rails. Painted interiors rarely survive intact, as rapidly changing fashions prompted frequent refurbishings during the eighteenth century. Owners banished the outmoded decorations either to the upper floors of their city residences or else to the rarely visited country houses. Other canvases from the Birmingham Museum series may have disappeared when the decoration was dismantled. These four panels are first recorded in the Château d'Ognon (Valois), for which they were undoubtedly purchased in the later nineteenth century.[1]

These panels belong to a category of decorative painting known as arabesques, so named for the intricate surface patterns of scrolling and interlacing ribbons or foliage. Typical of eighteenth-century examples, these arabesques confine the linear pattern of the ribbons to the top and bottom of the design, thereby giving prominence to the central narrative subject. The thematic programs of these painted decorations echoed the functions of the rooms for which they were created. The exotic picnic subjects at center

of the Birmingham Museum panels, together with the cornucopia and monkeys balancing pies and wine bottles below, suggest that the artist created them for a dining room.

The Chinese picnic scenes also reflect the mid-eighteenth-century's passion for things Oriental. Europe's centuries-old fascination with Asia, encouraged both by factual information and vivid imagination, gave birth to *Chinoiserie*, a pervasive decorative style in mid-eighteenth century Europe. Craftsmen, painters, and designers created furniture, ceramics, silver, clocks, textiles, and even entire rooms in a fantastical Oriental style. *Singeries*, or monkeys imitating human activities, reached their height of popularity during the mid-eighteenth century, when they became associated with the whimsical exoticism of *Chinoiserie*.

Little is now known about the French artist Christophe Huet, who was renowned during his lifetime as a master of *chinoiseries* and *singeries*. The Birmingham Museum panels relate closely to an extant decoration in the Hôtel de Rohan, Paris, documented as painted by Huet between 1749 and 1752. Other better-known decorations attributed on stylistic grounds to Huet include two *singeries*, one with Chinese figures, at the Musée Condé, Chantilly. Like the Birmingham Museum panels, these principal decorations epitomize the imaginative fantasy of Christophe Huet, one of the consummate decorative painters of the French Rococo.

TA

1. These panels were sold from the Château d'Ognon at the Hôtel Georges V, Paris, on March 18, 1981 (lot 73). The Château d'Ognon, located in Valois north of Paris, was furnished with eighteenth-century paintings and furniture purchased in France in the mid- to late nineteenth century. The residence for which the panels were originally commissioned has not been identified.

Page 109 left, The Hunt Picnic, *and right,* The Picnic in the Park.

109

The Cold Drink

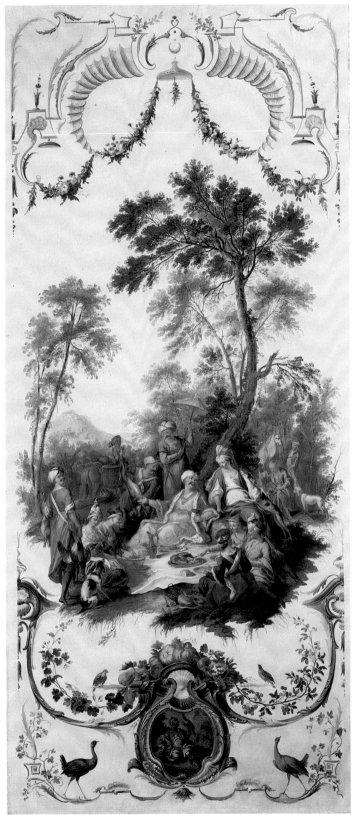

The Hot Drink

Set of tea shelves (Chadana)

Late 18th century
Edo period (1615–1868)
Japan
Maki-e and black lacquer, gold, silver, tin, and
 mother-of-pearl on wood
31 1/2 x 33 1/2 x 9 7/8 inches
Museum purchase in honor of Rebecca Bowers
 Cooper and Mildred Pipes Shook
1990.33

Originally owned by the Itakura family, lords of Bitchu Province (present-day Okayama Prefecture), this three-tiered set of shelves is decorated in a raised lacquer technique known as *takamaki-e*. The floral designs have been fashioned over a surface of raw lacquer and crushed stone to produce a three-dimensional effect. Powdered gold, silver, and tin were then used to create the compositions that were further inlayed with mother-of-pearl. The result is a surface rich in both material and design.

The Birmingham Museum of Art set of shelves includes a cabinet and drawer on the lower shelf.

The whole is embellished with a floral motif that has autumn as the dominate theme. Chrysanthemums and pampas grass by a meandering stream adorn the outside of the cabinet doors, with the theme continuing on the inside of the doors as quail feed by moonlight on an island in the middle of the stream. The three-tiered shelves are ornamented with a variety of flowers on small hillocks that echo back and forth as the pattern progresses from the top shelf to the bottom. The supporting pillars conclude the design with a stylized lozenge floral motif.

Sets of shelves such as this were important pieces of furniture for use in the Japanese tea ceremony and were luxury items of the highest order. The daimyo and famed tea master Furuta Oribe (1544–1615) is known to have treasured such sets, as did various other daimyo. These people belonged to an elite cultural world in which such pursuits as the tea ceremony were a preeminent aesthetic expression. The collecting of fine tea utensils became a pastime of refinement that provided considerable stimulus for the various artisans and craftsmen of the Edo period.

DAW

Cabinet

Ca. 1755–1760
France (Paris)
Oak set with four 17th-century Japanes lacquer
 panels and painted with French *vernis* and
 imitation *nashiji* lacquer, with gilding and marble
31 7/8 x 48 1/2 x 18 3/8 inches
Eugenia Woodward Hitt Collection
1991.28

This unique Parisian cabinet is mounted with four panels of seventeenth-century Japanese *urushi* lacquer, cut from an imported cabinet or screen. The *menuisier* (joiner) bent the panels with steam and weights to make them conform to the undulating Rococo contours of the case. Surrounding the panels and outside the gilded moldings is a painted finish simulating *nashiji*, a type of Japanese lacquerwork containing particles of gold, silver, or copper dust in the black background. A Parisian painter ingeniously imitated this finish to set off the dramatic black, gold, and silver colors of the Japanese panels.

Most of the Oriental lacquerwork available in seventeenth- and eighteenth-century France was imported by the Dutch East India Company in the form of screens, boxes, and cabinets. Despite an active trade, the East India Company never imported enough lacquer to satisfy the demand in Europe. Out of necessity, French craftsmen learned to approximate its hard, resistant, and lustrous finish using various combinations of imported materials such as copal resin, and native ingredients, including garlic, absinthe, and vinegar. Lacquerers developed varnishes in a brilliant range of colors, applicable for use on furniture, carriages, panelling, and other useful items. The most successful of these imitations was invented by the brothers Guillaume (d. 1749) and Étienne-Simon (d. 1770) Martin, who patented the formula in Paris in 1730. As on this cabinet, furniture makers often employed such European finishes to complete those areas not covered by the Oriental lacquer panels on a single piece of furniture.

Both Oriental lacquers and the superb French imitations enjoyed great vogue in France during the reign of Louis XV (1723–1774). Beginning in the 1730s French cabinetmakers set important casepieces with panels of Oriental lacquer; the earliest documented example is a commode delivered to the queen of France in 1737 for her apartment at the palace of Fontainebleau. The fashion for lacquer-mounted furniture arose at the height of Rococo *Chinoiserie*, an imaginative decorative style based on a fanciful European vision of the Far East. The asymmetry of Chinese and Japanese design complemented perfectly the graceful curves of French furniture at this time and encouraged the taste for lacquer decoration. Even after the emergence of Neoclassicism in the later eighteenth century, lacquer furniture remained in fashion as the quintessential statement of the extravagance, virtuosity, and innovation of high-style productions in ancien régime Paris.

TA

Tureen and lid with stand

Ca. 1754–1770
Niderviller factory
France (Niderviller)
Tin-glazed earthenware (*faïence*) with colored
 enamel decoration
Tureen and lid: 9 3/4 x 14 5/8 x 8 9/16 inches
Stand: 1 3/8 x 21 1/2 x 14 3/16 inches
Eugenia Woodward Hitt Collection
1991.344

From 1758, the *faïence* works at Niderviller produced complete table services in the high Rococo style. Tureens combined scrolls, shellwork, and gadrooning with fully three-dimensional mushrooms, leeks, mollusks, artichokes, and other elements modeled from life and painted in vibrant, naturalistic enamel colors. Their animated sculptural shapes and boldly modeled decoration depended on the Rococo silver designs of contemporary Parisian silversmiths such as Jean-Claude Duplessis and François-Thomas Germain.

In 1748, Jean-Louis Beyerlé, director of the Royal Mint at Strasbourg, had purchased the manorial lands of Niderviller, a village in Lorraine between Lunéville and Strasbourg. By 1754, Beyerlé had reorganized the small *faïence* factory located on the grounds and begun production of elegant tablewares in competition with the well-known factory founded earlier by Paul Hannong at Strasbourg. The immediate success of Beyerlé's concern was assured by the presence of talented painters lured away from the Strasbourg factory and in particular François-Antoine Anstett, who acted as artistic director of the Niderviller factory from 1757 until 1778.

From the beginning, the Niderviller factory employed the revolutionary *petit feu* technique. Unlike traditional or *grand feu* decoration, where the enamel colors are applied to the raw glaze, the *petit feu* technique consists of the application of enamel colors to the ceramic body after the glaze firing, so that the colors remained on the glassy, impermeable glaze surface. The lower kiln temperature required for *petit feu* decorations allowed for a wider and brighter color palette, apparent here in the bright green, blue, purple, and *pourpre de Cassius* (named after the seventeenth-century Dutch chemist who discovered this pink-purple). Inspired by the Strasbourg factory, the Niderviller artists rapidly developed a distinctive style of modeling and decoration, exemplified by the lively Rococo form and brilliant painting of this tureen.

TA

Portrait of a Gentleman

Ca. 1745–1760
Anton Raphael Mengs (1728–1779)
Germany
Oil on canvas
39 x 30 ½ inches
Museum purchase with funds provided by
 Motion Industries; Sterne, Agee & Leach,
 Inc.; Camp & Co.; CLP Corporation;
 Engel Realty Company; AMI Brookwood;
 Bradley, Arant, Rose & White; Automatic
 Detection Systems; Kidd, Plosser, Sprague
 Architects; Patrick Media Group, Inc.; and
 Altec Industries, Inc.
1988.44

In this portrait, possibly of Francois, Baron de Halleberg, Mengs depicts his subject as a handsome middle-aged man standing before a desk looking confidently to his right. The medals of distinction as well as his rich clothing allude to a man of position and wealth, yet the elegant and simple presentation of the figure is in keeping with Mengs's classicizing spirit. Here Mengs presents us with an ideal image of a man conscious of his power but at the same time pleasant, human, and friendly.

The royal blue velvet coat with ermine fur cuffs and shawl collar indicate a man of high status; ermine could be worn only by members of the nobility. The gentleman also wears two medals—a cross signifying his position as a Knight of Malta and another medal, possibly the Order of St. Lazarre. In eighteenth-century portraits of aristocrats, many artists painted their subjects with incidental medals, which not only served as attributes of honor but also helped to identify social status. The book signifies the man's high level of learning, and the dress sword peeking out from the jacket symbolizes his bravery and fighting spirit.

By combining a frontal pose with a low viewpoint, Mengs raises the gentleman above the spectator, thus affording the man greater monumentality and power. In addition, the positioning Mengs favored of the Greco-Roman portrait tradition, seen here in the standing three-quarter-length figure, afforded a restrained, solemn design intended to convey the moral dignity of the sitter. To Neoclassicists such as Mengs, the art and history of the classical world offered models to be used as guides for human behavior and achievement.

Mengs was especially adept in the accurate depiction of skin tones. Here, the man's face and hands are healthy and glowing with life. He achieved this effect by carefully building up layers of pinkish-yellow pigment. He then complemented these modulations by deriving the colors of the rest of the painting from these pigments so as to achieve a more unified color scheme.

Although he spent most of his life in Italy and Spain, Mengs was the most famous German artist of the eighteenth century and one of the three best-known Neoclassical theorists of his age. In 1741, at the age of thirteen, Mengs traveled to Italy with his artist father to study the works of Raphael. He returned to Dresden in 1744, where for two years he concentrated on painting portraits. Between 1758 and 1760, Mengs lived in Rome and painted portraits of the British nobility. It is from one of these two periods of portrait painting that this work is thought to date. In 1760, after living for many years in Italy, Mengs was appointed court painter to Charles III of Spain. From then on, he spent his life between Spain and Italy.

SBH

The Four Quarters of the Globe

Ca. 1765–1775
Derby factory
England
11 ¾, 12, 12 ½, and 11 ½ inches
Soft-paste porcelain
Promised gift of Mrs. Susan Hulsey

A pottery at the site of the Derby porcelain factory began functioning between 1751 and 1753, with Derby being founded there in 1756 by painter and enameler William Duesbury; John Heath, a banker and owner of the Cockpit Hill factory; and porcelain maker André Planché. The factory specialized in figures, allying itself with Meissen in Dresden and even describing their wares as "New Dresden." There was no regular Derby factory mark until 1773, when the "D" and anchor mark came into use to avoid confusion with the buy-out of the rival factory of Chelsea by Derby in 1771.

The porcelain figures of the four continents or four quarters of the globe represent Europe, Asia, Africa, and America (Australia was not largely found on maps at this time). Highlighting the interest of the day in the arts and sciences and world exploration, the figures are dressed in appropriate costumes from each continent and accompanied by a symbolic animal. The Chelsea factory was the first to make the figures in England in pairs on two candlesticks (during the red anchor period of ca. 1753–1757), these being after original Meissen models by Friedrich Elias Meyer. Chelsea also made the continents during the gold anchor period ca. 1760. Derby created the largest of the English continent figures by the use of a substantial and thick composition for its ceramic formula beginning in the 1760s. Looking like large cherub-faced children, the Birmingham Museum's figures were produced at Derby between 1765 and 1775, but they are familiar to most in the later Chelsea-Derby versions in various sizes. The Bow factory (ca. 1770) and Longton Hall factory

(in 1759–1760) produced the continents as adult figures in soft-paste porcelain, and after 1768 the Plymouth and Bristol factories offered the figures in hard-paste porcelain. Bow also made miniature continents.

Three of these figures—Africa, America, and Europe—are Derby-made ca. 1765–1775 with the characteristic patch marks (3) on the bottom, a small firing hole of about one-third inch in diameter, and sizable firing cracks across the bottom. The patch marks, used at Derby until 1811, resulted from the use of balls of clay for support during firing. The figures were slip cast. The three were perhaps decorated at Chelsea; thus the attribution is sometimes seen as Chelsea-Derby in other publications.

The figure of Asia has an unknown mark, a large firing hole of about one inch with a glazed interior, only a hairline brown crack on the bottom, and no patch marks. It is very heavy in weight in comparison to the other three. Although similiar in style, the exterior of the base is totally enameled in green, and the glaze throughout the piece is crackled. There is no crackling on the other figures.

A design source for the figures (see p. 121) is found the book *Iconogia*, in which a page devoted to each figure includes the accompanying implements as found on the Derby porcelain figures.[1]

EBA

1. Cesare Ripa, *Iconogia* (Rome, 1603), 333, 335–38.

121

Drop-front desk (secrétaire à abattant)

Ca. 1760
Stamped twice RVLC for Roger Vandercruse
(1728–1799, master 1749–1799)
France (Paris)
Oak and pine veneered with tulipwood, amaranth,
and *bois satiné*; gilt bronze; and *brèche d'Alep*
marble
54 7/8 x 33 3/16 x 12 1/8 inches
Eugenia Woodward Hitt Collection
1991.182

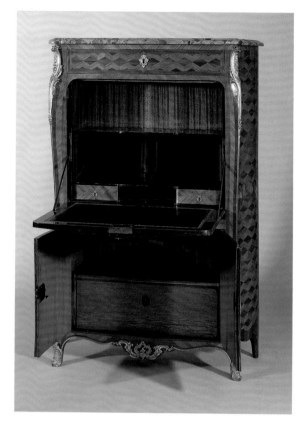

The name *secrétaire* for an enclosed desk is derived from the Latin word *secretum*, meaning secret or hidden place. The drop-front, or *abattant*, falls forward to form the writing table and to reveal small drawers and pigeonholes for storing papers. The right drawer of this desk originally housed small metal pots for ink, sand, and quill pens. In the cupboard below is an oak strongbox, securely locked with a second, iron key. Concealed in the frieze above the flap is a shallow locked drawer. Cabinetmakers ingeniously built such secret compartments into the design of their *secrétaires* to make them as secret as their name implies.

The *secrétaire à abattant* was one of numerous innovative desk forms made fashionable in mid-eighteenth-century France. Unlike roll-top desks or large writing tables (*bureaux plats*) placed at the center of the room, *secrétaires* stood against the wall and were veneered on only three sides. They occupied little space and consequently were better suited to the smaller rooms of the newly constructed Paris residences.

This *secrétaire* dates to the period of transition between the Rococo and Neoclassical styles, ca. 1755–1775. Designers and craftsmen at this time cautiously moderated the whimsical animation of the Rococo by introducing elements of the nascent Neoclassical style. The cabinetmaker Roger Vandercruse here mixed the serpentine contours and foliated gilt bronze mounts of the Rococo with the cube pattern veneer typical of the restrained Neoclassical taste. A master in the furniture-makers's guild from 1749, Roger Vandercruse worked almost exclusively in the Transitional Style, producing a homogenous oeuvre of great elegance and invention.

TA

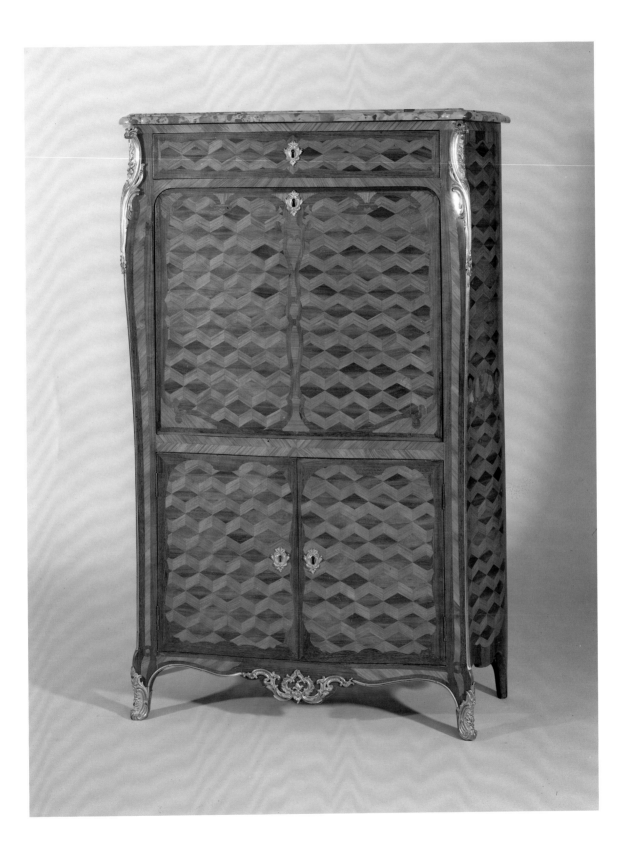

124

The Children of the Marquis de Béthune

Signed and dated, lower right corner:
 "Drouais le fils/1761"
François-Hubert Drouais (1727–1775)
France (Paris)
Oil on canvas
38 ¼ x 51 ¼ inches
Eugenia Woodward Hitt Collection
1991.254

This portrait belongs to a fashionable type of eighteenth-century portrait where the sitter, in a guise of romantic anonymity, is depicted in fancy dress. The children have been identified as Armand-Louis (b. 1756) and Armand-Louis-Jean (b. 1757), the sons of Armand-Louis, marquis de Béthune, and his second wife, Marie-Thérèse Crozat. The brothers here masquerade as Spanish peasants. They wear sumptuous velvet costumes tied with silk ribbons and elaborately trimmed with silver and gold braids. These suits, having slashed sleeves and ruffled collars, are luxurious interpretations of eighteenth-century Spanish dress. The guitar, a traditional Spanish instrument, serves as a costume prop.

The sons of the marquis de Béthune play in a wild landscape, bounded by a rough wood fence at left, a rock ledge above their heads, and a wooden orange tub planted with a rosebush at right. The rocky setting is as romanticized as the boys' impossibly rich costumes. Drouais here expressed the startlingly new, sympathetic attitude toward children in the eighteenth century. In an idealized vision of childhood, these small boys with rouged cheeks and powdered hair play contentedly in the outdoors and teach a beribonned pug to play the guitar. Drouais extolled the pleasures of childhood rather than depicting the heirs to a noble title in the formal poses of official portraiture.

Such attractive portraits of children assured François-Hubert Drouais's immense popularity during his lifetime. With a keen awareness of fashion and novelty, he depicted the progeny of grand families as Savoyards, Spaniards, grape gatherers, gardeners, montagnards, and in many other disguises. Realistic observation easily ceded to charm in the face of such delightful possibilities.

TA

Erasistratus the Physician Discovers the Love of Antiochus for Stratonice

1772
Benjamin West (1738–1820)
America
Oil on canvas
49 ½ x 72 inches
Museum purchase with funds provided by Mr. and
 Mrs. Houston Blount; Mr. and Mrs. Michael
 Bodnar; John Bohorfoush; Mr. and Mrs. Percy
 W. Brower, Jr.; Mr. and Mrs. Thomas N.
 Carruthers, Jr.; Catherine Collins; Mr. and Mrs.
 Henry A. Goodrich; Mr. and Mrs. Hugh Kaul;
 Harold and Regina Simon Fund; Mr. and Mrs.
 William M. Spencer III; Mr. and Mrs. Lee
 Styslinger; and other donors
1987.4

Benjamin West arrived in Rome as a young art student in 1760, just as the Neoclassical tide was beginning to rise. Excavations of Pompeii and Herculaneum had only just revealed new wonders of antique art, exciting scholars, artists, and a legion of amateurs. Led by critics such as the German Johann Winckelmann, a contemporary aesthetic developed in emulation of the classical ideal: Human anatomy would conform to proportional norms; facial features would be improved by smoothing over nature's imperfections; and the literature and philosophy of Greece and Rome would supply the subjects of art, scenes acted out by players robed in the garments of antiquity. It was an aesthetic whose figural and structural idealism led to a perfection of ethical ideas—the high moral order of the ancient world.

After studying in Rome for three years, West relocated to London, where in 1772, he won the favor of George III and was appointed history painter to the king, becoming the first American painter to achieve an international reputation. *Erasistratus the Physician Discovers the Love of Antiochus for Stratonice* depicts a celebrated scene from an ancient legend loosely based on Greek history in which Antiochus, the son of the Hellenistic king of Syria, has succumbed to a mysterious illness. Summoned by the king, the eminent Greek doctor Erasistratus observes the behavior of Antiochus and cleverly concludes the source of his ailment to be unrequited love. To determine the woman's identity, Erasistratus orders a parade of all court beauties in front of the invalid while he holds his patient's pulse, feeling for the revelations of his heart. One lady follows another until Stratonice, the second wife of the King, comes before them; Antiochus, the doctor discovers, pines for his own stepmother—the revelatory moment depicted in West's painting.

In the end, Erasistratus would reveal the situation to the King, who ultimately gives his wife to his beloved son, so the tale goes, saving the prince's life. The story could have been interpreted as an allegory for England's troubles with its thirteen American colonies: an advocacy for monarchial sacrifice for the good of the familial empire.

KS/DA/JW

Portrait of Sir George Chad and *Portrait of Lady Chad*

1775
Thomas Gainsborough (1727–1788)
England
Oil on canvas
Each: 29 ¼ x 24 ½ inches
Gift of Eugenia Woodward Hitt
1968.19 and 1968.20

A superb landscape painter in his own time, Thomas Gainsborough was best known for his elegant portraits of the English upper classes. He immortalized the aristocracy with dashing flair but without undue flattery, depicting them with a unique blend of formality and casual ease. So in these companion portraits, George Chad affably leans against a rock exuding an air of confidence and good breeding, a perfect complement to Lady Chad's nonchalance and aristocratic distinction. The portraits were probably painted on the occasion of their marriage in 1775.

Rather than trumpet revelations of his subjects' characters or their innermost thoughts, Gainsborough emphasized his own fluent brush technique, capturing a subtle array of flesh tones as well as the flash of luminous satin and the sober texture of Lord Chad's coat. Gainsborough's loose, confident brush stroke is especially evident in the shimmering accents on the delicate fabric of Lady Chad's dress and the glittering touches of gold in her hair, dress, and sash. It is an elegance of social stature and mannered repose, glossing over the traits that might set his subjects apart in an effort to establish them in the exclusive company of Georgian society.

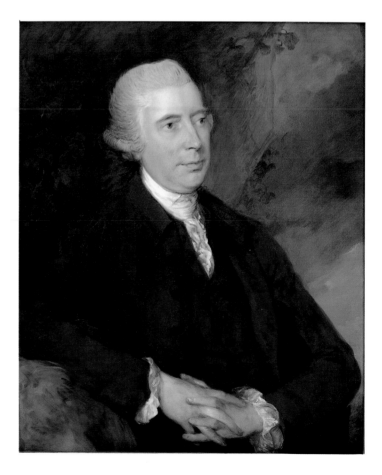

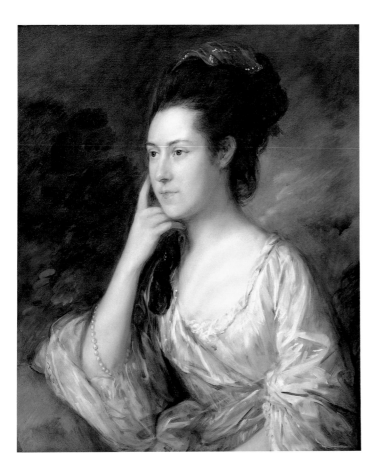

The natural setting in which both sitters appear reflects the popular appeal of nature at the time. The abrupt crag behind Lord Chad and the dark foliage and windswept clouds framing Lady Chad also reflect Gainsborough's first love, landscape painting. Unfortunately for him, at this time in England there was little demand for that genre; so in spite of his immense popularity as a portrait painter, there remained many unsold landscapes in his studio at the time of his death.

Gainsborough never used assistants to finish his paintings (a common practice among the prominent painters of his day), considering his own technique integral to the work. The background, especially, had to be his. Here, luxuriant screens of windblown foliage and rocky crags touched by gentle, subdued rays of light express idyllic moods that could only spring from Gainsborough's fertile imagination.

DA/JW

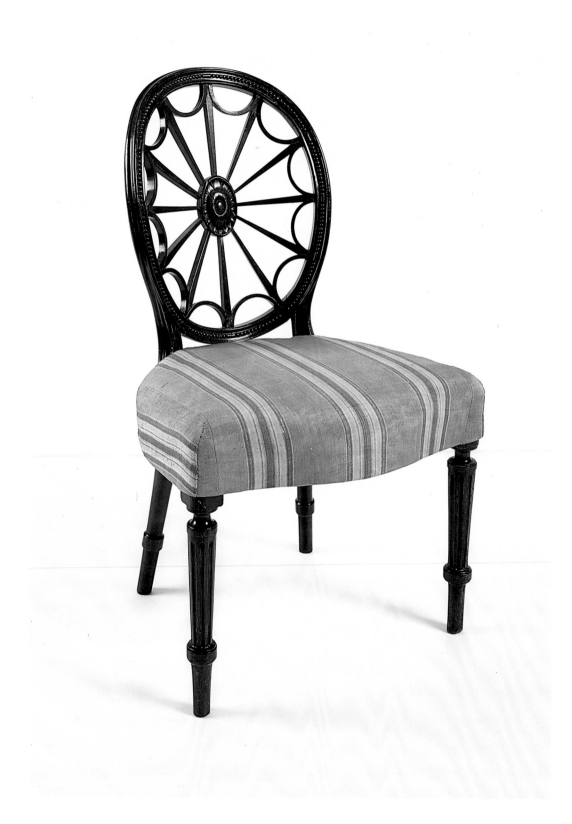

Chair

Ca. 1771
Attributed to Thomas Chippendale (1718–1779)
England
Mahogany and beech
37 x 22 ½ x 19 ½ inches
Museum purchase with funds provided by the
 Decorative Arts Guild in memory of Robert D.
 Horne
1989.1

This chair, with its pierced wheel back and straight legs, represents the furniture produced during the Neoclassical period of the late eighteenth century. The flamboyancy of the Rococo in the mid-eighteenth century gave way in the later eighteenth century to balanced, symmetrical compositions with fine details such as paterae, beading, and fluting. Although the work of Thomas Chippendale is most often associated with his Rococo, Chinese, and Gothic designs as illustrated in *The Gentleman & Cabinet Maker's Director* (1754), more furniture has been attributed to him from his post-Director Neoclassical phase than from previous decades. Sound attributions have been made by comparing existing furniture located in the great houses of England and listed in surviving estate records and bills of sale from Chippendale, further confirmed by constructional and stylistic comparisons made to known commissions.

Such a comparison and attribution were made with this chair in the Birmingham Museum of Art collection to a similar set of two armchairs and six single chairs in the entrance hall of William Weddell's Newby House in North Yorkshire, England. Weddell also made extensive alternations at Newby under the direction of Robert Adam between ca. 1772 and 1776. The estate records with bills of sale for Newby House have been lost, but an inventory was taken at Weddell's death in 1792. This inventory reveals that "Mr Thos. Chippendale an upholsterer who had supplied the Furniture in Newby Hall, . . . made out at the desire of the Steward an Inventory and Valuation of the Furniture." The document also refers to "an Affidavit sworn by Thomas Chippendale . . . that he hath known and been acquainted with the said Mansion house called Newby Hall for several years . . . and that the said Thomas Chippendale was the better enabled to depose with regard to the value of such Furniture as he supplied William Weddell with a considerable part thereof."[1]

This chair compares favorably with stylistic and structural aspects of the chairs at Newby dated ca. 1771. First, the oval-shaped, wheeled back is identical, with the exception of the beading around the rail. This beading, however, is seen on other documented Chippendale pieces. Also identical is the size and contour of the D-shaped seat; however, the Newby chairs being hall chairs have a wooden seat with finished rails and the museum's chair has over-the-rail upholstery, a normal practice for dining room or parlor chairs. The legs again are the same with the exception of fluting on the front legs of the museum's chair versus plain legs on the Newby chair. Fluted legs are also documented on other Chippendale chairs.

A construction feature on the chair seat rail further strengthens the Chippendale attribution. On the inner side of the back and sides of the chair seat rail are four V-shaped notches, cramping slots and batten holes, found on both the museum and Newby chairs. On documented Chippendale chairs at various houses including Newby and Burton Constable, these same notches, which accommodated the glue cramps when the seat rails were assembled, appear. [2]

EBA

1. Christopher Gilbert, *The Life and Work of Thomas Chippendale* (London: Studio Vista, Christie's, 1978), 265.
 2. Ibid., 113.

Pair of armchairs (fauteuils à la reine)

Ca. 1780–1785
Stamped by Georges Jacob
 (1739–1814, master 1765–1814)
France (Paris)
Painted beech, modern upholstery in an
 18th-century style
37 3/8 x 26 7/8 x 27 9/16 inches
Eugenia Woodward Hitt Collection
1991.191.1 and 1991.191.2

Each armchair bears the stamp of Georges Jacob, the foremost *menuisier* (joiner) in France during the reign of Louis XVI (1774–1793). Jacob surpassed his contemporaries both in his technical mastery and his innovative interpretations of the Neoclassical style. Between 1765, when he became a master in the furniture-makers's guild, and 1796, when he deeded his workshop to his sons, Jacob turned out a prodigious number of chairs in a range of styles and woods. Commissions from Marie Antoinette and other members of the French royal family constituted a significant portion of this immense production in the decade before the outbreak of the Revolution.

Typical of his Neoclassical seat furniture of this period, these armchairs adopt simple geometric profiles through straight columnar legs and rectilinear back supports and seats. The carved decoration, such as the leaf moldings, *piastres*, acanthus, and beading, derives from ancient architecture. By 1780, around which time Jacob designed these armchairs, the Neoclassical style had wholly supplanted the Rococo, where naturalistic motifs and curvilinear forms combined in whimsically animated inventions. By contrast, these Neoclassical armchairs find a quiet dignity in their harmonious proportions, symmetry, and refined ornament.

Small paper labels glued on the rear seat rail of each chair bear the handwritten inscription *Chambre à coucher* (bedchamber). Jacob often used such paper labels to avoid confusion in his workshop by identifying pieces from specific commissions and their patrons. The labels on the Birmingham Museum chairs indicate only the location for which they had been ordered. The chairs, in turn, offer much information about the decor of that bedroom. The original grey-green painted finish preserves the cool color harmonies of the decoration, whereas the elegant carving and symmetry of the wood frames speak to a refined and restrained Neoclassical aesthetic at its apogee in pre-Revolutionary France.

TA

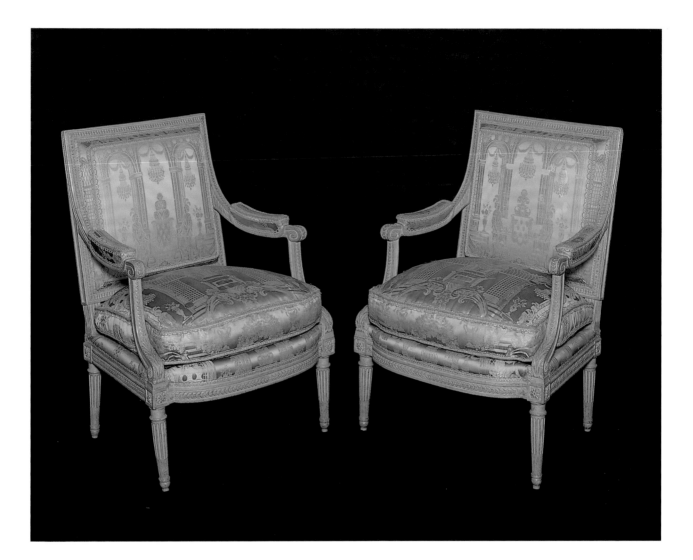

Mantel clock

Ca. 1785
Movement: Swiss, ca. 1800
France (Paris and Sèvres)
Soft-paste porcelain with colored enamel decoration
 in imitation of jewels, gilt bronze, rock crystal,
 and enameled metal
10 $^{15}/_{16}$ x 6 x 4 $^{7}/_{16}$ inches
Eugenia Woodward Hitt Collection
1991.45

This mantel clock is set with six Sèvres porcelain plaques, each decorated with brightly colored enamels in imitation of jewels. The embellishment involved the application of drops of colored enamel, backed by shaped gold foils, onto the porcelain surface before the final firing. Extremely fragile, jewel enameling enjoyed only short-lived popularity at Sèvres during the early 1780s and virtually disappeared from factory records after 1786.

The porcelain plaques were cut to fit the gilt bronze frame resembling a miniature temple. Inspired by Neoclassical architecture, the case is flanked by rock crystal columns with gilt bronze capitals and surmounted by urn finials. Sèvres factory archives mention *plaques de pendule* (clock plaques) in 1773 and 1789 only, though a number of porcelain-mounted clocks survive from the 1760s through the 1790s. Of this group, this clock case is unique in its design and use of rock crystal.

The present movement and blue-enameled dial are probably Swiss replacements of around 1800. An indication of what they were originally is given by another clock, set with identical jeweled Sèvres plaques, in the Victoria and Albert Museum in London.[1] That clock retains its late-eighteenth-century works and porcelain dial decorated with jewel enameling and three gold fleurs-de-lis, the symbol of the royal house of France. The movement bears the signature of the innovative Parisian clockmaker, Robert Robin (1742–1799). Traces of Robin's signature appear on front of the Birmingham Museum clock in the oval reserve below the dial. The complete inscription, visible under raking light, includes the title *Horloger du Roi* (Clockmaker to the King), which he held from 1784. Robin's signature was erased when the movement he provided, and also inscribed, was replaced around 1800.

Tradition in the family through which the clock descended maintains that it was made for Queen Marie Antoinette. Though this provenance is unsubstantiated, the Robin movement and porcelain dial were undoubtedly replaced during or shortly after the French Revolution, when royal references were systematically purged from works of art. Robin's signature on the movement and the fleurs-de-lis on the dial explain the replacement of both elements. A number of porcelain-mounted clocks appear in the inventory of Marie Antoinette's apartments written in the 1793, though none of the descriptions correspond to this unique clock. Nonetheless, its virtuosic execution and precious materials, especially the jeweled porcelain and rock crystal, epitomize the exquisite refinement and extravagance of French court taste in the final years of the monarchy.

TA

1. *Pendule de voyage* (traveling clock). Gilt bronze, Sèvres porcelain plaques decorated with jewel enameling. Signed *Robin Hor du Roy*. 9" high. Jones Collection, Victoria and Albert Museum, London, 1001–1882.

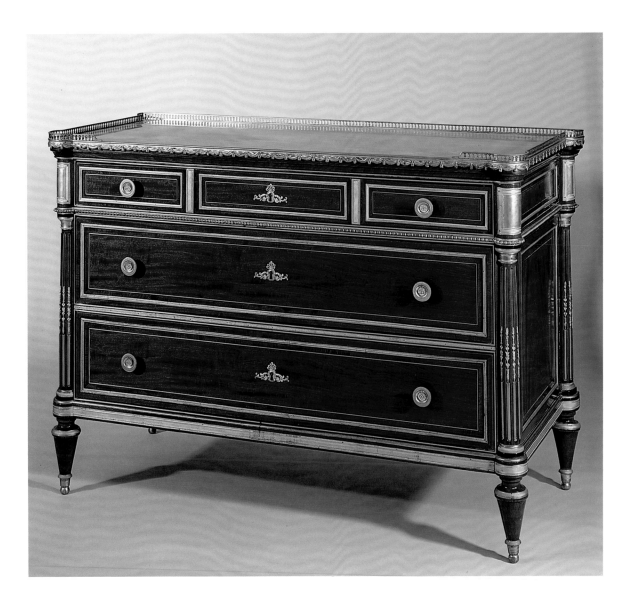

Chest of drawers (commode)

Ca. 1785–1790
Stamped by Guillaume Benneman
 (master 1785; d. 1811)
France (Paris)
Oak and mahogany with ebony and brass stringing,
 gilt bronze, and Saint Anne marble
36 9/16 x 53 1/4 x 23 1/8 inches
Eugenia Woodward Hitt Collection
1991.192

On back of this *commode* is the partly abraded stamp of the German-born cabinetmaker Guillaume Benneman. Benneman established a workshop in Paris some time before 1784, when he received his first commission from the French court. The crown's selection of the then-unknown craftsman Benneman is explained by the reforms sweeping through the *Garde Meuble de la Couronne*, the department responsible for the provision of furniture for the royal palaces. From 1784 the *Garde Meuble* made serious attempts to curtail the court's excessive expenditures on luxury furnishings and, to this end, promoted a more austere classicism in design and decoration. For reasons of economy, the superintendent of the *Garde Meuble* selected Benneman to replace as Cabinetmaker to the King Jean-Henri Riesener, whose extravagant case furniture had largely prompted these reforms. This *commode* bears no inventory or château marks to indicate royal provenance, though it epitomizes the more sober classicism of the later eighteenth-century court style.

For all its apparent simplicity, this *commode* was still an expensive commission. Narrow filets of ebony and brass and plain gilt bronze moldings outline the drawers, frieze, and side panels. The severely architectonic form is flanked at all four corners by detached columns inset with gilt bronze flutes. The decoration throughout is purposely restrained in order to highlight the broad planes of mahogany veneer.

French craftsmen had begun significant production of mahogany furniture ca. 1760, when ample quantities of the exotic wood became available in Paris. Mahogany was imported into France from Central and South America, Africa, Haiti, Cuba, and Santo Domingo during the eighteenth century. Cabinetmakers exploited the natural beauty and vivid color of mahogany by applying smooth planes of the wood to uncomplicated architectonic forms. Mahogany furniture demanded little surface embellishment and therefore complied readily with the more austere Neoclassical aesthetic of the 1780s.

TA

Sacrifice to Minerva

1788
Joseph-Marie Vien (1716–1809)
France
Oil on canvas
43 x 50 ¾ inches
Museum purchase with funds provided by the
 1989 Museum Dinner and Ball and the J. A.
 Vann Charitable Trust in memory of James
 Allen Vann III
1991.718

In *Sacrifice to Minerva* a mother lovingly guides her children through the sacred ritual of offering flowers at the altar of "Holy Athena." (Despite the altar's inscription, Vien's catalogue entry in the Salon of 1789 identifies the deity as Minerva, Athena's Roman counterpart, Goddess of Wisdom and also the Goddess of Reason, Good Sense, and the Liberal Arts).[1] Joseph-Marie Vien derived his theme from the teachings of Jean-Jacques Rousseau, the great philosopher of the Enlightenment and champion of the power of human reason to cure all of society's ills. Rousseau's writings especially promoted the societal importance of the family unit—particularly the family's importance in handing down tradition and rituals from one generation to the next.

Vien placed his figures across a shallow foreground primarily in profile, emphasizing their clearly delineated outlines, an arrangement strongly reminiscent of a Greek frieze. Purely rational, simplified forms; balanced composition; tranquil facial expressions; subdued colors; and smoothly applied paint all stem from Neoclassicism, an aesthetic movement that Vien helped to found. Ideologically, Neoclassicism stood on the precepts of Republican Rome, drawing its visual models from Greek Classic sculpture.

Neoclassicism developed at a time when people had tired of the florid Rococo painting style then in vogue (along with the frivolous, hedonistic life-style it represented). This new approach came out of the discoveries in 1709 of Herculaneum and in 1748 of Pompeii, ancient Roman cities that had been buried by the catastrophic eruption of Mt. Vesuvius in A.D. 79. Artifacts found there recalled qualities associated with the classical world: idealism, clarity, balance, and moral authority. The new ideology engendered a change in the technical approach to painting, shifting emphasis from the sensuous application of color to careful drawing.

Known as "Father of the Antique Style," Vien taught the new classicism to an idealistic group of young French artists, among them Jacques-Louis David, who became the leading exponent of Revolutionary and Napoleonic painting. When Vien exhibited *Sacrifice to Minerva* in the Salon of 1789, only a month had passed since the fall of the Bastille. In this context, his ideas of continuity and tradition, symbolized by the simple rite honoring the Goddess of Wisdom, may have become an appeal for restraint and reason during this time when escalating rumor, tension, and violence would culminate in the chaos of the French Revolution. During Robespierre's bloody Reign of Terror that followed, the life of those with ties to the royal family lay in peril. Vien, because of his pre-Revolutionary appointment as *Premier Peintre du Roi*, would have been standing in the shadow of the guillotine but for his former student David and for his well-known Republican sympathies. His name instead appeared among those artists adopted by the Revolutionary government. After the rise of Napoleon, Vien was appointed to the Legion of Honor, and at his death he was interred in the Panthéon, the final resting place of France's most illustrious citizens.

DA/JW

1. The preparatory ink and wash study for this painting, also shown in the Salon of 1789, is currently in a private collection in Berlin.

139

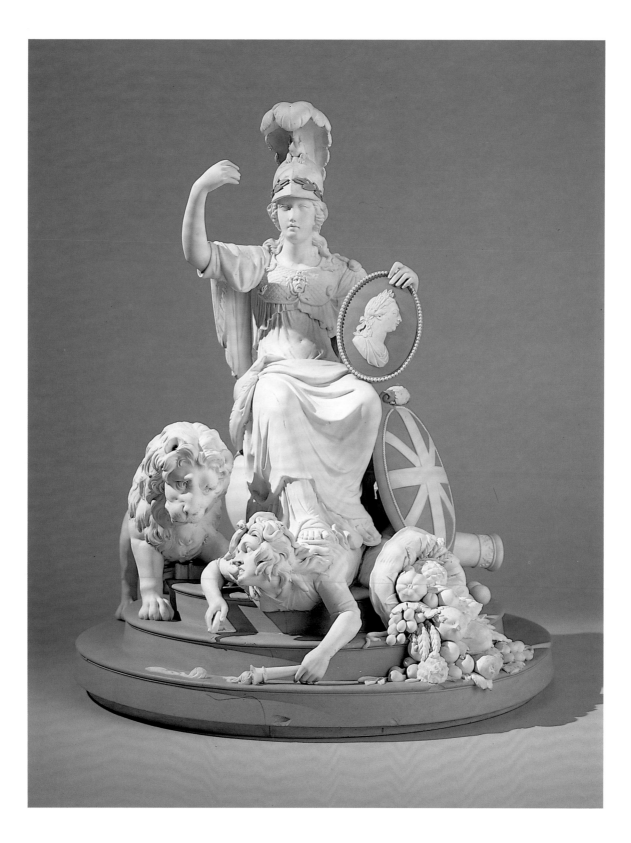

Britannia Triumphant

1798–1809
Wedgwood factory
England
Jasper, solid blue ground with blue wash; solid white
ground with white wash and green relief; and
thirteen firing holes
13 x 11 $^{7}/_{16}$ inches
Gift of Lucille Stewart Beeson
1990.1

Britannia Triumphant was undoubtedly produced to commemorate British naval victories over France between 1798 and 1809. The seated figure holds a portrait medallion of George III in her left hand and originally held a trident in her right hand. At her feet and closely watched by the lion lies a fallen female figure, representing France, carrying a torch. A shield ornamented with the British flag, a cannon and balls, a ship's prow, and an overturned cornucopia surround Britannia as symbols of strength and victory.

The modeler of the sculpture is to date unknown, although Henry Webber, William Theed, John Flaxman, Jr., and William Hackwood have been considered in the past. The modeler most likely copied the life-size statue of Britannia by John Bacon, Sr. (1740–1799), on the tomb of the Earl of Chatham in Westminster Abbey.

Britannia was pictured in a hand-colored aquatint by Thomas Hosmer Shepherd (1793–1864) in the center of the Wedgwood factory's London showroom at York Street in the February 1809 edition of Rudolph Ackermann's *Repository of the Arts*. There she is seen supported by a barrel base under a domed temple. In the mold storage room at the Wedgwood Museum in Barlaston, England, exist molds for this temple, marked "Theed's temple," referring to William Theed (1764–1817) who was a modeler for Wedgwood from 1798 until 1804, when he left to design for the London silversmiths Rundell, Bridge &

Rundell. A wooden simulation of the temple now surrounds the figure at the Birmingham Museum.

While only one Britannia figure is known today, two barrel bases made to accommodate this figure exist at the Wedgwood Museum. The bases were scored to simulate brick and then ornamented with portrait medallions of the four great admirals: Admiral Viscount Horatio Nelson (1758–1805), Admiral Viscount Adam Duncan (1731–1804), Admiral Richard Howe (1726–1799), and Admiral John Jervis St. Vincent (1735–1823). The four medallions were very likely modeled for this base, as the first was invoiced on November 9, 1798, and the remaining three on December 24, 1798, (Receipt I–23) by John De Vaere.[1] These medallions are set in pairs between applied arched niches around the midsection of the barrel.

EBA

1. I am grateful to the Trustees of the Wedgwood Museum at Barlaston, Stoke-on-Trent, England, for permission to use this information.

The Wheel of Existence (Bhavachakra)

Late 18th or early 19th century
Tibet
Appliqué and embroidery on silk
111 ¹/₂ x 80 inches
Gift of Mr. Joseph Rondina
1979.350

This is one of the largest and most impressive examples of a type of artwork that is both technically and iconographically very characteristic of Tibetan culture. It depicts what is generally known as the wheel of existence. These *thang-kas* are prominently displayed in Tibetan temples and monasteries to remind the viewer of the transience of life, the bondage that results from continuous rebirth, and the necessity to strive harder to be finally liberated.

A giant monster representing Yama, or gShin-rJe, the Lord of Death, firmly clasps the wheel of existence as he stretches from the sky to the earth. The blue sky is symbolized by a solar disc and a triad, including Buddha Sakyamuni, floating in cloud vignettes. The earth is a sketchy landscape with rocks, water, trees, animals, precious offerings, and a meditating monk. The hub of the wheel, which stands for the endless cycle of rebirth, includes a snake, a pig, and a pigeon, signifying the three basic causes of rebirth: aversion, delusion, and greed, respectively. Each of the conical segments of the circle depicts in considerable detail stereotypical representations of the six realms of existence. These are (clockwise from the top): gods, *asuras* or titans, *pretas* or ghosts, occupants of hell, animals, and humans. Along the rim are scenes denoting the twelve interdependent causes of rebirth.

Chandra Reedy has translated the cartouche below the solar disc in the sky:

> Make a beginning and renounce the world.
> Enter into the path of the enlightened ones.
> As a great elephant would crush a reed hut,
> destroy the armies of death.

Characteristic of Tibetan paintings of this period, the colors are bright and vibrant. The workmanship is so fine that the hanging, mounted in a richly colored Chinese brocade, looks like a painting. These expressive paintings reveal the Tibetan artists' inventive flair, for nothing similar is known in China. While the exact provenance of this piece cannot be determined, it was probably created in an eastern Tibetan monastery.

PP

Centerpiece

1810–1811
Paul Storr (1771–1844)
England (London)
Silver; mark: date letter P
Width at base: 18 x 14 inches
Gift of Mr. and Mrs. Bernard A. Monaghan
1986.17

Among the great English goldsmiths of the eighteenth and early nineteenth centuries, Paul Storr's name is recognized as probably London's most prominent and successful. He was born in London, the son of Thomas Storr, a silver chaser, whose work consisted primarily of ornamentation using a hammer and a punch. This component of the silversmithing profession involved an understanding of modeling and included chasing, embossing, and repoussé work on sheet metal. Undoubtedly influenced by his father, by 1785 Paul Storr was apprenticed as a plate worker in Soho working in gold, silver, and sheet metal. Thus began Storr's life, which illustrates the change in status brought about by the industrialization of the silver trade and a singularly skilled man's rise to a captain in the industry.

After his apprenticeship Storr entered his first of eleven marks at the Worshipful Company of Goldsmiths in London in 1793. In 1796 he started his own company, but soon embarked on a series of partnerships that culminated in 1807 with an association with Philip Rundell, a jeweler and dealer in silver. Already a successful businessman, Rundell and his partners, John Bridge, Edmund Waller Rundell, William Theed, and now Paul Storr, were appointed jeweler and goldsmith to the crown. The partnership offered Storr many commissions, as Rundell through Bridge had entrée to the royal family and the great aristocratic houses of wealth in England. Yet throughout the partnership, Storr maintained the use of his own mark on the silver made under his direction. To his chagrin, because of the success of the

partnership, he became more of a supervisor of mass production. So in 1820 he left the partnership and engaged in business with several other silversmiths until he retired in 1838.

Storr's work ranges from the simplest teaspoons and cruet frames to the most elaborate centerpieces and chandeliers. Up until 1800 his pieces show restrained taste and average execution, although in 1797 a foreshadowing of his mastery was produced in a remarkable gold font for the Duke of Portland, now in the collection of the British Museum. Paul Storr's reputation as a master silversmith rests on his grand presentation pieces of the English Regency style of exotic Roman, Greek, and Egyptian ornamentation (1811–1820). During this period of economic stability, silver such as this centerpiece celebrated England's dominance of world affairs. The centerpiece was used to decorate the center of a formal dining table, which came into use in the late eighteenth century as a permanent fixture of a dining room as opposed to smaller folding tables set up by footmen in the mid-eighteenth century. This example is topped with a filigree basket, which originally held a glass bowl for the display of fruit or flowers. Storr's inspiration came directly from classical Roman sculpture, seen particularly in the three caryatids and thyrsus (a wand or sceptre of Bacchus and his votaries surmonted by a pinecone) all of which is supported by shells, dolphins, and swags of fruit on a triform base. The arms of the Earl of Coventry appear on the three sides of the base, presumably made for the eighth earl, George William (1784–1843), upon his second marriage in 1811. The Latin motto *candide et constantes* reads "upright and constant."[1]

EBA

1. N. M. Penzer, Paul Storr (London: Batsford Ltd., 1954).

Liberty Giving Sustenance to the Eagle

Ca. 1810
Attributed to Margaretta Ray Smith Locke
 (1800–1884)
School of Samuel Folwell (ca. 1765/68–1813),
 Philadelphia, Pennsylvania
After an engraving (1796) by Edward Savage
 (America, 1761–1817)
America
Silk, chenille, metallic thread, and oil on silk
25 x 16 inches
Gift of Mr. and Mrs. E. Mabry Rogers and Mr.
 and Mrs. J. Robert Fleenor, in honor of Hugh
 Allen Locke, Sr., father of Mrs. Margaret Locke
 Fleenor
1984.43

This silk embroidered picture of Liberty is based on Edward Savage's engraving of the same subject after his own life-size painting of 1793, exhibited in 1802 in New York (and subsequently lost). The engraving, published June 11, 1796, in Philadelphia, was widely distributed and copied in various media including watercolor on paper, oil on velvet, oil on canvas, and reverse painting on glass. As in other interpretations of Savage's engraving, the offscape of Boston Harbor in this work has been changed by the artist or needleworker. The background fabric of the picture is silk throughout, and it is embroidered with silk and metallic threads in various stitches. The sky, offscape, and visible parts of the body including the hair were also painted in oil for precision.

The drawing of this needlework picture is attributed to the artist Samuel Folwell, who worked at a Folwell school for girls run by his wife, Ann Elizabeth (1770–1824). He was known for his proficiency in engraving; painted profiles; miniatures, including memorial compostitions on ivory; and painting on silk; and he taught drawing to the young ladies attending the school. Folwell sketched the design of Liberty on this silk sometime between 1805 and 1813.[1] It was then embroidered by Margaretta Ray Smith while she

was attending the Folwell school in Philadelphia. Margaretta Ray Smith later married Robert Locke and before 1836 moved to Fayette County, Tennessee.

The long and short stitch were used extensively throughout the picture, and thirteen metallic stars were applied to the flag. The shading of the ground and the garland of flowers is similar to other examples from the school. After the embroidery was completed, Folwell painted the face, hair, and elongated hands; all are typical of his work. A comparison to the frontispiece of the *Philadelphia Repertory* drawn by Folwell related favorably to the figure in the needlework picture as well as to the building in the background.[2]

The popularity of silk embroidery was at its height between 1800–1825 and was the tour de force of a young girl's needlework education and an integral part of her schooling. Because the materials as well as the education were expensive, only those whose parents could afford it received such education. This piece would represent the climax of the girl's accomplishment in needle techniques and would be proudly hung in her home as exemplary of her skill to future suitors.

On the back of its original frame, a newspaper was glued as a dust buffer. The fragments that remain are from the *Evening Star*, published in Philadelphia in the years 1810 and 1811, further documenting a date of ca. 1810. The frame is atypical of the Philadephia Folwell School.

A second needlework picture by Margaretta of the birth of Christ has also descended in the family and was dated 1810.

EBA

1. Davida Tenenbaum Deutsch, "Samuel Folwell of Philadelphia: An Artist for the Needleworker," *The Magazine Antiques*, vol. 119 (February 1981), 420–23.
2. *Philadelphia Repertory*, vol. 1, no. 1, (May 5, 1810).

148

Dress

Ca. 1828–1830
America (Boston)
Silk faille with silk embroidery
Length: 48 ½ inches
Museum purchase with funds provided by the
 Fashion Group, Inc., Birmingham Region,
 in memory of Mary Faust
1989.32

The dress of cream silk faille hand-embroidered with polychrome silk floral sprays was constructed completely by hand and decorated at the neck and over the sleeves with Buckinghamshire blonde lace. A double V-shaped scalloped overlay of the faille fabric enhances the empire bodice. The embroidery was the work of professional embroiderers in small workshops either in England or Paris using the satin stitch, chain stitch, and French knot. Initially stitched onto singular twelve-inch panels and sold, the panels were then cut and sewn together for the specific dress. An expensive ensemble in absolutely mint condition, this dress seems to have never been worn, but many from this time were subsequently altered and updated.

The high waistline is a carry-over of the dress style of the previous ten years. The sleeves, however, are the distinguishing characteristic of the dress in that each is actually a large puff attached to the shoulder of the dress with tiny double pleats. Boldly patterned silk fabrics embroidered with the sprays of flowers, as in this case, were fashionable as early as mid-1828 and continued to appear in fashion plates for several years thereafter. This sleeve was the predecessor to the even more famous leg-of-mutton sleeve. Supported by stiffened gauze, the sleeve and the whole ensemble were described in *Philadelphia Ladies Literary Portfolio* in July of 1829: "Look into our churches. Sleeves en gigot, two feet in circumference, enclosing little, beautiful slender, ivory arms of four or five inches. . . . What with their hats, and sleeves, and hoops, and buckram, and foundation muslins, three ladies now make a full pew."

EBA

Quail Feeding by Moonlight in Susuki and Kikyo

1830
Matsumura Keibun (1779–1843)
Japan, Edo period (1615–1868)
Ink, color, gold, and silver on silk
67 ¾ x 152 inches
Gift of Mrs. Benjamin C. Russell in memory of Mr.
 and Mrs. Karl L. Landgrebe
1990.6.1 and 1990.6.2

Matsumura Keibun was one of the leading proponents of the Shijo, or realistic, school of painting during the later part of the Edo period. The younger brother of the school's founder, Matsumura Goshun (1752–1811), Keibun studied with both Goshun and Maruyama Okyo (1733–1795). In 1796, while still in his teens, Keibun participated in an exhibition of painting and calligraphy organized by Minagawa Kien (1734–

1807), and by 1813 he was already listed in the *Heian Jinbutsu-shi* (*Personalities of Kyoto*) as one of the leading artists of Kyoto. Keibun was versed in the Nanga tradition that had initially inspired his elder brother and was also familiar with the work of the later Chinese dynasties. His own work, however, most closely followed that of the Shijo school, specializing in the painting of birds and flowers.

In the Birmingham Museum of Art screens Keibun has portrayed a bevy of quail feeding by moonlight amidst *susuki* (pampas grass) and *kikyo* (Chinese bellflowers). The scene evokes a rich autumnal mood for the Japanese, steeped in the traditional aesthetic concepts of austere simplicity and refined poverty. The glimmering light of the wan moon in the dawning sky and the quail

making its plaintive cry from pampas grass on a withered plain create a scene of desolate beauty that is rich in poetic allusion.

The Birmingham Museum screens are superbly crafted. A layer of gold foil was covered with silk to provide a deep shimmering background for the painting. The heavy dew is depicted in gold and silver dust, while delicate brushwork was used to render the entanglement of flora and fauna. The screens are dated "The third month of the kanoe-tora year of Bunsei" (1830), reflecting the best of Keibun's mature period.

DAW

A Romantic Landscape

Ca. 1834
Thomas Doughty (1793–1856)
America
Oil on canvas
26 ¼ x 34 ¾ inches
Gift of Dr. and Mrs. Harold E. Simon
1980.224

Thomas Doughty devoted himself to landscape painting at a time when no other American artist painted exclusively in this genre. Originally an apprentice to a leather currier, Doughty painted only in his leisure time, gradually painting more and more until by 1820, he had abandoned the leather business altogether. He studied the terrain of New York, New England, and Pennsylvania, vistas which he later developed in his studio, emphasizing the fresh, expansive elements of the wilderness. Landscape painting in America during Doughty's time was based on the European tradition. Landscapes usually were backdrops to classical ruins and idealized figures, serving larger purposes of allegory or history, in the tradition of Nicolas Poussin and Claude Lorriane. Doughty drew from European masters such as Jacob van Ruisdael, from whom he derived his sense of compositional balance, and John Constable, from whom he gained his studied naturalism and a free, ethereal manner. But Doughty also exceeded European influences with his fresh vision of the American wilderness. In the 1820s, America was still full of vast, open territory, but untamed nature no longer symbolized the wild unknown once facing the early settlers. Civilization had tamed, at least in the eastern region, America's virgin territory into a place of interest, majesty, and mystery.

Doughty's paintings are quiet, tranquil pastorals, as projected in the pleasant warmth of *A Romantic Landscape*. It glows in a magical haze, full of soft forms and gentle tones. Doughty idealized rivers, mountains, and trees, bathing them in a golden atmosphere of sunlight: Each delicate and frothy leaf seems sun kissed, the mountain is drenched in the warm light, and the river reflects a solid silvery mass of color. The gossamer-like quality of the atmosphere adds to the scene's lyrical and poetic tone, a tone further emphasized by the mystical aura originating in the distance and reflecting on the mountains.

There is also a sense of inspiring solitude in the painting. The lone hunters, symbolically small amidst the vast wilderness, do not disturb the quiet majesty of the scene. Nature seems endowed with a sense of divine grandeur, in which a heavenly presence is implied and man's insignificance obvious.

In his time, Doughty was criticized for combining this spiritual and romanticized vision with his factual, meticulously studied settings. His poetic interpretations of actual locations were condemned for leaving details skimmed over and forms generalized. However, time would render such criticism inconsequential compared to his pioneering influence on American landscape painting. His pantheistic vision, in which man and nature are secondary to divine majesty, would inspire such American masters as Thomas Cole and flourish in a unified movement in American landscape painting, the Hudson River School.

WE/JW

Still Life with Pineapple

1835
Johan Laurents Jensen (1800–1856)
Denmark
Oil on canvas
31 3/4 x 25 3/4 inches
Gift of the J. A. Vann Charitable Trust in memory
 of Sallie Mae Jernigan Vann
1984.193

Universally acknowledged as the father of Danish flower painting, Johan Laurents Jensen exhibited at an early age his propensity for floral depiction. When he was fourteen, he entered the Royal Danish Academy of Art where he studied with Claudius Ditlev Fritzsch, a specialist in floral still life. It was during this time that he became acquainted with the floral paintings of the eighteenth-century Dutch master Jan van Huysum, whose style he would emulate. His precocious talent attracted the attention of Crown Prince Christian Frederick, later King Christian VIII, who provided him a scholarship and directed him to study at the Sèvres porcelain factory near Paris. While in France, Jensen was introduced to the venerable two-hundred-year-old French still life tradition and to contemporary artists working in the floral genre, particularly the talented Belgian emigrés Gerardus and Cornelis van Spaendonck and the most noted floral painter of his generation, Pierre Joseph Redouté.

In 1825, after his return to Denmark, Jensen became head of the painting studio at the Royal Copenhagen Porcelain Factory, a position he held until 1840, when he resigned to devote himself full time to easel painting. It was during this period, between 1833 and 1835, while on a trip through southern France and Italy, that he became part of a circle of Scandinavian artists living in Rome, a group which included the renowned sculptor Bertel Thorvaldsen and that famous teller of fairy tales, Hans Christian Andersen.

Jensen's superior technical abilities as painter, draftsman, and colorist shine in this exquisite painting, where botanical accuracy has been raised to romanticized perfection. A collection of dahlias in a variety of rich jewel-like colors are arranged in an antique vase. What appears to be an example of Greek red figure ware may in fact be Jensen's invention. The vine leaves on the neck, while formally linking the flowers above and the fruits below, add yet another dimension of aesthetic illusionism—introducing a painted image within the painting. On the marble pedestal, a golden pineapple rests among clusters of wine-colored grapes. The neutral monochromatic background sets off the lush color and extensive variety of surface textures, creating a composition of magical refinement and delicacy. It is a style that recalls seventeenth-century Dutch still life painting such as that of Huysum, whose richly colored floral pieces set against tenebrous backgrounds also lovingly record surface textures in this detailed, sensual way.

Jensen frequently enlivened his compositions with rare flowers. He often drew studies of floral exotica at the Old Botanical Gardens and the Royal Greenhouse. For instance, dahlias had only been cultivated since the 1820s and were still prized as botanical rarities at the time of this painting.

The artistic merit of Jensen's work has only recently been discovered, in part because most of his work remained beyond public view in private collections in Copenhagen and Hamburg.

DA/JW

American Magpie

1835 or 1836
John James Audubon (1785–1851)
America
Pencil, watercolor, and pastel
32 x 22 inches
Gift of Mrs. I. Croom Beatty II
1957.225

An outdoorsman, artist, scientist, and entrepreneur, John James Audubon embodied the individualistic ideal of the nineteenth-century American spirit. For the crowning achievement of his career, his book about the birds of America, he acted as artist, writer, and publisher. In addition to searching for specimens in the backwoods and in naturalist collections of the United States, he drew and painted every image, wrote the text, traveled to Europe where he found engravers to translate the drawings into prints, and enlisted subscribers for the publication. The result was the double elephant folio of *Birds of America*, represented life-size in 435 hand-colored prints in four volumes, with accompanying text in the five-volume *Ornithological Biography*. (The term "double elephant" refers to a standard paper size approximately 40" by 27".)

This drawing corresponds with plate 357, *American Magpie*.[1] Unlike many images in *Birds of America*, it lacks vegetation or a landscape setting, which Audubon usually included to provide information about the birds' habits. Having never traveled to the far West, Audubon had not observed western birds in their habitats, which explains the absence of environmental context for the magpie. For birds that he had not personally encountered in the field, he used skins gathered by other naturalists, drawing from these for about seventy images of western birds in *Birds of America*.

In *American Magpie*, as in all of his bird pictures, Audubon excelled at integrating scientific accuracy based on observation with attractive design based on aesthetic considerations. In order to show the most information about each bird's appearance, he often presented them in different active positions within one image. This also led to more interesting compositions, with more visually complex relationships between forms or between figure and ground. Audubon delineated silhouettes with careful attention, generating exciting lines, patterns, and rhythms. To focus further attention on distinguishing characteristics, he rendered the birds without fully rounded volume, flattening them somewhat to allow space for each surface detail, each feather, each subtle shift of color. Drawings such as *American Magpie* demonstrate Audubon's ability to capture nature's dazzling hues while artistically arranging his color areas across the paper. The striking contrasts of black and white bodies counterbalance the brilliant green tail and blue wing. Compositionally, the diving diagonal of the upper bird forms an exhilarating zigzag with its own rippling wing span and the broken diagonal of the twig below. In these ways and more, Audubon combined factual clarity with visual delight to create works that transcend the boundaries of both art and science.

AF/JW

1. The New York Historical Society has Audubon's original drawings, which the engravers used as models for the prints that comprise *Birds of America*. *Handbook of the Collection: Birmingham Museum of Art* (Birmingham: Birmingham Museum of Art, 1984), 138, states that this *American Magpie* was a preliminary drawing that was reworked for the final version the printers used, and that the "artist was surely pleased with this work, for it was his habit to destroy preliminary renditions when he produced a better drawing of the same subject." In *The American Tradition in the Arts* (New York: Harcourt Brace Jovanovich, 1968), 222, Richard McLanathan wrote that Audubon "sold drawings and made paintings to order after his watercolors to support himself and to pay the engravers and colorers." The precise relationship of this drawing to the final version has yet to be determined.

157

158

Christ Healing the Mother of Simon Peter's Wife

1839
John Bridges (1818–1854)
England
Oil on canvas
48 x 68 ¼ inches
Gift of the children of the Vann family in memory of
 James Allen Vann, Jr.
1978.29

On the reverse of this painting, the artist quoted verses 30–31 from the first chapter of the Gospel of St. Mark, which read as follows:

> Now the mother of Simon Peter's wife lay sick of a fever; and straightway they told him of her; and he came and took her by the hand and raised her up; and the fever left her.

Bridges presented this dramatic event in a consciously unsentimental, restrained manner. Christ extends his hand as if healing power flows through his arm toward the uplifted, waiting hands of the sick woman. She looks up at him with unquestioning faith while his glance imparts quiet assurance. Disciples look on, each reacting differently; one of them lends comfort to the distressed man in red, probably the invalid's husband. Outside, a group of people approach, alluding to later verses in which the townspeople gathered at the door, everyone to be healed by Christ.

Balance and integration of the figures cause the viewer's eye to move in a gentle, flowing rhythm from one individual to the next. Geometry ties together the painting's structure. Christ's head forms the apex of an equilateral triangle (the bottom of the painting serves as its base), causing the eye to focus on him while, at the same time, imparting feelings of strength and stability. A strong diagonal running from Christ's head through his arm to the sufferer reinforces the perception of power flowing between them. A second diagonal from the disciple on the left runs past the sick woman's knees to Christ's left foot, forming an X with the first diagonal that intersects over the space between their hands, focusing on the miracle of healing.

Balanced composition, exacting draftsmanship, monumental purity of form, and clarity of color reflect the influence of the Nazarenes, German and Austrian artists who espoused a program of religious painting founded on ideals of piety, sincerity, and purity. Such artists as Frederick Cornelius and Peter Overbeck looked back to the art of Raphael and Dürer in a effort to revive Renaissance idealism. Intensely religious, Nazarenes wore their hair long in imitation of Christ and wore cloaks and sandals to emulate the early Christians. By 1810 they were established outside Rome in the deconsecrated monastery of St. Isodore, intending to pattern their lives after such Renaissance artist-monks as Fra Angelico. Their influence would span a generation, sustaining itself in the classical tableaux of Bridges, who at the time the Nazarenes were first formed, had not even been born.

DA/JW

View of Mount Etna

Ca. 1842
Thomas Cole (1801–1848)
America
Pencil and wash
20 x 70 ½ inches
Museum purchase with funds provided by the
 1979 and 1980 Beaux Arts Committees
1980.351

As "the father of the Hudson River School,"
Thomas Cole pioneered the first inherently
American painting style. Though born in
England, he moved to the Ohio frontier with
his family while still young. When he later settled
near the Catskills, he began to paint the American
countryside in a new way, basing his paintings on
careful observation and concentrating on nature
rather than on human stories or constructions.
Cole felt that it was essential to study nature

firsthand, making sketches and notes out-of-doors
in order to capture details accurately and then
translate them into finished studio paintings.
Through his art and his published writing, Cole
greatly influenced other artists.

Cole first made his mark with paintings
that celebrated the sacred splendor of the
American wilderness, paintings in which people
and their edifices played little or no role. As his
art developed, he incorporated more figures,
more historical and narrative elements, and
used landscape settings to accentuate the dramas
being played out within them. His trips to Europe
reinforced this tendency, both in terms of the
art that he studied and what he interpreted as the
decline of civilization. For Cole, there were moral,
political, and social lessons to be learned from the
rise and fall of European civilizations, from the

ancient, deteriorating architecture. These lessons could be communicated to others through art.

Cole visited Sicily in 1842 and later painted the island's volcanic peak, Mount Etna, as seen from several vantage points. In *View of Mount Etna*, he depicted it from the ancient Greek theatre of Taormina, the crumbling walls of the theatre visible on the far right. With his light touch, fine lines, and delicate washes, Cole created a precise topographical record, rendering a profusion of accurate details. Each tiny building seems to be delineated, each rock outcropping, each bend in the shoreline.

While attending to detail, Cole also expressed profound feelings about the scene before him. In images such as *View of Mount Etna*, he skillfully united symbols from nature and culture, representing ideas about time, creation, and destruction. Cole portrayed different eras: the geologic agelessness of the volcano, the ancient Greek buildings falling into ruin over the centuries, and the present-day sprawling city. Nature as a creation of God endures; civilization as a creation of human beings decays. While the volcano exists as divine creation, it also possesses tremendous destructive power, against which humans and their minuscule structures are defenseless. However, living during an age of industrial revolution, Cole also witnessed the ability of humans to destroy the beauty of nature. Many of his images cry out for the need to understand the delicate balance between nature and culture and to embrace the rhythmic cycles of growth, death, and rebirth.

AF/JW

Pair of busts of King Frederick William III of Prussia and Louise of Mecklenburg-Strelitz, Queen of Prussia

Ca. 1815
Christian Daniel Rauch (1777–1857)
Berlin Foundry
Prussia
Cast iron
Each: 13 inches
Gift of American Cast Iron Pipe Company
1986.223.4 and 1986.223.5

Casket

Ca. 1815
Gleiwitz Foundry
Prussia
Cast iron
6 3/4 x 6 x 3 1/2 inches
Gift of American Cast Iron Pipe Company
1986.498.1

This casket and pair of busts, part of the museum's large collection of decorative cast-iron objects, were made between 1798 and 1848 primarily in Prussia at three royal factories located in Gleiwitz, Berlin, and Sayn, all now in what was East Germany. Toward the end of the eighteenth century, numerous iron foundries existed throughout Germany, but after the defeat of Napoleon at Waterloo in 1815, only the Prussian foundries turned from producing munitions to fine art casting. The depletion of metal for war had left only the iron for sculptors and modelers to work with, and these foundries became schools for artists to practice their skills. Intricate jewelry, portrait medallions, filigreed fruit bowls, candlesticks, statuettes from the smallest chessmen to life-size busts of kings and queens, trinket holders, writing stands, signets, andirons, and vases are some of the many decorative forms that were produced.

The three primary artist-teachers represented in this collection are Christian Daniel Rauch, best known for his equestrian statue of Frederick the Great in Berlin and busts and statues; Johann

Gottfried Schadow (1764–1860), one of the greatest German Neoclassical sculptors; and Leonard Posch (1750–1831), a Tyrolean sculptor of portrait reliefs. Wilhelm August Stilarsky (ca. 1780–1838) was the pattern master at the Berlin factory and in 1815 invented sectional sand molding to replace the lost-wax method. His kiln-dried two-part mold made it possible to cast thin-walled hollow pieces without destroying the molds. Stilarsky then lacquered the resulting flawless sculptures to prevent them from rusting. This unique molding and lacquering technique was heralded between 1810 and 1830 at the Royal Academy of Fine Arts in Berlin.

The Birmingham Museum Prussian cast-iron decorative arts collection is the largest and finest in the world, including household objects made primarily at Gleiwitz, structural and architectural objects from Berlin, and finely detailed objects of exceptionally pure iron from Sayn. Gustav Lamprecht, a professor of graphic art at the University of Leipzig around 1890 who originally collected these pieces, sold the 917 objects in 1922 to Max Koehler of Los Angeles. Subsequently the American Cast Iron Pipe Company of Birmingham purchased and loaned it to the museum in 1951, making the collection an official gift in 1986. Inspired by this collection, Maurice Garbaty donated fifty-one additional Prussian cast-iron objects to the museum in 1962.

EBA

Sofa

Ca. 1850–1855
John Henry Belter (1804–1863)
America
Primary wood: laminated rosewood
48 x 88 ½ x 27 ½ inches
Gift of the family of Dr. and Mrs. Jackson Leonard
 Bostwick
1989.185

The nineteenth century witnessed a series of revivals in the decorative arts that were most prevalent in furniture styles, including Egyptian, Greek, Gothic, Renaissance, and Rococo. Perhaps the most flamboyant and best known was the Rococo revival from the 1840s to the 1860s. The Rococo emulated that of eighteenth-century Louis XIV furniture, but in its nineteenth-century transformation the furniture was more robust, realistic, and bolder in design. John Henry Belter was the premier manufacturer of Rococo revival furniture, operating in New York City from 1844 to 1867.

Belter was born in Iburg, Hannover, Germany, and immigrated to New York in 1833, becoming a United States citizen in 1839. The Rococo revival was introduced to him in Germany in the 1830s. Initially listed in the New York City directory of 1844 as a cabinetmaker, by 1853 his occupation was changed to furniture manufacturer, a natural transition that frequently occurred during the Industrial Revolution. In making his furniture, Belter utilized an ancient lamination process whereby with hot glue, six to eight cross-grained layers of thin wood were plied together, which he then slowly shaped into a cawl or curved cradle to form the solid wooden backs of his furniture. The strength of the laminated layers allowed Belter to employ deep piercing and carved decoration. In 1847, Belter entered his first of four patents relating to his cabinetry, this one for "Machinery for sawing Arabesque Chairs." Although some of Belter's furniture is made of oak or mahogany, he primarily used rosewood (so named for its faint scent of roses), which he procured from Brazil or East India, because of the exotic, decorative quality of its contrasting rose- and black-colored grain.

Belter made furniture for the hall, dining room, bedroom, and library, but largely for the parlor. These suites of furniture were expensive, selling in the mid-nineteenth century for $1,200; yet in March of 1860 Dun and Company, the predecessors of Dun and Bradstreet, stated that Belter "makes first rate work, too g[oo]d to be profit."[1] The parlor suite usually consisted of a large and small settee and several arm- and side chairs. This settee or sofa is an example of the Fountain Elms pattern, so named in the twentieth century after a suite of furniture of the same design at the home Fountain Elms in Natchez, Mississippi. One of Belter's most elaborately carved patterns of scrolling oak leaves, acorns, grapes, and leaves, the carved crest rail undulates up to six inches in height at the top of the back, slowly graduating to one and one-half inches in height at the armrest. The sofa is supported by cabriole legs that terminate in brass castors utilized for movement and flexibility. Unlike other manufacturers of the period, Belter limited his production to the Rococo style, making New York the center for such furniture, although other companies in New Orleans and Cincinnati made Rococo pieces. Representing the bridge between the eighteenth-century craftsmanship and nineteenth-century technology, so respected and prolific was Belter's output that most furniture in the Rococo revival style is today generically called "Belter," regardless of which factory actually produced the furniture.

EBA

1. Marvin D. Schwartz, Edward Stanek, and Douglas K. True, *The Furniture of John Henry Belter and the Rococo Revival* (New York: Dutton, 1981), 36.

Landscape Album

Li Kui (1793–1879)
Qing dynasty (1644–1911)
China
Ink and color on paper
Each: 13 x 11 ¾ inches
Museum purchase with funds provided by the
 Endowed Fund for Acquisitions and the
 Birmingham Asian Art Society
1988.82.69–.76

Over the past millennium Chinese painting has been in a constant process of evolution. Within this historical context, painting of the nineteenth century has been one of the least studied and understood of the Chinese painting traditions. The nineteenth century witnessed the beginning of the disintegration of traditional China. The ramifications of this transition were reflected not only in political and economic spheres but within cultural and artistic circles as well. By the end of the nineteenth century the leading artists were no longer the scholar-painters of the past, but were instead commercial artists. The repertoire of subject matter expanded as well. Although the preeminence of landscape painting was still acknowledged, there was an increase in the popularity of painting figures, birds and flowers, and a variety of novel subject matter. In the Pearl River delta area of southern China there was a great cultural awakening at this time. An innovative circle of landscape painters emerged in Guangzhou, establishing a regional tradition that had its origins in the late eighteenth century. Li Kui was one of the most talented painters within this vibrant tradition.[1]

The Birmingham Museum's album by Li Kui is undated and consists of eight leaves. The album firmly attests to the individuality of Li Kui's brush. The use of "roasted ink" and pale tints of color engenders a cleansed and arid atmosphere derived in part from an allegiance to the seventeenth-century Anhui school of painting. Human habitation is evident throughout the album. However, it is the various aspects of nature, its grandeur and tranquility, that captured the artist's attention. Some of the leaves in the album bear only the artist's seal; others contain inscriptions that explain the scenes presented or the painting techniques used.

Little is known about Li Kui's life. Born into a poor family in the Xinhui district of Guangdong province, he painted temple murals as a profession. This artisan status made him socially unacceptable to the literati of the region. We know, however, that he was friends with Zheng Ji (1813–1870?), a painter of semiprofessional status and author of a treatise on painting who had connections with some of the Guangdong intelligentsia. Perhaps it was this association that allowed Li Kui to mature as an artist. Regardless of the circumstances surrounding Li Kui's life, his extant oeuvre represents the personal vision of an enormously gifted artist.

NAB

1. This album was exhibited in Li K'uei and His Contemporaries, Art Gallery of the Chinese University of Hong Kong, June 1978.

167

Aspidium Lonchitis.

168

Aspidium Lonchitis

1852–1854
Anna Atkins (1799–1871)
England
Cyanotype
Image: 12 7/8 x 8 7/8 inches
Sheet: 19 x 14 7/8 inches
Museum purchase with funds provided by Keehn W. Berry, Jr., and the Acquisitions Fund, Inc.
1991.792

The Prussian blue color of the cyanotype gives it the common name *blueprint*. One of the earliest photographic processes, the cyanotype is made by coating paper with ferrous salts and placing an object on the paper while the surface is exposed to light. The paper is then rinsed with water to develop the image and bring out its brilliant color. Although this is considered a photographic process, the resulting image is more correctly called a photogram because it is made by direct exposure of the object on the paper rather than by use of a camera and negative.

Anna Atkins, believed to be the first woman photographer, used the cyanotype process in order to explore her greater interest, botanical studies. In doing so, she created the first book of photographic images, *British Algae: Cyanotype Impressions*, the first part of which was issued in 1843.[1] Her close association with Henry Fox Talbot, one of the inventors of photography, and Sir John Hershel, who discovered several chemical processes that are used in developing photographs, was responsible for her early knowledge and use of cyanotypes. Hoping to replace the tedious process of making scientific drawings, Atkins worked with the cyanotype process as an experiment in making more accurate and affordable visual records of botanic specimens. However, the blue color of the print and the lack of detail inherent in this method limited its popularity, so it was never widely used for scientific purposes.

The Birmingham Museum's print *Aspidium Lonchitis* represents what is commonly known as a shield fern. It is a sheet from an album, *Cyanotypes of British and Foreign Flowering Plants and Ferns*, that Atkins made for her closest friend and fellow photographer, Anne Dixon, to whom she presented it in 1854. This album included some of Atkins's most beautiful and inventive cyanotypes, which differ from her earlier studies in format and selection of images. In her book of algae studies, she had selected the format and terminology so that her album would be a companion to a recent unillustrated scientific text on algae. However, in this album, which was meant purely as a gift from one photographer-botanist to another, she chose plants on the basis of personal interest rather than attempting to make a scientific record. The handling of the fern as subject is both descriptive and expressive. Atkins's work is quite rare, and it serves as an important document of the early history of photographic experimentation.

SVS

1. Atkins's first book was meant as a companion to William Harvey's *Manual of British Algae* (London: J. Van Boorst, 1841). The album from which this print is taken remained intact until 1981, when it was taken apart for sale of the individual prints. The most complete study of Atkins's work is Larry J. Schaaf's *Sun Gardens: Victorian Photograms by Anna Atkins* (New York: Aperture, 1985).

Four stained glass windows

Ca. 1860
Workshop of Giuseppe Francisco De Matteis
 and Bruscli
Italy (Florence)
Glass, lead, and wood
First two, each: 49 x 28 inches
Second two, each: 28 x 33 inches
Permanent loan from the Samuel H. Kress
 Foundation
1959.45–.48

These four windows are part of the Samuel H. Kress collection and were probably purchased by Mr. Kress with the thought that they were of seventeenth-century origin. New research has determined that while they appear to be seventeenth century, they are the product of two nineteenth-century master craftsmen, Giuseppi Francisco De Matteis and Bruscli, both of whom specialized in copying earlier work. The workshop of De Matteis and Bruscli, according to a document dated February 1861 from the Academy of Arts and Manufacturers of Florence, was responsible for the restoration of the stained glass in the Church of Santa Croce in Florence.[1] Only one of the Birmingham Museum windows (1959.47) is stamped and signed "De Matteis/Firenze" in the lower-right corner above the Latin caption.

The production of these windows represents the romantic taste of the mid-nineteenth century for revivals, in this case the Renaissance revival. By the 1860s this style reached its zenith with squared, geometric classical entablatures, ornament of oval or round bronze, and incised gilt lines often separating contrasting light and dark panels.

These four windows are variations on eight glass windows en grisaille of 1560 in the colloquium of the Chartreuse or Carthusian monastery of Florence. Construction of this monastery was begun in 1342, and the windows are now located in a cloister adjacent to the *Colloquio dei Monaci* (the Monk's Conversation), where Carthusian monks discussed religious subjects. The original windows are attributed to the artists Paolo di Brondo and Gualtieri di Fiandra. Six of the eight depict episodes from the life of St. Bruno within a cartouche framed by grotesques, rosettes, and anthemia.

St. Bruno (ca. 1030–1101) was the founder of the Carthusian Order at Chartres. In 1084, he persuaded six of his friends from Rheims to join him in a life of seclusion and penance. They petitioned Hugo, Bishop of Grenoble, who then had a dream in which he saw seven stars stand over his diocese, convincing him of the importance of this monastery. The four windows represent the circumstances of Bruno's call. The legend tells that as the service of the dead was being recited for Raymond Diocre, a learned doctor in Paris, canon of Notre Dame, and teacher of Bruno, Raymond raised his head on three different days stating the Latin phrases now found within the cartouches on three of the windows: *Justo Dei Judicio accu/Satus Sum*, "I have been called to account by the perfect judgment of God" (1959.46); *Justo Dei Judicio Ju/dictatus sum*, "I have been judged by the perfect judgment of God" (1959.47); *Justo Dei Judicio/Condemnatus sum*, "I have been condemned by the perfect judgment of God" (1959.48). At this point his body was flung into a field as the priests felt it unworthy of a Christian burial. The events at this funeral, which Bruno witnessed, convinced him to renounce the world. The fourth window illustrates the dream that led to the establishment of the order: *Epus vidit in somnio/septe steltas*, "Hugo has seen seven stars in a dream" (1959.45).

EBA

1. Unpublished research by Dr. Caterina Perina in Milan revealed this document was written in response to the management of Milan Cathedral's request for information on highly skilled glaziers, according to a letter written to Mrs. Kress from Madeline H. Caviness, president, international board chairman, U. S. editorial committee, Corpus Vitrearum, August 17, 1987.

Quilt

Ca. 1861
Martha Jane Singleton Hatter Bullock
 (1815–1896)
America (Greensboro, Alabama)
Silk with wool challis appliqué and cotton
66 ½ x 65 ½ inches
Museum purchase with partial funding provided by
 The Quilt Conservancy
1985.209

In mid-February of 1862, a Mobile, Alabama, newspaper, the *Register and Advertiser*, published a letter from "A Southern Woman" who wished to appeal to the patriotism of Southern women in general and Alabama women in particular to raise money for a gunboat for the defense of the Confederacy. This was the beginning of what came to be known as the "Women's Gunboat Fund," which was also instituted in Georgia, Louisiana, South Carolina, and Virginia. Fund raisers such as dinner parties, auctions, concerts, raffles, bazaars, and fairs were organized by the women, with contributions of objects as well as money from throughout the state. These donations were recorded weekly in the various newspapers with heartfelt thanks for "the cause."

Of the many objects received for auction were two quilts donated by "Mrs. Hatter . . . a widow of our town of Greensboro, who has two sons in the army."[1] These quilts "of most rare and beautiful workmanship" were auctioned at least twice, being donated back to the auctioneer to be resold for the same patriotic efforts.[2] They eventually descended in two Alabama families, with the familiar name of "gunboat quilts," and one is now owned by the Birmingham Museum of Art and the other by the White House of the Confederacy in Montgomery, Alabama. Further research has also located three smaller quilts attributed to Mrs. Hatter on the basis of their remarkable needlework and central motifs.

Made by Martha Jane Hatter prior to 1862, the quilt at the Birmingham Museum of Art is a showcase for her considerable needlework skills. The quilt features an embroidered basket in the center overflowing with appliquéd flowers and surrounded by an appliquéd and embroidered flower wreath. Two three-dimensional stuffed strawberries are also attached to the flowers in the basket. The highly detailed embroidery and elaborate diamond and clamshell quilted pattern are unusual even for an elaborate mid-nineteenth-century quilt. The background fabric of a chocolate-brown silk taffeta was indeed innovative in 1862, as cotton was the standard of the time for pieced or appliquéd quilts. This unique combination of the central floral motif of the early nineteenth century with the background fabric, colors, and dimensions of a Victorian decorative textile spans two nineteenth-century extremes in the tradition of quilting, as it was not until the 1880s when the use of silk became commonplace for crazy quilts.

EBA

1. *The Alabama Beacon*, April 4, 1862, vol. 6, no. 2, 3.
2. Ibid.

Looking Down Yosemite Valley, California

1865
Signed and dated lower left: ABierstadt/1865
Albert Bierstadt (1830–1902)
America
Oil on canvas
64 x 96 ¼ inches
Gift of the Birmingham Public Library
1991.879

By the mid-1860s, Bierstadt had achieved considerable national acclaim for his panoramic views of America's western territories, based on his travels to the Rocky Mountains with Frederick W. Lander's western survey of 1859 and an expedition to the Sierras with artist Fitz Hugh Ludlow in 1863—regions that at the time were still considered mysterious, rugged, untamed, and especially dangerous to city-dwellers back East.

Looking Down Yosemite Valley, California attained instant celebrity at its debut in 1865, when the painting received the place of honor at the National Academy of Design's Annual Exhibition, the first held in the academy's new building. Critics buzzed at the vast western spectacle, some with unrestrained admiration, others with contempt. "We have seen few landscapes since the 'Heart of the Andes' (Frederic Church's epic landscape of 1859) that will compare with this," rhapsodized San Francisco's *Golden Era*. "It looks as if it was painted in an Eldorado, in a distant land of gold; heard of in song and story; dreamed of, but never seen. Yet it is real."[1] But to a writer in the *New York Leader*, "The execution reminds me of nothing upon the earth, or in the waters under the earth, or in the heavens above the earth, save the drop-curtain of a minor theatre."[2]

To many, this and other Bierstadt landscapes affirmed a grandeur of the American West—now tamed through art—comparable to the magnificence of Europe, thus celebrating the nation through the splendor of its natural resources: "Why should our artists make their pilgrimages to the Alps for mountains, to Italy for skies, or to Chamouni Valley, when we have the mountains and skies of California, and the valley of Yo-Semite."[3]

The painting has its own colorful history. In 1866, it was purchased by a Chicago entrepreneur, Uranus H. Crosby, whose Crosby Art Association began as a mutual fund for investors. Burdened by the debt he had incurred building the Chicago Opera House and desperate for cash, Crosby offered the painting as a premium in a raffle, valued at $20,000. Many tickets went unsold, so when the drawing took place, it was Crosby who held the winning number. The painting thus remained in Crosby's Opera House, now financially solvent, until the Great Chicago Fire of 1871, when it was rescued with forty-eight other paintings from the infernal blaze.

In 1929, after being purchased at auction for $300 by a Mr. Friecz (an employee of Tennessee Coal and Iron who was transferred from Chicago to Birmingham), the painting was donated to the Birmingham Public Library. It hung in the Reading Room for forty-five years, virtually hidden behind a surface of grime, soot (from the fire), and dust, unknown to scholars of American art. In 1974, after a cleaning that revealed some of the landscape's vibrant colors, Library Director Richardina Ramsay transferred the painting to the Birmingham Museum to protect it in a humidity-controlled environment, guarded by museum security. In 1991, the library board officially converted the indefinite loan into a gift.[4]

JW

1. *Golden Era*, July 23, 1865.
2. *New York Leader*, May 20, 1865.
3. *Golden Era*, July 23, 1865.
4. On Bierstadt, see Nancy K. Anderson and Linda S. Ferber, *Albert Bierstadt: Art & Enterprise* (New York: Brooklyn Museum in association with Hudson Hills Press, 1990). An earlier, smaller (11 3/4" x 19 1/4") version of this scene with a somewhat different foreground, *Vallery of the Yosemite*, 1864, is in the Museum of Fine Arts, Boston.

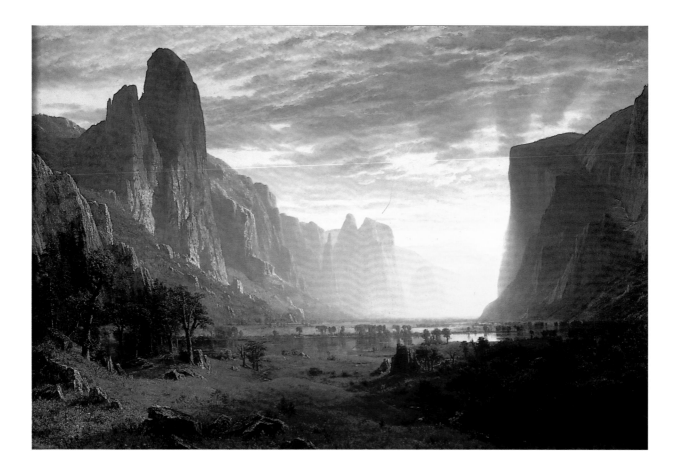

Standing figure (dege)

19th century
Dogon people
Mali
Wood
19 ¼ x 4 ½ x 4 ½ inches
Museum purchase with funds provided by Mr. and
 Mrs. Henry Goodrich and Mr. and Mrs. E. M.
 Friend, Jr.; also with funds provided by Jay Jacobs
 and Dr. and Mrs. Harold Simon, by exchange
1987.39

This partial figure, now missing the lower portion of its legs, exists as an austere and elegant composition of parallel cylinders arranged in dynamic diagonal antithesis to one another. It manages to communicate simultaneous attitudes of tension and repose. A necklace resting on the shelflike chest and the stylized, braided helmetlike coiffure form opposing arcs that frame the dignified, expressionless face. These more complex elements of small repeated forms punctuate the angular geometry and simplification of the figure. Like the other known works in this style, the Birmingham figure is sculpted from extremely hard wood, and its surface retains evidence from past offerings in the form of crusty patches and stains.

Such sculptures known as *dege* are placed on altars where they may serve as physical supports for the souls of the deceased. In addition to ancestral altars dedicated to family dead and mythical ancestors, the Dogon put figurative carvings at altars devoted to a living person's individual force, altars that are used in rain-making rituals, and altars for women who have died in childbirth. These sculptures may also be displayed as part of the funeral rituals for wealthy men. Used in conjunction with sacrifices of animal blood and millet porridge, the sculptures can also act as intermediaries between humans and the gods and direct divine attention to the problems of the living. There is no indication that a particular function can be determined by the stylistic characteristics of a work, and carvings of similar appearance may be used in differing contexts.

Although the Dogon people have been the subject of study for decades, scholars offer contradictory interpretations as to exactly which beings are represented by these works or what they mean.[1] Such carvings have been linked to characters in the Dogon's complex mythology, and according to this view, the androgyny of this figure may refer metaphorically to aspects of Dogon belief. According to the Dogon account of creation, the sexes were not differentiated in an earlier, primordial state. Supernatural beings associated with fertility are also said to possess androgynous characteristics, and human men and women are considered to have components of each other's gender. Field research indicates that the *Hogon*, an elderly male and the community's religious and political leader, assumes certain female aspects in his ritual role.[2] Another interpretation advanced by Walter E. A. van Beek suggests Dogon figurative sculptures may actually be portraits that substitute for their owners. He quotes a Dogon saying, "One cannot always pray and kneel at the altar, but the statue can!"[3]

EFE

1. Kate Ezra, *Art of the Dogon: Selections from the Lester Wunderman Collection* (New York: The Metropolitan Museum of Art, 1988).
2. Barbara De Mott, *Dogon Masks, A Structural Study of Form and Meaning* (Ann Arbor, Michigan: UMI Research Press, 1982), 60.
3. Walter E. A. van Beek, "Functions of Sculpture in Dogon Religion," *African Arts*, vol. 21, no. 4, (August 1988): 58–65.

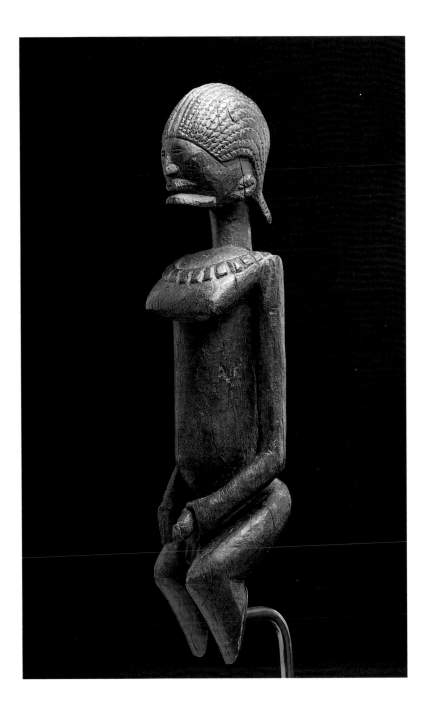

Still Life with Watermelon

1869
William Merritt Chase (1849–1916)
America
Oil on canvas
28 x 25 inches
Given in memory of Mrs. Margaret Woodward
 Evins Spencer
1986.654

Only twenty years old when he painted *Still Life with Watermelon*, William Merritt Chase exhibited his prodigious skill in this, his earliest known still life. At the time, his formal training in art amounted only to modest instruction from two Indianapolis artists, Barton S. Hays and Jacob Cox. Even before embarking on his formal training in Europe, Chase demonstrated here, through his sensuous and elegant detail, how truly advanced an artist he had intuitively become.

This painting carries on the tradition of still life established in the seventeenth century by the Dutch masters and elevated through their skill to high academic regard. Typically, still life arrangements have consisted of painstakingly realistic depictions of flowers, foods, and wine as well as objects relating to the arts. Often, subtle references to aging or decay—an insect or withering leaf—render a gently somber note of life's fleeting duration (the *momento mori*). Here omitting any philosophical reference to death, Chase, like a long line of students before him, sought to capture the richness and precision typical of the Dutch and to demonstrate his artistic acuity in the process.

The various fruits composing this traditional arrangement sit ripe, cut, and ready to be eaten. Chase lusciously rendered the juicy fibers of the watermelon, the slick mahogany of the table, and even the soft fuzz of the peaches with the richness of their actual textures. In addition, Chase's mastery of light and reflection energizes the whole, particularly evident in the reflection of the watermelon seen pink in the deeply polished surface of the table. He also captured the textural sheen of the checks in the silk fabric draped across the table.

Chase was as fine a teacher as artist, his flamboyant personality capturing the attention of his students as well as the progressive art scene of his time. He would later use such still lifes as fundamental examples to his own students, in one case pointing out how the exquisite luminosity in each grape should reflect on their surfaces objects in the room. Still lifes were, for Chase, basic building blocks for artistic mastery.

Over the years Chase's style evolved away from the precise attention to detail and use of dark colors toward a looser brush stroke and brighter palette, characteristics now associated with the Impressionist movement. He would continue to paint still lifes throughout his career, culminating in his now-famous depictions of fish—masterful symphonies of rare textures, reflections, and colors.

WE/JW

180

Gloria Victis

After 1874
Marius-Jean-Antonin Mercié (1845–1916)
France
Bronze with gilt highlights
42 1/2 x 22 x 18 inches
Gift of Margaret Gresham Livingston
1989.140

During the Prussian invasion of France in 1870, Antonin Mercié lived in the tranquility of Rome, an art student at the prestigious French Academy. As wartime news filled his patriotic imagination, Mercié sculpted an heroic winged allegory of fame—the *Gloria Victis*—carrying on her shoulders a victorious French soldier. Only later did he learn that the French lost the war.

Following the Prussians' humiliating rout, rebellious mobs set up barricades throughout Paris, ousted the local government, and proclaimed themselves a commune. After six months of civil bloodshed and starvation marked by the second pitiful seige of Paris, the ruling powers of Adolphe Thiers's Third Republic took back the French capital, killing and executing thousands, leaving only weary bitterness in the hearts of the beleaguered survivors.

Still abroad, the young sculptor was now forced to rethink the old clichés of heroic monuments. Saving the powerfully charging winged goddess of fame, Mercié changed his French warrior: he was now a nude youth, eyes closed and body almost placid, as though in the last throes of mortal life. (Mercié based this figure on his friend Henri Regnault, who died on the last day of the Prussian invasion.) Holding a broken sword, the youth now stood for the brave sons of defeated France, still noble and worthy of immortality.

After Mercié returned to Paris, he exhibited his model of the *Gloria Victis* at the Salon of 1874—Paris's first grant art exhibition since the war. He won the Medal of Honor and instant acclaim from wildly enthusiastic critics. In the *Gloria Victis* spectators found the patriotic sentiments they had been longing to express: eternal valor, even in defeat.

Critics used the statue to berate France's political leaders, opportunistic betrayers of a noble people. One commentator called the naked youth a symbol of "progress" having died in the hands of "imbeciles." Another visitor admitted that upon seeing the statue, his heart pounded rapidly, his throat choked up, and he had to turn away "overcome with patriotic emotion." According to yet another witness, Mercié had "ascended the highest realm of thought . . . to speak directly to our nation and to console our people who have suffered so much and to whom no one else had listened."[1]

Now acknowledged as the symbol of France's horrific wartime debacle, the *Gloria Victis* was cast in bronze, placed in a prominent Parisian square, and later moved to the Hotel de Ville (the city hall of Paris). Many more casts were made (the best by the Barbedienne Foundry) to accommodate the clamor of popular demand. No statue of the 1870s held more nationwide esteem than Mercié's *Gloria Victis*, no symbol more typified that troubled era, and no sculpture more triumphantly lifted the dejected hearts of France.

JW

1. Ruth Butler and Albert Elsen, ed., *Rodin Rediscovered* (Washington D.C.: National Gallery of Art and Boston: New York Graphic Society, 1981), 27.

Sunset, Haywagon in the Distance

Ca. 1875
Martin Johnson Heade (1819–1904)
America
Oil on canvas
13 ½ x 29 ½ inches
Museum purchase with funds provided by the
 Friends of the Museum through Vulcan Materials
1977.192

During the third quarter of the nineteenth century, a number of American landscape painters took the already well-established principles of the Hudson River School in a new direction. While still expressing a veneration for nature, these painters emphasized special qualities of light, atmosphere, and repose, relying upon strongly horizontal compositions to provide tranquil stability. Though these artists, including Martin Johnson Heade, Fitz Hugh Lane, Sanford Gifford, and John F. Kensett, did not form an organized movement, twentieth-century art historians have discerned the distinguishing characteristics of their style, clustering them under the general term "luminism."

One of the foremost proponents of the luminist approach, Heade imbued landscapes with clarity and ethereality, calmness and intensity. In serene scenes of verdant marshes as well as dramatic images of storms over harbors, Heade captured a moment's look and feel. Gazing into his painting, *Sunset, Haywagon in the Distance*, a viewer can sense the enveloping peaceful atmosphere of a harvested field at sunset. Light suffuses the painting, blazing orange behind distant hills, veiling the vast sky with subtle color, reflecting on a winding stream, and delineating the jagged contour of a leafless branch. The sensation of tremendous depth created by the distant setting sun and the expansiveness of the uninterrupted sky suggest immensity, even in such a small canvas. Contemplation of this infinite space may lead to thoughts on eternity and the divine.

To evoke timeless harmony and stillness through composition, Heade emphasized the horizontal axis, painting the bands of grasses, meadow, and hills as an orderly, measured recession into space. Each shape echoes or offsets another: The attenuated clouds and long, low mounds of trees repeat the overall horizontality; the rounded haystacks, gently rolling hills, and bends in the stream counter the great flat expanses of field and sky. With the visual rhyme and meter of a poem, Heade composed his forms in a peaceful balance, illuminated by spiritual light, to express his reverence for nature as the emanation of divine presence.

AF/JW

184

Le Matin, Temps Brumeux, Pourville

1882
Claude Monet (1840–1926)
France
Oil on canvas
24 x 29 ⅛ inches
Museum purchase with funds provided by the
 1979–1983 Museum Dinner and Balls
1981.40

When Claude Monet was sixteen years old, Louis Boudin, an artist who believed in capturing his first impression in the landscapes he painted, introduced the young artist to painting out-of-doors. (The recent invention of paint in a tube had made painting outside the studio easier than in previous eras.) In 1864, after a trip to Honfleur with Boudin and the Dutch painter Jongkind, Monet began extending this idea of first impression by seeking to capture on canvas transitory instants from nature's constantly shifting interplay of light, shadow, color, and atmosphere. By working directly from his subject in sketchy, staccato brush strokes, Monet achieved the illusion of time in motion and a spontaneity and vivacity foreign to paintings created in the studio. Because of the loose brush strokes and absence of academic finish, Monet and artists like him were ridiculed by critics as "Impressionists."

To capture the immediacy of the moment, Monet made no preliminary sketches. He began by delineating his motif with a few thin, blue lines that disappeared as the picture developed. Then, after arranging widely separated strokes, he gradually filled in the spaces between them for his subject to emerge. He placed his colors side by side in separate brush strokes to animate the surface, creating a shimmering calligraphy of color analogous to the dazzling brightness of the sun.

Growing up at Le Havre on the English Channel, Monet knew the coast intimately. Between 1881 and 1882, the time of *Le Matin, Temps Brumeux, Pourville*, he returned as he often

did to the Channel for inspiration, this time to the white chalk cliffs of the Alabaster Coast. In February 1882, after a short stay in Dieppe, he moved on to Pourville to concentrate on subjects within the five-mile stretch between Dieppe and Varangeville.

In *Le Matin, Temps Brumeux, Pourville*, Monet created a mosaic of multicolored shadows and reflections trembling in a pale opalescent light. Summits of the distant palisades glow with the warm rays of the rising sun. Still wrapped in morning fog, they loom over the placid sea, indistinct and mysterious.

DA/JW

Moonlight in Virginia

1884
George Inness (1825–1894)
America
Oil on canvas
19 ½ x 29 ½ inches
Museum purchase with funds provided by the
 Friends of the Museum through Vulcan Materials
1977.193

The art of George Inness spans several distinct tendencies in nineteenth-century American landscape painting. Initially he worked in the highly detailed style of the Hudson River School, but after trips to Europe and exposure to the French Barbizon painters, Inness painted with broader brush strokes, fewer precise outlines, and greater emotional expressiveness. In his later paintings, he created a more spiritual mood through ethereal lighting with subdued tonality and softened atmosphere. This style, similar to Impressionism in its rendering of transient light and its dissolution of forms, would prove influential to later American artists.

In *Moonlight in Virginia*, Inness used his technical mastery to go beyond the physical appearance of nature, revealing some of its intangible spiritual essence.[1] Here, he harmonized a powerfully forthright composition with colors that seem delicately evanescent. Structural clarity arises out of his careful arrangement of horizontals and verticals; the dark green horizon and the black silhouettes of trees, buildings, and figures form an enduring geometry. The dramatic contrast between linear somber branches and bright, spreading moonlight is balanced by the quiet scene in the opposite corner. There, the woman's face and hand catch the warm orange glow of the flames rather than the cool illumination of the moon. Through the rest of the painting, muted colors and indistinct edges unite everything in a mystical ambience, incandescent light and poetic stillness conveying a divine presence permeating all living things.

Many people attribute the deep spirituality of Inness's paintings not only to his personal beliefs about the sanctity of nature, but also to the teachings of Emanuel Swedenborg, a Swedish scientist-mystic who interpreted the spiritual realm in terms of the material world—a land of trees, rivers, and mountains all in a state of perpetual flux. Inness's softly diffuse treatment of objects and distance in *Moonlight in Virgina* seems to illustrate this concept.

Whether primarily personal or indebted to Swedenborgian concepts, Inness's art communicates eloquently about mind, matter, and soul. In the late twentieth century, when so many live so detached from nature, Inness's paintings continue to evoke reverent feelings about humanity's enduring link with the natural and spiritual world.

AF/JW

1. In "Why not Goochland? George Inness and Goochland County" (*Goochland County Historical Society Magazine*, 1988, 24–35), CeCe Bullard attributes four (and possibly six) known Inness paintings, including *Moonlight in Virginia*, to a three month stay by Inness in Goochland County, Virgina, from March to May 1884. In a letter dated March 25th, he wrote about his paintings in progress: "I think I am doing better from nature than ever before the[y] seem to be perfect as pictures and very real being thoroughly unified from nature."

187

Le Village d'Eragny

1885
Camille Pissarro (1830–1903)
Denmark/France
Oil on canvas
23 x 28 inches
Gift of the 1980 Beaux Arts Committee
1979.353

> Remember that I have the temperament of a peasant, I am melancholy, harsh and savage in my works, it is only in the long run that I can expect to please, and then only those who have a grain of indulgence; but the eye of the passerby is too hasty and sees only the surface. Whoever is in a hurry will not stop for me.
>
> Camille Pissarro, in a letter to his son Lucien November 20, 1883[1]

In 1884 Camille Pissarro settled in the small Norman village of Eragny-sur-Epte. Urban life in Paris had become too expensive for the struggling artist and his large, still-growing family of seven, prompting him to search for a more economical rural setting. He chose Eragny for its natural beauty and wealth of available subject matter. Here, far from the overcrowded bustle of metropolitan Paris, he could be close to his favorite themes, the peasants and the land. Here, the careful arrangement of his compositions would express his feeling for permanence and stability—of the eternal place of man as a part of the greater context of his natural environment.

In *Le Village d'Eragny* a fence line leads the viewer across fallow fields toward the self-contained hamlet of Eragny. Enfolded within verdant hills and dominated by its ancient church and manor house, the village drowses in the winter haze. A plume of smoke curls upward in the hushed stillness. Rich dark soil in the freshly tilled field carries with it an enduring promise to the future. In contrast to the slumbering earth, the sky is alive with swirling, dancing color.

The painting's mortarlike texture reveals the labor involved in Pissarro's technique. Brush strokes were heavily overlaid, one pigment over the other in a dense web of varying hues, capturing the incandescent effects of light. Their variety in type and direction create a rhythmic mosaic of color, shape, and movement.

By 1880 Pissarro and other Impressionists had come to the conclusion that their art lacked form and objectivity. Rather than simply capturing transient effects of light, they wanted a more scientific, rational approach to yield clearer, more luminous colors and greater emphasis on surface pattern, composition, and the object depicted. Toward this end, Pissarro began to experiment with optical theories, at times approaching the divisionist separation of color being pioneered by Georges Seurat, whom he finally met in 1885. They systematically studied the interaction of colors, particularly the phenomenon of "After-Image." This results when, after looking at a certain color, a shadow of that color's complement appears in its stead. Placed side by side, two complementary colors will reinforce one another with vivid intensity.

JW/DA

1. John Rewald, ed., *Camille Pissarro, Letters to his Son Lucien,* trans. Lionel Able (1944; reprint, Santa Barbara and Salt Lake City: Peregrine Smith, Inc., 1981), 37.

190

Jean d'Aire, Nu

1885–1886, cast 1986
Auguste Rodin (1840–1917)
France
Bronze
82 x 24 x 23 inches
Museum purchase with funds provided by the
 Greater Birmingham Foundation, the O'Neal
 Foundation, the Susan Mott Webb Foundation,
 and the members of the Birmingham Museum
 of Art
1987.21

The Burghers of Calais commemorates an event
in the Hundred Years' War when six of the leading
citizens of Calais offered their lives as ransom to
save their city from the besieging English army.
In the finished sculpture, each individual exhibits
a different emotional reaction as he takes the first
step towards certain execution (in fact, their lives
were spared by the intervention of the queen).[1]
Rodin initially created *Jean d'Aire, Nu* as a nude
study, a version of which he would refine, drape,
and incorporate with the other five burghers.
In 1886, prior to completion of the monument,
Rodin displayed the nude at a public exhibition,
daringly inferring that his preliminary study

possessed the aesthetic completeness of a finished
work of art.

To Rodin, the expression of the inner state
of mind was paramount. He gave up prettiness
to express deeper emotional truths, using bodily
distortion to reveal impassioned feelings. As
a lawyer, the historical Jean d'Aire would have
violently abhorred the English king's demand
for human sacrifice—a violation of the chivalric
conventions of war. Details such as deeply cut
eyes, strained exaggerated musculature, enlarged
hands (which would clutch the keys to the city
in the final version), and the huge feet fiercely
gripping the earth, together reveal Jean d'Aire's
anguish in reconciling civic duty with the will
to live.

Rodin purposely left his surface textures
uneven, abandoning the polished refinement
demanded of academic artists of his time. He
assured that the imprint of his fingers on the
original clay mold would be replicated in the
bronze cast; on the figure's right arm, he left
a remnant of a support for the clay model; and
he insisted that casting seams not be smoothed
away. These surface elements, in addition to the
deeply incised carving, enabled Rodin to catch
light and shadow dramatically, thus infusing his
figure with the appearance of life.

By abandoning the polished idealism of his
day, by distorting anatomical proportion, and by
presenting human emotion free from the heroic
cliché expected in monumental sculpture, Rodin
redefined realism with candor and truth.

JW

Auguste Rodin, The Burghers of Calais, *1886. Photograph courtesy
of the Hirshhorn Museum and Sculpture Garden, Smithsonian
Institution, gift of Joseph H. Hirshhorn, 1966. Photo by Lee
Stalsworth.*

1. On *The Burghers of Calais*, see Mary Jo McNamara and
Albert Elsen, *Rodin's Burghers of Calais* (Stanford, Ca.: Cantor,
Fitzgerald Group, 1977). Rodin's historical source for the siege
of Calais was Jean Froissart's fourteenth-century *Chronicles*,
trans. Geoffrey Brereton (New York: Penguin Books, 1968).

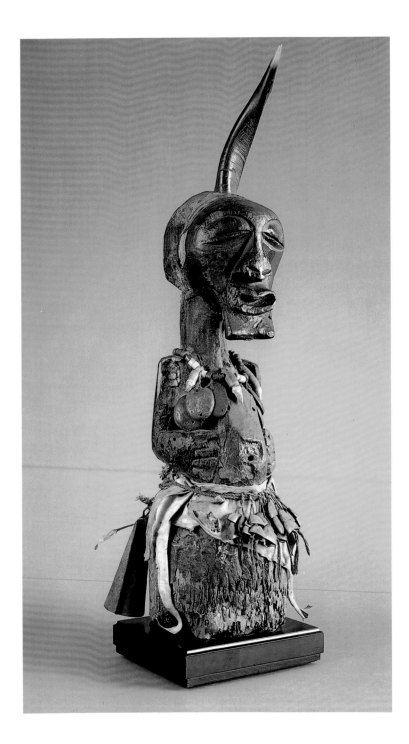

Community power figure (nkishi)

19th–20th century
Songye people, Kalebwe style
Zaire, Sentery (Lubao) region
Wood, animal skin, horn, metal, animal teeth, glass
 beads, seed pods, and fiber
35 x 7 ½ x 8 inches
Museum purchase with funds provided by the
 Birmingham City Council through the
 Birmingham Arts Commission and the
 Endowed Fund for Acquisitions
1989.64

This imposing figure once served to protect an entire community from war, illness, and sorcery and encouraged procreation and stability. Through such *mankishi* (singular *nkishi*), the living members of a community were able to invoke the spirits of the powerful ancestors whose intervention was thought capable of affecting the lives of their descendants. The figures, which bore the names of former village chiefs, beneficial spirits, or power symbolizing animals, were kept in special structures and possessed guardians devoted to their care.

The figure's stance is rigidly frontal in a characteristic posture with its hands placed upon its rounded protruding belly. As with many Songye figures of this type, the legs are not carved and the torso merges with the cylindrical base. The lower third of the figure is partially covered by what remains of a chief's skirt made of animal skins. The lack of patination on the rear surface of the enlarged head indicates that a head covering of feathers or fur was once worn by the figure. The only penetrations of space into the massive, compact form are the openings between the arms and the body. These allowed the figure's caretakers to manipulate it by means of sticks or leather thongs without touching the highly charged image.

The magical power of the *nkishi* derived from secret materials known as *bishimba* that were inserted in a horn atop the head of the figure or in its abdominal cavity. While carving the wooden figure was the work of another, a ritual specialist or *nganga* inserted the materials and magical medicines that empowered it, and he was thus considered its maker.[1]

Although retaining much of the material that was added to empower it, the Birmingham figure is not complete; the *bishimba* are missing. From its lack of wear, there is reason to believe as well that the horn, an important aspect of the iconography of community *nkishi*, may have been replaced. Jean Willy Mestach describes the horn's exterior as the male element and the interior as the female or fertile element. He also likens the horn to "radar" joining heaven and earth.[2] While the bulging abdomen alludes to fertility, pregnancy, and the continuity of the heritage of the ancestors and the iron bell worn around the waist is like those traditionally worn by pregnant women, the primary metaphors of the figure, manifested by such additions as animal teeth and chiefly garments, are those of male power, physical strength, and social authority.[3] The figure's activation also involved a ceremony at which the *nganga* sprinkled gunpowder in a large circle around the figure and ignited it, a possible explanation for the scorched areas on the surface.[4]

EFE

1. Dunja Hersak, *Songye: Masks and Figure Sculpture* (London: Ethnographica Ltd., 1985), 122.
2. Jean Willy Mestach, *Etudes Songye: Formes et Symbolique Essai D'Analyse* (Munich: Galerie Jahn. 1985), 107.
3. Dunja Hersak, *Songye*, 131.
4. Anita J. Glaze and Alfred L. Scheinberg, *Discoveries: African Art from the Smiley Collection* (privately published with the assistance of Marin van de Guchte, 1989), 77.

Grand Canyon, Yellowstone River, Wyoming

1886
William L. Sonntag, Sr. (1822–1900)
America
Oil on canvas
54 x 39 ½ inches
Gift of Mr. and Mrs. John M. Harbert III
1986.628

For aeons the Yellowstone River has roared through this golden gorge where thousand-foot sculptured walls are home of the eagle and osprey. Rhyolite, a product of volcanism, gives the area its vivid color. Today the Grand Canyon of the Yellowstone is located within the confines of Yellowstone National Park, a spectacular setting surrounding a dying volcanic area renowned for its hot springs and geysers.

In *Grand Canyon, Yellowstone River, Wyoming*, William Sonntag delineated a carefully observed foreground comprised of water, rock formations, and vegetation. In the more loosely painted middle ground, detail gradually fades with distance. All lines of topography draw the eye to the distant waterfall as the twisting blue river joins earth to sky. No human figures impinge upon the scene; only a pair of soaring birds of prey evoking the wild, free spirit of the West define the epic scale of the canyon. Such a grandiose setting, painted in rich exalted color, harkens back to the Hudson River painters and their reverence for the heroic aspects of primal nature.

William Sonntag continued the tradition of explorer-artists pioneered by George Catlin, Thomas Moran, and Albert Bierstadt, recording wonders he found in the new territory west of the Mississippi. In fact, Sonntag followed some of the very trails blazed by Catlin. On these trips he made numerous watercolor sketches and drawings that later in his New York studio he would expand and refine into finished paintings.

Sonntag transformed the transcendentalism of the early Hudson River movement into a grandiloquent expression of Manifest Destiny, the mystical notion that the United States was divinely ordained to conquer and civilize North America. His idealized panoramic vision captured and dramatized great sweeps of land and sky for consumption in the East, romanticizing the frontier and convincing Americans that their country with its vastness and richness was indeed superior to all others—a new Eden, richly endowed by God with natural abundance, where upright men basked in the blessing of liberty and prosperity.

DA

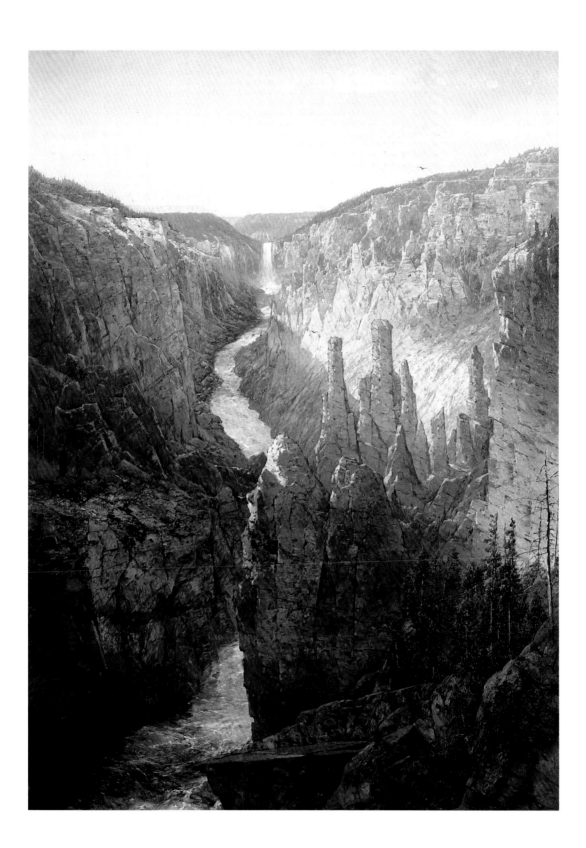

195

196

Storage jar

1890–1895
Toña Peña Vigil (dates unknown, still active in
 1915), or Martina Vigil (1856–1916) and
 Florentino Montoya (1858–1918)
Pueblo people
America (San Ildefonso Pueblo, New Mexico)
Fired clay and slip
15 x 17 1/4 x 17 1/4 inches
Gift of Mr. and Mrs. Donald Speer
1987.60

The San Ildefonso Pueblo is perhaps best
known as the home of the famed potter Maria
Martinez. Less known, but just as important,
were a family of potters from the same pueblo of
the previous generation. The husband and wife
team of Martina Vigil and Florentino Montoya,
and Martina's mother, Toña Peña Vigil, were
highly innovative and experimental with materials
and technique. In fact, their polychrome wares
inspired Martinez's work. Maria once said of
Florentino and Martina, "They were good potters.
Nobody can touch them."[1] Although unsigned,
this vessel has been attributed to this family.[2] The
creation of pueblo pottery is most often the work
of women, although men may decorate the forms,
as with Martina and Florentino. Their pottery was
well known before the turn of the century because
of Martina's ability and Florentino's innovative
style of surface decoration.[3] Florentino learned to
paint while assisting his mother-in-law, Toña, and
it is extremely difficult to distinguish between their
works.[4] They favored several designs, such as the
stepped motif, cloud, leaf, feather, and the wing.[5]
The meanings of most of their motifs are unknown
and many may be purely decorative; however, two
can be tentatively identified. The cloud, depicted
as scalloped forms suspended from the rim of this
vessel, refers to the importance of rain in an arid
region. The large black elements that rise from the
lower band of the design field are feathers or wings
that express the concern of the people to appease
the powers of the sky.[6] Typical of San Ildefonso
polychrome ceramics of this period are black and
red motifs on a cream stone-polished background,
with red slip band at the lip and bordering the
bottom of the design area on the underbody.

Although the coming of the railroad to the
Southwest in the early 1880s spurred tourist trade
and travel, San Ildefonso remained isolated until
1924, when a highway bridge over the Rio Grande
was built in the vicinity of the pueblo.[7] Perhaps
because of this the pueblo's pottery remained more
traditional, with so few active potters that the
tradition almost died out.[8] In the more accessible
pueblos the increased tourist trade encouraged the
production of small "trinkets".[9] However, large jars
such as this vessel were common and appear not
to have been used. They were made perhaps for
tourists who wanted to acquire "major" examples.[10]
This vessel is considered to be one of the finest
known historic period works from San Ildefonso
Pueblo.[11]

MMV

1. Susan Peterson, *The Living Tradition of Maria Martinez*
(Tokyo, New York, and San Francisco: Kodansha International,
1977), 83.
2. Jonathan Batkin, "Martina Vigil and Florentino Montoya:
Master Potters of San Ildefonso and Cochiti Pueblos," in
American Indian Art Magazine, vol. 12, no. 4 (Autumn 1987a):
28–37.
3. Kenneth M. Chapman, *The Pottery of San Ildefonso Pueblo*,
with supplementary text by Francis H. Harlow, published for the
School of American Research (Albuquerque: University of New
Mexico Press, 1970), 26.
4. Ibid.
5. Batkin, "Martina Vigil and Florentino Montoya," 31–32.
6. Chapman, *The Pottery of San Ildefonso Pueblo*, 12–13.
7. Ibid., 4.
8. Batkin, 29.
9. Chapman, 23.
10. Batkin, 30.
11. Ibid.

Lamp

Ca. 1900
Auguste (1853–1909) and Antonin (1864–1930)
 Daum
France
Cameo glass
Height : 13 $^{15}/_{16}$ inches
Museum purchase with funds provided by John
 Bohorfoush and Sylvia Worrell
1985.135.1 and 1985.135.2

The firm of Daum was originally owned by Jean Daum (1825–1885), the father of Auguste and Antonin. Daum was not a glassmaker himself but an investor in the Verrerie Sainte-Catherine (Saint Catherine Glassworks) in the suburbs of Nancy, which opened in 1875 as a watch glass, plate glass, and tableware firm. By 1878 he became owner of the firm by default while attempting to recoup his loans. He changed the name to Verrerie de Nancy, and towards the end of 1879 his eldest son, Auguste, came into the business, although he also had no technical knowledge about glassworks. Yet Auguste quickly brought the management of the firm under control and through marriage in 1883 secured the capital to keep the firm solid. In 1887 a second son, Antonin, joined the firm as production manager, successfully dividing the responsibility with his brother Auguste as business manager.

Verrerie de Nancy expanded into decorative glass using polychrome enamel and acid etching in 1891. The firm exhibited at all of the great exhibitions and won the Grand Prix at the Paris 1900 International Exhibition. This particular exhibition celebrated the age of electricity, and the various glass firms competed in producing table lamps and lighting fixtures. The Daum firm survived the world wars with various descendants at the helm and is still in operation today.

The decoration and even the shape of this lamp represents the Art Nouveau movement prevalent ca. 1885–1910 and characterized by curvalinear lines and bulbous shapes in imitation of nature.

The mushroom-shaped lamp depicts a scene of winter with bare trees and snow, one of the four seasonal scenes produced by Daum, this one being the most popular. The embellishment on the lamp was produced by acid cutting and the application of enamel on cameo glass. The semi-opaque background effect was produced by rolling a gather of clear glass on a blowpipe onto yellow and orange powdered glass, and then an outer layer of clear glass was blown over it. (The use of the powdered glass was called *verre de jade* or jade glass because of its relationship to natural gems.) The tree was then outlined on the glass and waxed before being bathed in hydrofluoric acid, giving the background a textured appearance and perspective. Enameling was the next step, adding brown for the trees and white for the snow. The total effect is almost Impressionistic in style.

The lamp is signed in enamel on the bottom of the lamp base with the Daum-Nancy signature and the cross of Lorraine mark, which was used largely after 1910. The museum also has a small pitcher with the same winter scene.

EBA

Lady with a Bouquet (Snowballs)

1890
Charles Courtney Curran (1861–1942)
America
Oil on panel
10 ½ x 8 ½ inches
Gift of Mr. W. Houston Blount, Jr.; Dr. and Mrs. Walter D. Clark; Dr. and Mrs. Orville W. Clayton; EBSCO Industries; Mr. and Mrs. Raymond Gotlieb; Estate of Mr. Clarence B. Hanson, Jr.; Mrs. W. W. McTyeire, Jr.; Estate of Mr. George H. Matthews; Mr. Joshua R. Oden, Jr.; Mr. William M. Spencer III; Mrs. Alys R. Stephens; Mr. Elton B. Stephens; Mr. Elton B. Stephens, Jr.; Mr. James T. Stephens; Mrs. Martee Woodward Webb; and Mr. Thomas M. West, Jr.
1985.134

Elegant ladies in pleasing, genteel settings characterize many of Charles Curran's paintings. In his small, intimate *Lady with a Bouquet*, Curran captured the external charm and elegance of his subject, even if little of her actual persona. Beautifully dressed from the fine-textured ribbon of her hat to the chiffon edges of her sleeves, the model gracefully arranges the illuminated flowers with her gentle hand caressing a blossom. Her grace resonates as her facial character remains obscured. She is herself a flower, a delicately ephemeral object of beauty.

Curran's depictions of women typically feature an inventive use of light. In this painting, the shaded profile contrasts with the snowball blossoms, brilliantly illuminated from behind.

Light focuses on the flowers, the vase, and the table, endowing them with an opalescent quality. A gentle, iridescent glow defines the woman's chin and hand as well as her hat ribbon and dress. Brush strokes heighten this luminous effect, as in the lacy texture of the blossoms.

This use of light and the loose brush strokes reflect the passing influence of Impressionism, to which Curran was exposed during his studies at the Academie Julian, the time this work was painted. His use of color, though, softens any Impressionist association, the light lyrical mood emanating from a harmonious blend of blues, greens, and greys gently highlighted by the contrasting effects of light. The Impressionists were concerned with the depiction of light, whereas Curran used light to create the pleasant moods of his idealized beautiful scenes.

WE/JW

Three for Five

1890
John G. Brown (1831–1913)
England/America
Oil on canvas
60 x 35 inches
Gift of Mr. and Mrs. Charles W. Ireland, lent by the
 Acquisition Fund, Inc.
AFI 1.1980

Successive waves of immigration beginning in the 1840s put a strain on the social and economic fabric of American cities. Pressures created by the rapidly growing population forced the poor into squalid slums, unkempt and overcrowded. Such neighborhoods teemed with children living on the streets—orphans and the abandoned castoffs of unhappy homes. Traditional jobs as apprentices or domestics, now taken by adults, were no longer open to them. So they earned their living on the pavement, often becoming bootblacks or street vendors by day and, in some cases, thieves by night. To combat this urban blight, a legion of social reformers emerged. Men such as Charles Loring Brace, founder of the Children's Aid Society, novelist Horatio Alger, and artists such as John G. Brown set out to reverse the downward spiral by seizing upon the independence and savvy of street children to fashion a uniquely American ideal, grounded on the promise of equal opportunity for all. Their creed: enterprise and honesty lead to economic success; or put another way, work hard and get ahead.

John George Brown, or as he called himself, "J. G.," was born in England in 1831. His parents, attempting to thwart his desire to become a painter, apprenticed him at the age of fourteen to a glass worker, leaving him to study art at night. Lore has it that emigrant songs, then popular in London, filled young Brown's head with visions of American prosperity and inspired him to seek his fortune abroad. He arrived in New York on his twenty-second birthday and soon found work in a Brooklyn glass company. Two years later, he married his employer's daughter, gaining a father-in-law who would encourage his artistic vocation and provide the financial support to enable him to paint full time. But even with the success that he would soon attain, Brown would claim never to forget his working-class origins: "I do not paint poor boys solely because the public likes such pictures and pays me for them, but because I love the boys myself, for I, too, was once a poor lad like them."[1]

Painted with precise detail on a monumental scale—a size normally reserved for high-society portraiture—*Three for Five* depicts an earnestly hopeful flower vendor carrying a bunch of pink carnations in his left hand, offering three of them for sale with his right. The boy is clean and sweet; his cheeks, rosy; eyes slightly moist; his poverty conveyed solely through his worn, drab clothing. But there is something disquieting about this child: He is too well fed, too well scrubbed, and too sweet to be believed, except in a drawing room—a poverty further undermined by the painting's heavy golden frame. To middle-class businessmen (the usual clientele for such a painting), though, Brown offered an uplifting icon of industry and entrepreneurship, glossing over any association with an exploited underclass. This was not child labor, but street work—excellent preparation for the world of business . . . at least in the imaginative realm of oil on canvas.

DA/JW

1. "A Painter of Street Urchins," *New York Times Magazine*, August 27, 1899, 4.

204

Building a Schooner, Provincetown

1900
Childe Hassam (1859–1935)
America
Oil on canvas
20 ½ x 22 inches
Museum purchase
1956.22

Childe Hassam never considered himself a true Impressionist, but by the early 1900s, critics were hailing him as "the greatest exponent of American Impressionism." Some went so far as to call him the "American Monet," an appellation he detested because his artistic goals so differed from those of the French master.

Like Monet, he had produced some serial pictures (a subject painted under varying conditions of light), but he had little interest in Impressionism's scientific basis. Monet and his peers, supported by contemporary optical theory, had visually equated objects and the space around them. By concentrating solely on the visible properties of light, their paintings became atmospheric renderings of seemingly substanceless color. Hassam had quite different concerns. While appropriating the loose brush strokes and vibrant colors of the French, he sought to preserve tangible reality within atmospheric ambiance. Throughout his career he experimented constantly, varying the emphasis between carefully detailed reproduction and more decorative, loosely painted renderings. Tangible reality aside, he certainly did understand the principles of Impressionist color in which short strokes of prismatic colors applied in juxtaposition blend at a distance to create optical effects of shimmering light. But unlike Monet, Hassam never released his conceptual grip on the solid object itself.

With John H. Twachtman and J. Alden Weir he founded an informal association of New York and Boston artists known as "The Ten," all of whom, to a greater or lesser degree, adopted the stylistic tenants of Impressionism. But the long-standing American tradition of realism, sweetened by Romanticism, impeded any conceptual quest to capture fleeting moments of time. The Ten maintained a historical vision of America as a harsh, challenging wilderness, one later transformed by the Industrial Revolution into an urban jungle: ugly, dirty, sometimes sordid. So these artists grasped for themes of stability and permanence, organized around idealized beauty, to escape from their view of dismal realities of everyday life. Landscape for them offered not a laboratory for natural inquiry but a retreat into lyrical Arcadia.

Between 1898 and 1900 Hassam produced a series of canvases depicting shipbuilding in New England. During this period, he adopted a rougher, more varied brush stroke, along with stronger contrasts between light and shadow. His compositions also became more dynamic, as in *Building a Schooner, Provincetown*, where repeated curves of the ship's ribbed skeleton create optical rhythms, visual rhyme that other elements— human figures, trees, clouds—repeat. In counterpoint to these verticals, the building materials in the foreground draw the eye to the ship while horizontal motifs, such as the roof and piers in the background, stabilize the composition. In other words, the painting relies on a preconceived structure, elegantly designed, upon which the lively patterns of brush strokes and dazzling shimmer of sunlight emulate the coloristic brilliance of the Impressionist masters.

DA/JW

Village Scene

Date unknown
Maurice Vlaminck (1876–1958)
France
Oil on canvas
31 ½ x 24 ½ inches
Lent by the Acquisitions Fund, Inc.; presented in
 loving memory of Dr. Beryl Rogers McClaskey,
 native of Birmingham, Alabama, by Irene L.
 Jones II, her friend and onetime resident of
 Birmingham
AFI 6.1981

Village Scene comes from the middle period
of Maurice Vlaminck's artistic life (ca. 1907–
ca. 1917), after he had abandoned the overtly
emotional use of vivid, explosive pigments.
His new approach was more cerebral, stressing
carefully structured, balanced composition. In
this painting, Vlaminck distorted shapes, defied
laws of perspective, and used pigments judiciously
to create compositional integrity—unity and
harmony of visual rhythms through repetition
of interrelated patterns and colors.

Compositional lines fan out in horizontal
paths across the canvas. In the foreground the red
roof line and golden field seem to emit successive
waves, culminating in the cloud patterns overhead.
Buildings, reduced to their geometric essence,
serve as vertical accents to this unfolding hori-
zontal movement. The vertical counter-rhythm
repeats itself in the dark rectangles representing
doors and windows.

Color is not only a rhythmic motif but also
a unifying agent. For instance, the blue patch
of color on the roof in the foreground unites
the top and bottom of the picture. Using optical
principles, Vlaminck placed the colors green and
blue in relation to their complements, red and
orange, to cause the brighter, warmer hues to
move forward in space, creating an illusion of
shallow depth.

A self-taught artist, Vlaminck had no use for
tradition and discipline, putting more confidence
in his instincts. He was a man of prodigious
energy and enthusiasms. During his lifetime
he had been a racing cyclist, double bass player,
anarchist, journalist, violinist in a gypsy orchestra,
weight lifter, novelist, billiards player, sculler,
Greco-Roman wrestler, motorcyclist, and race-
car driver. His active, dynamic brush strokes
hint at the eagerness and force with which he
embraced life.

DA

Cour 12 Rue Pierre du Lard

Ca. 1900
Eugene Atget (1857–1927)
France
Gelatin silver print on printing-out paper
8 ⁵/₈ x 8 ⁵/₈ inches
Museum purchase with funds provided by the
 Acquisitions Fund, Inc.
1990.34

Cour 12 Rue Pierre du Lard is an evocative image of a passageway between two streets in one of the older sections of Paris. The interplay of light and dark areas lends an air of drama to the rather ordinary-looking architecture. In the foreground, a broom is laid against the wall as if a sweeper has taken a break from his labor. Details such as the rungs of the ladder and handrail form geometric counterparts to the rounded doorway and the drainpipe that follows the curve of the doorframe. This seemingly spontaneous image was, as with all Atget's work, carefully composed prior to the shutter of the camera being released.

Between 1898 and 1926, Atget obsessively photographed turn-of-the century Paris. He chose to photograph his subjects only in the light of the early morning and was usually processing and printing his work by noon. To Atget, images of Old Paris chronicled the spirit of French culture as it was expressed in the shape of her historic buildings, parks, and sculpture. This French culture, which had existed for centuries, was rapidly nearing its end as modern industrialization proceeded. Atget felt French heritage was much too important to let it disappear, so he aimed his camera in order to preserve it.

An out-of-work actor and failed painter, Atget only began photographing when he was forty-two years of age. In the following near-thirty years, he dedicated his life to recording the old buildings, streets, doorways, and statues of Paris. In his lifetime, Atget was considered a commercial photographer and sold most of his works to public institutions and private collectors interested in documents about turn-of-the-century Paris. Artists such as Georges Braque, Henri Matisse, and Man Ray purchased his photographs to use as aids to the creation of their own artwork. Atget and his work received little attention until after his death, when Berenice Abbott, a young American photographer, bought almost all of his works and eventually entrusted their care to the Museum of Modern Art in New York. Because of her efforts, other photographers took note of his work and were inspired by his documentary style of photography, which he is now credited with fathering.

SBH

Raven rattle

19th–20th century
Tlingit people
America (Alaska)
Wood and pigment
13 x 3 ½ x 4 ½ inches
Museum purchase with funds provided by the
 Traditional Arts Acquisition Fund
1989.53

Classic Raven rattles of the Northwest Coast region of North America typically are composed of three distinctive and consistent iconographical elements. As illustrated on this rattle, the main body is in the form of a raven, a reclining human figure (often with a frog and another bird) is on the raven's back, and the belly of the raven is carved with a highly stylized face. The complex composition of Raven rattles has not been fully interpreted or understood, but much of the imagery may be related to Northwest Coast sacred and secular canons.

The graceful S-curved rattle body depicts Raven, a trickster-transformer important in many Northwest Coast myths and legends and the most popular of all familial totemic figures. Raven's beak holds a disk that possibly represents the sun or moon. According to one legend, a powerful chief held the celestial bodies imprisoned in a box; Raven freed them and returned light to the sky. The reclining figure on Raven's back is simplified and flattened, almost like a cutout paper doll. This figure and the small frog held in a bird's beak share a common tongue. In Northwest Coast shamanic belief, the tongue is thought to contain the knowledge of the supernatural, and the life-force is transferred through it after death. The figure on the rattle may be a shaman communicating or transferring spiritual power. The low-relief carved face on Raven's belly, with attributes of both bird and whale, may represent an ancient sea monster or power-spirit.[1]

The Raven rattle used by shamans is not easily distinguishable from secular ones. Shamans have carried the rattles to indicate their high social status. In recent years, such rattles have been utilized in potlatches and other performances by "chief dancers." They are constantly vibrated while held beak downward at the dancer's side, with the underbelly facing up—perhaps because if held upright and shaken in the air, they could "come alive" and fly away.[2] The tongue-connection motif may communicate the concept of interchange and alliance, while the uniformity of the iconography could represent social structure and balance.

The Birmingham rattle is formed of two pieces of wood so finely carved and joined together that the seam is virtually invisible. A vertical wedge has been cut through the head of Raven, leaving it hollow, possibly to lighten the rattle and increase its resonance. The dull red coloring used on early rattles was originally from ocher and was later replaced by Chinese vermillion obtained from foreign traders. The blue-green pigment is perhaps from copper minerals. Black pigment is lignite, graphite, or charcoal mixed with dried salmon eggs and applied with a bear- or porcupine-hair paintbrush.

MMV

1. Aldona Jonaitis, *Art of the Northern Tlingit* (Seattle and London: University of Washington Press, 1986), 54; and Marjorie M. Halpin, museum note 6 in *Viewing Objects in Series: The Raven Rattle* (Vancouver: UBC Museum of Anthropology with assistance from the Leon and Thea Koerner Foundation, 1978).
2. Bill Holm and William Reid, *Form and Freedom: A Dialogue on Northwest Coast Indian Art* (Houston: Rice University, Institute for the Arts, 1975), 198–99.

212

Coming Through the Rye

1902
Frederic Remington (1861–1909)
America
Bronze
26 ½ x 25 x 25 inches
Gift of Dr. and Mrs. Harold E. Simon
1962.74

Probably his most famous sculpture, *Coming Through the Rye* exhibits Frederic Remington's remarkable expertise in figural rendition. At full gallop, the four cowboys revel in a reckless, drunken spree, returning home with pistols brandished and whips flying wildly. Though frozen in time, the figurative detail and spirited poses of the horses and riders generate vibrant energy and compelling motion, the transitory animation characteristic of Remington's work at its best.

Remington's mastery of detail, his variety of textures, and the sculpture's structural and compositional balance combine to make *Coming Through the Rye* a technical tour-de-force. The leather accoutrements—bridles, stirrups and saddles—display minute detail attributable to Remington's personal love of horsemanship. Remington accentuated this detail through the lost-wax process, a technique that afforded him greater textural expression than the previously used method of sand casting. The piece in its entirety exhibits remarkable balance; only seven of the horses' sixteen hooves actually support the riders. Remington packed the figures so closely together that they appear as a single unit, creating a powerful whole out of the disparate, rollicking many.

The momentary intensity in Remington's figures evokes the boundless spirit of the American West, forged by rugged, fiercely independent herders of cattle across the vast, unconquered western plains. Together, the powerful forces of man and nature stand for a larger-than-life national myth: the freedom and adventure inherent in the American frontier.

WE/DA/JW

214

Lady Helen Vincent, Viscountess d'Abernon

1904
John Singer Sargent (1856–1925)
America
Oil on canvas
62 x 40 inches
Museum purchase with funds provided by John
 Bohorfoush, the 1984 Museum Dinner and Ball,
 and the Museum Store
1984.121

John Singer Sargent was the preeminent
portrait painter of late Victorian and Edwardian
society. American by nationality, he moved from
Paris to London in 1885 to escape the scandal
that erupted when he exhibited his notorious
portrait of "Madame X" at the Paris Salon the
previous year. In England he would receive
hundreds of commissions from socialites,
politicians, aristocrats, and business tycoons, all
of whom were enamored by his elegant composi-
tions and painterly flair.

Born in Italy of American parents, Sargent
spent most of his life in Europe. While he studied
art first in Rome and Florence, he later developed
his facile technique in the studio of the celebrated
Parisian portrait painter Emile Carolus-Duran.
After subsequent trips to Spain and Holland,
Sargent assimilated the realism of Diego
Velázquez and the dashing flair of Frans Hals
into his own unique style of society portraiture,
characterized by gracefully elongated forms and
bravura brushwork.[1]

Lady Helen Vincent was painted in 1904, when
Sargent was at the peak of his success, while artist
and sitter were visiting Venice. (The left lower
corner reveals a portion of the Grand Canal
through a typical Venetian balustrade.) Sargent
labored over the painting for three weeks, painting
Lady Helen first in a white dress. Then, on the
very morning of what should have been the final
sitting, he abruptly scraped the white paint away
and transformed her into an elegant woman in
black.

Emulating the grand manner of the eighteenth-
century masters, Sargent posed Lady Helen
leaning against a massive stone column. Her
costly jewels and fur-lined dress compliment the
richly colored texture of her voluminous pink
stole. Her composed, thoughtful gaze subtly
suggests her intellectual stature. She was, in fact,
a member of "The Souls," an exclusive intellectual
circle comprised of the most influential and
creative figures of the day (among them Arthur
Belfour, George Curzon, Henry James, and Edith
Wharton).

DA/JW

1. Sargent's reverence for the Dutch master Frans Hals is
aptly demonstrated in another painting in the collection of the
Birmingham Museum of Art, his copy from Hals's *Regentesses
of the Old Men's Almshouse* (ca. 1664, Frans Halsmuseum,
Haarlem, the Netherlands). This painting, reproducing the
right portion of the Hals masterpiece, hung prominently in
Sargent's Paris studio.

Funerary vessel (abusua kuruwa)

19th–20th century
Akan people, Asante subgroup
Ghana
Fired clay, kaolin, and slip
17 ½ inches; diameter: 10 inches
Anonymous gift
1988.179.1 and 1988.179.2

Vessels such as this *abusua kuruwa* are made as memorials for nonroyal Asante. *Abusua* means family or clan, and *kuruwa* means drinking-water pot. These vessels are used in burial ceremonies performed by members of the deceased's clan on the sixth day after a death. Blood relatives shave the hair from their heads and put it inside the *abusua kuruwa*, sometimes with hair and nail clippings of the deceased, thus symbolically referring to the continuance of the clan. The vessel is then deposited together with cooking paraphernalia and sacrificial food not on the actual grave but at "the place of the pots," an area adjoining the cemetery also known as the "bush of ghosts" (*asensie*). When the vessel is deposited the deceased is addressed:

> Here is food.
> Here are (hairs from) our heads.
> Accept them and go and keep them for us.[1]

The vessels are often ritually cleansed one year after the death of the clan member.

Although all other Asante pottery is made by women, ceramics with anthropomorphic or zoomorphic decoration are made only by men. The reason given is based on an Asante legend where a woman potter's sterility was attributed to the confusion between her natural role as childbearer and her ability to make the human image in clay.

The pots are entirely hand built and are fired outdoors using a wood fire. Immediately after removal, the red-hot pots are placed in a pile of dry vegetable matter, which ignites. The fire is extinguished with water, producing smoke which creates the carbon-black surface of the vessel.

The half-figure on the lid of the piece displays the mourning pose of the Akan, with the right hand touching the middle of the chest and the left hand on the hip. Often these vessels carry motifs relating to Akan proverbs associated with death. The rings around the figure's neck may allude to the proverb, "The rainbow of death encircles every man's neck."[2]

The unknown artist who created this vessel was especially sensitive and adept at the use of repeated forms, which can be seen in the etched and raised curves decorating the surface and the arcs of the figure's arms and the supporting "legs" of the base. The neck-ring motif is echoed in the raised rings around the narrow neck of the vessel. This work is exceptional both for the artist's skill and for the fact that this fragile and complex vessel remains intact.

EFE

1. R. S. Rattray, *Religion and Art in Ashanti* (1927; reprint, London: Oxford University Press, 1959), 165.
2. William Fagg and John Picton, *The Potter's Art in Africa* (London: British Museum Publications, 1978); and Herbert M. Cole and Doran H. Ross, *The Arts of Ghana* (Los Angeles: Museum of Cultural History, University of California, 1977).

Dancer

Ca. 1913
Gino Severini (1883–1966)
Italy
Watercolor
15 x 10 ¹/₂ inches
Gift of Mr. Isodore Pizitz
1955.45

In 1909, the Italian poet F. T. Marinetti published in *Le Figaro* a compelling and controversial manifesto calling artists to abandon their ties to the past and make art that would be relevant to a young, revolutionary generation. Several Italian artists including Carlo Carra, Umberto Boccioni, Luigi Russolo, Gino Severini, and Giacomo Balla answered his challenge and joined the movement known as Futurism. Severini's watercolor *Dancer* is an excellent example of Futurist experimentation with the principles of dynamic forms.

Although Futurism is acknowledged as an important movement for its insistence on the need to break away from traditional styles, it is often faulted for adopting the stylistic techniques of Cubism. Severini, who lived in Paris from 1906, was particularly aware of Cubism. While many Futurist paintings resemble Cubist compositions in their fragmentation of images and use of text and collage, they differ in at least one major aspect. Cubism is primarily concerned with fragmentation as a formal means of representing a static object shown through time; Futurism is concerned with dynamic forms (objects in motion) and the displacement of time and space in order to reorient the viewer's perception.

Severini's painting technique is called divisionism because of the use of distinct dots of color to define planes. In this abstract work, the triangular planes and arcs intersect and overlap and appear to radiate from a central core. They suggest the movement of the dance rather than the dancer herself. Severini was particularly captivated by the idea of the "dynamic sensation"—the feeling of movement. This particular work may be a study for a painting, although a direct relationship with known finished works has not been established. It has been associated with a series of paintings of dancers made between 1912 and 1914. However, it shows a closer affinity to an abstract theme Severini explored in a painting called *Spherical Expansion of Light* (1914). In this work, as in the Birmingham Museum's watercolor, Severini is concerned with the effects of movement and the abstract concept of universal forces that are constantly pushing things apart and pulling them together again.

SVS

The Barricade

1918
George Bellows (1882–1925)
America
Oil on canvas
48 ½ x 83 ½ inches
Museum purchase with funds provided by the Simon
 Fund, the Friends of American Art, Margaret
 Gresham Livingston, and Crawford Taylor
1990.124

George Bellows's *The Barricade* is one of
five large-scale canvases that Bellows painted in
sympathy for the innocent civilian casualties of
World War I.[1] It illustrates a gruesome incident
during the invasion of Belgium in August 1914
when German soldiers forced captive townspeople
to march before them as a human shield—often in
the face of gunfire. Bellows's poignant scene was
based on a thirty-thousand-word report by the
Committee on Alleged German Atrocities that
appeared in the *New York Times* in May 1915. The
report, conducted by British historian and former
Ambassador to the United States Viscount Bryce,
charged the German army with "systematically
organized massacres of the civil population . . .
isolated murders and other outrages . . . looting,
house burning, and the wanton destruction of
property . . . systematic incendiarism," also rape
and the murder of children, all "where no military
necessity could be alleged, being indeed part of a
system of general terrorization." Bryce's findings
concluded, "That the rules and usages of war
were frequently broken, particularly by the using
of civilians, including women and children, as a
shield for advancing forces exposed to fire, to a
less degree by killing the wounded and prisoners,
and in the frequent abuse of the Red Cross and
the White Flag."

But nothing in the documents mentioned
nakedness. Bellows deliberately presented his
victims as nudes, classically posed, to recall timeless
masterpieces from the history of art: Ingres's *The
Source*, an image of ideal feminine beauty; Rodin's
St. John the Baptist; and, in a loosely configured
way, Rodin's *The Burghers of Calais*. In this context,
the German soldiers affront not only the accepted
conventions of war but also the humanistic values
of Western civilization.

Bellows never served in the armed forces,
nor indeed did he ever travel to Europe. When
criticized by Joseph Pennel that he had no right
to paint such a scene, Bellows responded that he
was not aware that Leonardo da Vinci had "had
a ticket to the Last Supper."[2]

Bellows himself felt deeply sympathetic to
the victims of war, but wanted also to separate
his indictment of the mob leaders from any kind
of national hatred. He said of these paintings, "In
presenting these pictures of the tragedies of war
I wish to disclaim any intention of attacking a race
or a people. Guilt is personal, not racial. Against
that guilty clique and all its tools, who let loose
upon innocence every diabolical device and insane
instinct, my hatred goes forth, together with my
profound reverence for the victims."[3]

JW

1. The five paintings in the set were based on a larger series
of prints that Bellows executed in late 1917 and 1918. See
Jane Myers and Linda Ayres, *George Bellows: The Artist and His
Lithographs 1916–1924* (Fort Worth: Amon Carter Museum,
1988), 95–112.
2. Charles H. Morgan, *George Bellows: Painter of America* (New
York: Reynal & Company, 1965), 221.
3. *Catalogue of an Exhibition of Lithographs by George Bellows*
(New York: Frederick Keppel and Co., 1918), 3.

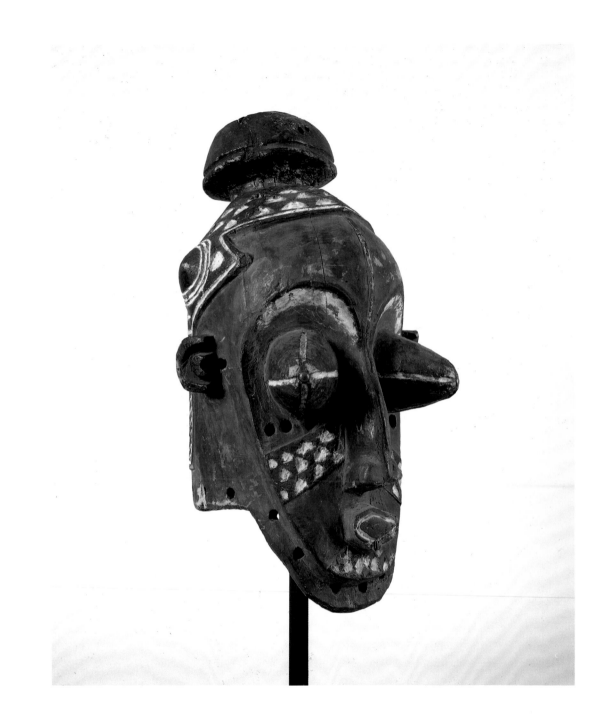

Helmet mask (muluala)

19th–20th century
Biombo people
Zaire
Wood, metal, and pigment
20 x 11 x 13 inches
Gift of Brian and Diane Leyden
1989.164

Surface decoration may echo and thus accentuate sculptural forms, or such treatment may add another layer of visual complexity and create tension by opposing or contradicting the forms to which they are applied. A profusion of geometric carved surface patterning accented with white and black pigment was applied to this rich-red painted ceremonial mask known as *muluala*. Diagonal slashes break the exterior at the cheeks, while white linear elements increase the prominence of the eyes and mouth protruding sharply from the facial plane. On the intricately designed back surface of the mask, an indigenous repair made from a flattened sardine can curiously echoes in shape the lively clusters of geometric motifs found elsewhere.

The cone-shaped "chameleon" eyes are typical distinguishing features and may sometimes be carved as tubes so extended that they almost touch the chin. The rounded form atop the head that represents an upside-down cooking pot is always present on *muluala*. Cooking pots are used to hold palm wine, an important ingredient at ceremonial observances. The addition of the pot affirms the male identity of the mask, as men are responsible for palm wine collection. It may also warn of the possibly aggressive and dangerous state of the drunken *muluala*, who is restrained by a rope held by an attendant during the rite. The raffia fringe once attached to the holes that border the lower part of this mask is now gone, and the mask's worn edges provide evidence of many past performances. Other costume elements included eagle and parrot feathers and a monkey-skin skirt.

Precise identification of many objects of African origin is difficult on stylistic grounds alone, as object types and cultural practices are often shared by neighboring groups. Masks such as this occur among the Southern Kuba, who call them *mulwalwa*, and among the Northern Kete peoples. This work has been attributed to the Bena Biombo, who live south of these groups at the junction of the Lulua and Kasai rivers, because of the black and white triangular patterning on the cheeks that is characteristic of their style.

While these masks have not been documented in context among the Biombo, they have been observed in use by neighboring groups. Among the Southern Kuba, these large wooden helmet masks are employed at funerals and at initiation ceremonies when young men mark their transition from childhood to adulthood. Masks of this type that have not been hollowed out as well as fully carved masks are also used to adorn walls constructed in villages as part of initiation rituals.[1]

EFE

1. Hans-Joachim Koloss, *Art of Central Africa: Masterpieces from the Berlin Museum fur Volkerkunde* (New York: The Metropolitan Museum of Art, 1990), 46; Marc L. Felix, *100 Peoples of Zaire and their Sculpture: The Handbook* (Brussels: Zaire Basin Art History Research Foundation, 1987), 14-15; Edward Park, *Treasures of the Smithsonian* (Washington, D.C.: Smithsonian Books, 1983); and Roslyn Adele Walker, *African Art in Color* (Washington, D.C.: National Museum of African Art, 1983).

Death, Mother and Child

1910
Käthe Kollwitz (1867–1945)
Germany
Etching, aquatint, and drypoint
16 x 16 inches
Gift of Mrs. David Larson
1979.45

Käthe Kollwitz lived during turbulent times, and her art reflects the social upheavals of that era. Early in her life, she was moved by the workers' uprisings and steeped herself in socialist ideas for improving life for the masses, as found in the theories of Karl Marx, the writing of Ferdinand Freiligrath, Heinrich Heine, and Thomas Hood; Emile Zola's novel *Germinal*; and Gerhart Hauptmann's play *The Weavers*.

Since Kollwitz strove for social impact over aesthetic appeal, for humanitarian resonance over individual artistic glory, printmaking ideally suited her expressive goals. She used the bold immediacy of black-and-white prints to make very readable messages and, through multiple impressions, made her prints available to many people.

Kollwitz's identification with the struggles of the working class intensified after 1891, when she moved to a poor neighborhood of Berlin where her husband was a doctor. Kollwitz often portrayed the difficulties of life for peasants and workers as well as her vision of the revolts that would result when suffering became too extreme. In these images, strong, committed women play active social roles. In other prints, Kollwitz celebrated mothers' devotion to their children and their resolute determination to protect them from harm. These mother and child images took on added significance with the world wars, when so many mothers, including Kollwitz, experienced the painful loss of their offspring.[1]

Kollwitz returned again and again to the theme of maternal love confronting death. In this 1910 version, *Death, Mother and Child*, a radically asymmetrical composition of figures bent over sideways in their struggle, creates powerful dramatic tension. The mother's hand around the child's neck pulls him toward her while the skeletal arm around his waist pulls him up and away. The downward weight of the mother's effort suggests that she might not prevail in this battle, but the melding of the faces of mother and child emphasizes that their spiritual bond will continue despite the physical separation of death. Kollwitz surrounded their heads with deep, dark, forceful lines so that the right side of the print conveys a sense of life, love, intensity, and emotional richness. In contrast, she defined the skull with relatively few, lighter lines set off against the pale emptiness created by the child's legs and back. Thus, the unmarked left area of the print simultaneously serves as the child's innocent young body and the stark void of death into which he is inexorably drawn. Near the center of the composition, the mother's hand, rendered with great sensitivity, expresses care, hope, and strength.

AF/JW

1. Kollwitz's identification with the mothers and revolutionaries that she portrayed is borne out in her numerous self-portraits—they embody the same personal qualities of strength, devotion, and commitment. This striking profile portrait from 1919 shows a woman who has experienced sorrows but who has remained determined and focused.

Acanthus vase

Ca. 1925
René Lalique (1860–1945)
France
Molded and frosted red glass
Diameter: 9 inches; height: 11 1/2 inches
Gift of Dr. Charlotte Schneyer in memory of her
 husband, Dr. Leon H. Schneyer
1991.811

At the Paris Exposition of 1900, René Lalique became famous as a revolutionary and highly acclaimed artist for his designs for Art Nouveau jewelry. Rejecting the need for precious jewels and diamonds, Lalique selected semiprecious stones with mountings of horn, ivory, tortoiseshell, enamel, and inlaid glass paste. In 1902 he purchased a small estate at Clairfontaine, near Rambouillet, France, for his glassworks. Approached by Francois Coty to design attractive perfume bottles around 1907, Lalique turned his career toward full-time glass production. The windows for the Coty building on Fifth Avenue in New York were commissioned in 1908 and are today a masterful survival of his work in America.

A second glassworks was purchased in 1921 at Wingen-sur-Möder in Bas-Rhin, France, the factory being called Verrerie d'Alsace René Lalique & Cie. With bold, imaginative patterns now in the Art Deco fashion, the roster of objects that he manufactured included ashtrays, bowls, clock cases, decanters, vases, wine glasses, statuettes, scent bottles, pendants, lamps, hood ornaments for automobiles, and even architectural elements such as fountains, ceilings, windows, doors, and lighting fixtures. Methods of production were the traditional blowing of glass into hinged molds or stamping the glass into a press, allowing for strong definition. Uniting art and industry, most of Lalique's work was mass-produced from models of animals, flowers, fish, and women originally created by Lalique himself and etched or molded with his signature, R. Lalique. The majority of these luxury objects were available at affordable prices in a variety of colored or clear glass including blues, greens, reds, oranges, browns, purples, and blacks. A wedding or anniversary gift of Lalique glass was common in prosperous families of the 1920s and 1930s.

From Lalique's 1932 illustrated catalog of some fifteen hundred different items comes the title of this vase *Acanthus*. Made of mold-blown red glass, the signature R LALIQUE in block letters appears on the bottom of the vase. The frosty opalescent outer finish on this intaglio vase was achieved by the application of neutralized acid (acid mixed with ammonia). Art Deco in style, the acanthus leaves have a rigorous zigzag pattern, characteristic of Lalique's design vocabulary.

EBA

Wall Street

Ca. 1929
Berenice Abbott (1898–1991)
America
Gelatin silver print
9 ¹/₈ x 7 ¹/₄ inches
Museum purchase with funds provided by William
 M. Spencer III
1987.15

Berenice Abbott is best known as a documentary photographer of New York City during the late 1920s and 1930s. Abbott's documentary photographs are not just records of buildings, cars, and people but reveal the tempo, scale, and power of New York through their emphasis on the immense architecture that towers over the urban residents. *Wall Street* exhibits many hallmarks of her work embodying these ideas of power and scale. An emphasis on the vertical elements of the buildings, such as the columns, combined with a narrow depth of field seems to flatten the image so as to lend claustrophobic feeling to the work. The static quality of the buildings is offset by the bustling crowds moving below, and several pedestrians are blurred in order to emphasize the fast beat to which the city moves.

While *Wall Street* stands on its own as a portrait of the stock exchange building, it also suggests more abstract concepts of national monuments and the historical events with which they are associated. Here, Abbott captures the importance of the stock exchange building in the life of the nation's economy, especially during the late 1920s. The stock exchange building is illuminated with an almost heavenly light that ironically gives the building and its inherent affairs an air of infallibility. Just as the stock market building is consumed in light, many Americans were consumed with and ultimately destroyed by the Stock Market Crash of 1929.

Like Eugène Atget, the French photographer who inspired her work, Abbott felt it important to document the older parts of New York, which were rapidly disappearing as the modern industrialization continued its spread. In her New York photographs, Abbott presents the relationship between the skyscrapers of the modern city and the older buildings. The exchange building in *Wall Street* is dwarfed by the new superstructures surrounding it. Its decorative pedimental sculpture is sharply delineated by the light and as a result looks more real than the people moving below on the sidewalk.

Abbott was born in Ohio and left for Paris in 1921 to fulfill her dream of becoming a sculptor. In 1923, she became an assistant to the well-known photographer Man Ray. By 1925, Abbott had opened her own studio specializing in the portraiture of Parisian social and literary society. It was then that she discovered Eugène Atget, when he posed for his photograph. She fully embraced his belief in the validity of realism as a means of expression and is credited with collecting and preserving his works after his death in 1927.

SBH

236

Silver Torso

1931
Alexander Archipenko (1887–1964)
Russia/America
Polished bronze
43 x 8 ½ x 3 inches
Museum purchase with funds provided by Mr. and
 Mrs. Jack McSpadden; Mrs James A. Livingston,
 Jr.; and Mr. John Bohorfoush
1985.343

The upraised and extended arms of this
abstracted female nude circumscribe her head,
suggested only by a keyhole-shaped opening.
With Jacques Lipchitz, Alexander Archipenko
discovered that "the void" in sculpture could
convey artistic expression as effectively as solid
form. According to Archipenko, he discovered
this principle when he once placed two vases
together and noticed that the space between them
appeared as sculpturally real as the objects that
defined it. In unison with surrounding volumes,
the void engenders impressions of transition,
disclosure, and evolution, and so introduces a
fourth dimension: time, through the motion
suggested by visual rhythm. This fleeting idea is
accentuated as well in the highly polished bronze
surface which appears to dematerialize in a
constant flux of changing reflections.

In *Silver Torso* subtly alternating concave
and convex planes cause fugitive shadows and
reflections to play over the surface, creating the
illusion of enhanced volume in this thin, flamelike
form. These undulating planes reflect light with
soothing rhythms that accentuate the body's
serpentine contours. Viewed from the side, they
imply the continuation of the form into space.

While the stance and proportion of *Silver
Torso* recall classical modeling, Archipenko
revealed in this sculpture a new relationship
between space, mass, and time, cast in a highly
polished vocabulary of simplified modernist form.
Sensuous curves become not a literal description,
but an elegant, abstracted analogy of ideal
feminine beauty.

DA/JW

239

Headdress for Epa masquerade

First half of the 20th century
Yoruba people
Nigeria, Ekiti, Osi-Ilorin area
Carved wood and pigment
50 x 20 x 18 inches
Museum purchase with funds provided by the
 Birmingham City Council; Mr. and Mrs. Henry
 Goodrich; SONAT, Inc.; Mr. and Mrs. J. Mason
 Davis; Sigma Pi Psi Fraternity-Beta Kappa Boule;
 and others
1984.112

The first major African work to enter the Birmingham Museum's collection was this massive wooden mask carved by an unknown Yoruba artist. The work once served as a headdress for the Epa masquerade, an important cyclical festival held only in the northeastern part of Yoruba territory by the Ekiti and Igbomina Yoruba people. As part of this festival, complex masks that can weigh up to sixty pounds are commissioned by particular lineage or family groups and are used in performances with a costume of fresh palm fronds to memorialize ancestral culture heroes. Masks are the focus of offerings and praise, and the skill of their athletic young wearers affirm the physical strength and achievements of the living as well.

Epa masks consist of relatively abstract single- or double-faced helmet masks topped by complex superstructures of one or several figures carved in a more naturalistic manner. The carvings are of certain idealized types; the mother, the king, the doctor, or the equestrian figure. The superstructure of the Birmingham example depicts a hunter or warrior on horseback, historical references to the creation of the Ekiti kingdoms in the nineteenth century by warrior chiefs and the cultural role of the hunter-warrior in the establishment of political power and social stability. The identity and status of the figure are indicated by the long-tailed hunter's hat, tunic, protective amulets, and fly whisk. His horse,

diminutive in size compared to its rider, functions as a symbolic rather than historical allusion. Horses were not used by the armies of the northeastern Yoruba, and this image may incorporate and thus harness the threatening power of the mounted invaders of Ekiti as well as imbuing the figure with the qualities of superhuman swiftness and strength. A common name for this type of headdress is *Jagunjagun* (fight war fight war).

In Yoruba sculpture, body proportion is related to significance or meaning rather than given in a manner consistent with the surface reality of the visible world. The head, the locus of spiritual power, is enlarged so that it incorporates fully one-third of the height of the body. The characteristic bulging eyes and the hunter's cap, which extends the head further, emphasize the figure's spiritual power. The heavy-lidded and deeply carved eye motif is repeated on the horse and dominates the double-faced helmet. Strong, stabilizing horizontal and vertical elements of the work are broken by arcs of the long-tailed hat and opposed curves of the fly whisk and the reins held respectively by the right and left hands of the horseman. The massiveness of the form is lightened both by the lively painted patterns, freshly executed by the mask's owner before each use, and the carver's sensitive use of negative spaces. An image of timeless dignity and contained energy, the Birmingham Epa mask visually and symbolically constructs a living reality from a mythic and historical past.[1]

EFE

1. William Fagg and John Pemberton III, *Yoruba Sculpture of West Africa* (New York: Alfred A. Knopf, 1982), 133; Ellen F. Elsas and Robin Poyner, *Nigerian Sculpture: Bridges to Power* (Birmingham: Birmingham Museum of Art, 1984), 37; Henry John Drewal and John Pemberton III with Roland Abiodun, *Yoruba: Nine Centuries of African Art and Thought* (New York: Harry N. Abrams, Inc., 1989), 189–206; and J. R. O. Ojo, "The Symbolism and Significance of Epa-type Masquerade Headpieces," *Man*, vol. 12, no. 3 (1978): 455–70.

242

Headdress in the form of an antelope (Chi Wara Kun)

20th century
Bamana people
Mali
Wood, metal, and fiber
12 ½ x 2 ½ x 22 ½ inches
Museum purchase with funds provided by Dr. and
 Mrs. Harold Simon and Jay Jacobs, by exchange
1987.26

Animal imagery figures prominently in African sculpture. Often animal forms represent human attributes or are depicted because they possess characteristics that humans are encouraged to emulate or to avoid. Such a creature appears in this headdress, which represents *Chi Wara*, a mythical being believed by the Bamana people of Mali to have taught humans the secret of agriculture. *Chi Wara* (alternately spelled *Tji Wara* or *Tyi Wara*) is also the name of the ceremonial and the men's initiation society that performs the dance and a term meaning champion farmer.

As with other animal figures in African sculpture, this work is not merely the result of an artist's observation of the natural world; the choice of imagery is motivated by symbolic and social demands. A composite creature, *Chi Wara* incorporates elements of the roan and dwarf antelopes, the anteater, the chameleon, and the hornbill. *Chi Wara* headdresses include references to seeds, the sun, and the earth, while the costume, fabricated of flowing, mud-dyed plant fibers, alludes to the rains necessary for a successful harvest.

The origin of this carving can be localized to the western region of Bamana country, where such headdresses are horizontal in orientation, relatively naturalistic, and carved from two pieces of wood that are joined at the neck by a metal band. Before performances, western Bamana headdresses are also heavily ornamented with beads, earrings, and coins.

The surface is worn smooth from washing and oily shea butter oozes in areas, evidence of repeated preparations for ceremonies. A second head emerges branching like a bud from the chest of the composite creature. The tapering horns and tail curve upward in the manner of newly germinating seeds, and the bent knees imply potential action and vigor. Geometric incisions on the vertical facial surface of the creature are scarification marks, the permanent body markings acquired by humans that denote membership in their cultural community and submission to the orderliness imposed by civilization. Their presence on this creature of the bush unifies the realms of nature and culture.

This carving was once lashed to a wooden hat and served as a headdress for a young male dancer. Holding sticks in each hand, he performed in the vigorous leaping motions of the antelope to songs that praised the virtues of champion farmers and encouraged observers to work diligently in their fields. Two dancers, one wearing a headdress representing a male *Chi Wara* and one wearing a headdress representing a female version, always perform together. They celebrate male and female cooperation and suggest an analogy between human and agricultural fertility. While such headdresses are still in use today, the context in which they are used has evolved from a secret religious ritual performed in a field to invoke the spirit of a divine being to a secular public celebration of agriculture danced in a village square.[1]

EFE

1. Pascal James Inperato, "The Dance of the Tyi Wara," *African Arts*, vol. 4, no. 1 (Autumn 1970): 8–13, 71–80.

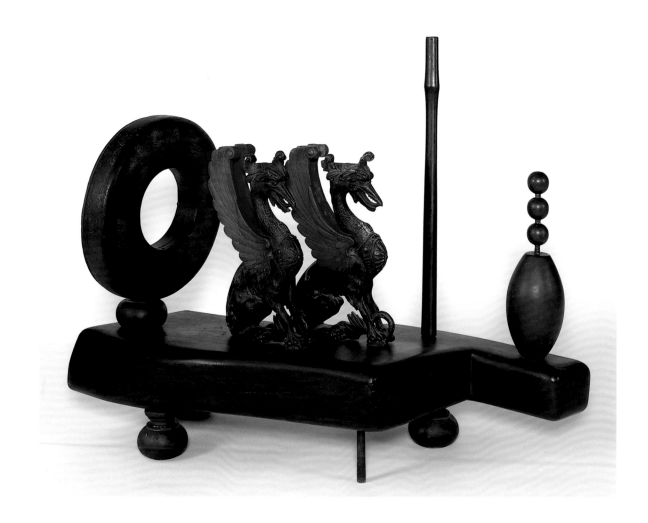

244

Ancient City

1945–1955
Louise Nevelson (1889 or 1890–1988)
America
Painted wood
34 x 45 x 22 inches
Gift of Mr. and Mrs. Ben Mildwoff through the
 Federation of Modern Painters and Sculptors
1961.147

> I was working quite desperately . . . only
> for one reason—that I have made reality
> that is a personal reality. Since I did not
> find a reality . . . on the outside, I have
> built a whole reality for myself.
> Louise Nevelson[1]

Louise Nevelson's art developed from a
profound need to create a transcendent spiritual
environment, an imaginative refuge where she
could reign as absolute ruler. As a child she had
experienced isolation and anti-Semitism and
distress over her parents' unhappy life together.
The subsequent failure of her own marriage
impelled her to create environments that she
herself could alone control. Metaphysical studies
brought her to the belief that each person was
the center of his or her own world—the real or
"outside" world only a projection. In this ego-
centric spirit, *Ancient City* is a personal universe,
reflecting the artist's personal iconographic
system.

Ancient City is a rare example from the beginning
of Nevelson's artistic maturity. There is disquiet-
ing poetry in this piece, evoking the mystery of a
vanished civilization in a hovering, asymmetrically
balanced landscape full of unresolved tensions in
mass and space. The composition carries with it
a surrealistic feeling of loneliness and isolation,
as though the scene were being viewed from
a great distance. Though personal, Nevelson's
iconography was distinct. In describing this piece,
she referred to the pedestal as consciousness being
elevated on three sphere-worlds that symbolize
thought; the fourth support, which is straight,
stands for reason. The circle alludes to the sun, the
griffins to flight. The tall, slender post represents
the barren, cold seasons while the vaselike object
with its shaft of three rounded forms signifies the
time of warmth and fruition.

Ancient City derives from an earlier sculpture
of the same name created in 1943 (now destroyed),
one with which the Birmingham piece has often
been confused. It appears, however, that the
Birmingham example may have been made a
decade later—in fact, reconstructed from another
earlier piece. Originally, the circular shape and
the vaselike object were components of *Three-Four
Time*, a sculpture shown in October 1944 at the
Nierendorf Gallery in Nevelson's one-woman
exhibition, Sculpture Montages. She would
later dismantle this work to use its elements in
two new sculptures, *Bride of the Black Moon* and
Birmingham's *Ancient City*, exhibited in 1955 at
the Sculptor's Guild outdoor exhibit as *Winged
City*. (Comparison of Birmingham's *Ancient City*
with photographs of *Three-Four Time* reveal that
the circular shape in both works exhibits similar
marks and scratches, notably a distinctive chip
[since repaired] out of the back inside edge).

DA/JW

1. Diana MacKown, *Dawns and Dusks: Louise Nevelson, Taped
Conversations with Diana MacKown* (New York: Charles Scribner
& Sons, 1976), 95.

Mother and Child

1949
Jacques Lipchitz (Chaim Jacob Lipchitz, 1891–1973)
Lithuania /America
Bronze
Inscribed: 5/7 Lipschitz
54 3/4 x 26 3/8 x 29 1/4 inches
Museum purchase with funds provided by Mr. and
 Mrs. William J. Cabaniss in memory of William
 Jelks Cabaniss III and the Meyer Foundation
1986.639

The mother and child theme preoccupied Jacques Lipchitz throughout his career. To Lipchitz, the mother image symbolized the nurturer and protector and expressed both love and joy. He viewed the child as both an innocent and, at times, a victim.

Mother and Child was inspired by his newfound happiness with his second wife, Yulla, and by the birth of his baby daughter, Lolya Rachel, in October of 1948. Here, the twisted, anguished lines of the artist's previous mother and child compositions have been replaced by an image of maternal love and protectiveness. Cradled in the mother's powerful left hand as she nurses at her mother's breast, the tiny infant is totally enveloped within and becomes a part of the swollen, curving volumes and deeply incised drapery. The solidity and massiveness of the sculpture is pierced, liberating the upraised right arm from the rest of the surging form. The textured surface is a direct result of Lipchitz's method of working the clay model by hand prior to the work being cast in bronze. Seven casts of *Mother and Child* were made. However, the original model was slightly altered for each successive cast so that no two casts in this edition were exactly alike.

Jacques Lipchitz had achieved international recognition as a Cubist sculptor in Paris by the 1920s. Gradually, he transformed the strict Cubist vocabulary of angular, geometric shapes and shifting, overlapping planes into a freer treatment of form that emphasized volume, curving rhythms, and a lively modeling of the surface. These new formal concerns coincided with a fresh interest in subject matter and expressive content as a means of conveying deeply felt emotions. From the 1930s onward, Lipchitz derived his subjects from mythology and religion, which served as metaphors for disturbing political events and universal human experiences such as love, pathos, struggle, life, and death. In 1941, Lipchitz emigrated to America and settled in New York to escape Nazi persecution. It was in America, during the postwar decades, that his mature style reached its final definition.

JY

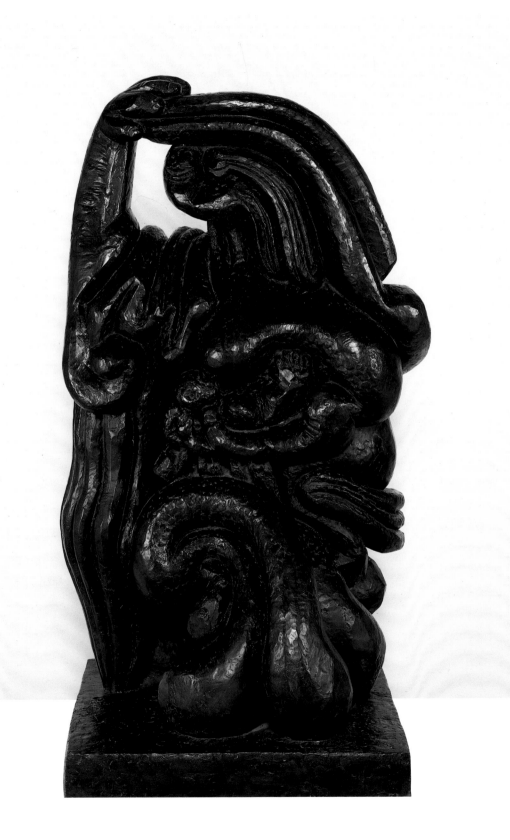

Madonna Corpusculaire

1952
Salvador Dali (1904–1989)
Spain
Ink and pencil
21 ³/₄ x 16 ³/₄ inches
Gift of Mr. and Mrs. Charles Ireland
1953.1

During the late 1920s and early 1930s, Salvador Dali joined with the Surrealists in trying to unite subconscious inner states of mind with conscious perceptions of reality, thus creating a more complete, heightened reality. Surrealism's early manifestations took the form of automatic writing, a process in which writers let words flow from the subconscious free of rational thought or moral considerations. Surrealist painters also practiced automatism through spontaneous drawing, collage, rubbing, or any method that suppressed calculated rationality in favor of uninhibitedness. Dali's work, though, suggested another path for surrealist painting: the literal representation of dreams. His meticulously detailed technique required careful attention and reason, while the images themselves soared into realms of hallucination. Dali sought to render his fantastic visions so precisely and intensely that the reality inside his mind would become as convincing as that of the external world.

After spending the war years in the United States, Dali returned to his native country, Spain. His repatriation to this deeply religious country and his reaction to the war amplified his fascination with Christian imagery, though his images characteristically wedded the bizarre, the extravagant, and the profane with sacred iconography. Consequently, though his drawing

Madonna Corpusculaire embodies a centuries-old revered motif of the Madonna and Child, the Madonna's lap and baby Jesus erupt with phallic forms. Dali rejected the meditative calm so often expressed by the mother and child, replacing it with a frenzied whirlwind of geometric fragments. These elemental forms suggest nuclear physics, the space-time continuum, and the structure of the universe. In the atomic age, the swirling particles represent both creation and destruction, the building blocks of life and the horrifying ability to blow it all away. The parallels with Surrealist tenets abound, even though when he drew this image, Dali had been excluded from the Surrealist movement for more than a decade. In 1936 Breton wrote:

> There is a hint in all this of a belief that there exists a certain spiritual plane on which life and death, the real and the imaginary, the past and the future, the communicable and the incommunicable, the high and the low, are not conceived of as opposites. It would therefore be vain to attribute to surrealism any other motive than the hope to determine that plane, as it would be absurd to ascribe to it a purely destructive or constructive character: the point at issue being precisely this, that construction and destruction should no longer be flaunted against one another.[1]

SVS

1. André Breton, *What is Surrealism?* (London: Faber & Faber Ltd., 1936), 71–72.

Two Riders

1953
Marino Marini (1901–1980)
Italy
Oil on canvas
65 x 45 inches
Gift of Mr. and Mrs. Merton Benton Brown
355.1985

Inspired by the Han dynasty tomb horses of China, Marino Marini used the imagery of horse and rider to convey his feelings about human suffering, a theme made all the more poignant by the global tragedies of World War II. The powerful, bold, harshly contrasting shapes and colors of this painting suggest violent conflict, as though the figures were participants in a battle. "Tragic rather than heroic" was the way Marini hoped his horses and riders would be viewed. Marini's desire to evoke pathos, using the subject of horse and rider, contradicts the grand tradition of equestrian themes throughout art history.

This particular painting is a product of Marini's mature work, when he had fully integrated the Cubist technique of using fragmented planes with the aggressive paint application of the Abstract Expressionists. Here, the two horses and riders stand in profile. The riders are almost completely composed of flat, geometric shapes, while the horses are rounded with more volume. The composition is held together by the repeated use of circles and strong brush strokes.

Marini was born in Pistola, Italy. He was a student at the Academy of Fine Arts in Florence, where he studied painting and sculpture. The sculptural quality of this painting probably relates to his success as a sculptor as well as a painter. The combination of flat planes and modeled forms reminds us of the process and materials often used in the construction of a three-dimensional object. These elements in particular are reminiscent of plaster, wood, and cast metal, the media preferred by Marini in the creation of his sculptures.

CH

251

Sun Mountain

1968
Helen Frankenthaler (b. 1928)
America
Acrylic on canvas
120 ½ x 87 inches
Bequest of Mrs. C. B. Ireland
22.1993

To many who see it, *Sun Mountain* is a luminous evocation of a desert sunset. Abstract equivalents of sky, mountain, and horizon exist within an illusion of infinite depth and billowing movement as flowing, ethereal shapes appear to dissolve into light. The painting's large scale (approximately ten feet high by seven feet wide) enfolds the viewer within these glowing diaphanous veils of color, intermingled to create a serene, lyrical mood.

In *Sun Mountain* Helen Frankenthaler created spatial interrelationships between opposing areas of rich, sensuous hues. The dominant area of incandescent gold, counterbalanced by soft purple, is accented at the bottom by white and a surprising slice of dark green. From their point of convergence, these shapes appear to expand outward, beyond the painting's outer edge, into infinity.

Frankenthaler's subject is color, pure color. To stress its expressive power and to enhance its brilliance, she applied highly diluted washes of pigment directly onto unprimed canvas, allowing it to be absorbed, to become one with the fabric's uniform weave. In this way, brush strokes, the personal touch of the artist, have been eliminated. In addition, light reflecting through the layers of thinly applied paint from the underlying white canvas endows the painting with an inner radiance.

Sun Mountain exemplifies Frankenthaler's intensely poetic style. Her control over the colors in her bold, bright palette, which appears so deceptively facile and spontaneous, creates an impression of space, light, and movement. It is twentieth-century American art in the Grand Manner—forceful, exuberant, emphatic, yet at the same time, unpretentious.

DA

Flin Flon VI

1970
Frank Stella (b. 1936)
America
Polymer and fluorescent polymer on canvas
108 x 108 inches
Gift of the Museum of Art Education Council, the
 Birmingham Art Association, the members of the
 Birmingham Museum of Art, and an anonymous
 donor
1971.81

In his geometric paintings, Frank Stella demonstrated that abstract painting can be used to create sophisticated decorative objects as an alternative to the metaphysical messages or emotional self-revelations popularized by Abstract Expressionism. Painting on the large scale of the urban environment with bold patterns of exuberant, interlocking colors, Stella employed the Day-Glo palette of commercial America, applied with the neutrality of billboard advertising. But the painting evokes the past as well: thin bands of unpainted canvas that separate the color fields function like the leading that borders sections of medieval stained glass windows.

Stella chose semicircular shapes for the basic motif in this highly controlled, hard-edge format. A vortex of great arcs sweeping in from the perimeter draw the viewer's eye into the center. Fragmentary horizontal and vertical lines parallel the edges, breaking up the color pattern with variety and ambiguity, and in so doing, call attention to the four diagonal elements that suggest the petals of a flower. The contrast of curves to straight edges and the interplay of related versus competing colors create vibrantly rhythmic relationships between the center and outer edge and among the four quadrants of the composition. By choosing a narrow range of color values, Stella contained this energy with compositional unity, preventing any abrupt contrasts that would destroy the precise balance of the design.

Flin Flon VI was part of a series in which Stella used the geometric precision of the protractor as his design motif. During the 1960s, many modern painters began making multiple paintings in order to explore all permutations possible in a chosen motif. In the summer of 1967, while teaching in Canada, Stella began what he would call the Saskatchewan series in which he returned to the monumental square format, relying once again on the image itself to provide the geometry. (Previously, he had explored painting on canvases of varied geometrical shapes—a practice he was forced to abandon in Canada because he could not obtain shaped stretchers or sculpted canvases). While the four-petal motif was inspired by the protractor, its interlacing patterns reflect Stella's early interest in Islamic art and illuminated Hiberno-Saxon manuscripts.[1]

DA/JW

1. A full-color illustration of *Flin Flon VI* appears on the dust jacket of the monograph by William S. Rubin, *Frank Stella* (New York: Museum of Modern Art, 1970).

255

Builders No. 1

1971
Jacob Lawrence (b. 1917)
America
Gouache on paper
30 x 22 inches
Museum purchase with funds provided by the
 Simpson Foundation, private contributions,
 and with museum funds
1972.26

As a young artist working in Harlem during the 1930s, Jacob Lawrence was inspired by the ideals of the Harlem Renaissance, a movement which celebrated the great achievements and cultural pride of African Americans. Beginning in the 1920s, many black intellectuals, writers, musicians, and artists—people such as Alain Locke, Langston Hughes, Duke Ellington, and Aaron Douglas—developed a philosophy and an aesthetic that expressed their identity and their African heritage with dignity. Infused with these ideas, Lawrence painted works in a series that portrayed historic and contemporary struggles of African Americans, emphasizing their heroism and determination. Through clarity and simplicity of style, using a minimum of bold shapes and strong, flat colors, Lawrence conveyed his messages directly and powerfully. Over his long career he has not diverged significantly from these essentials, communicating as effectively in recent paintings as in those done fifty years ago.

When he moved to Seattle to teach at the University of Washington in 1971, Lawrence began to concentrate his art more intensely on builders, a subject he had treated occasionally since the 1940s and frequently since 1968. In *Builders* Lawrence abandoned the idea of series to embrace the theme of human aspiration. While not making specific reference to events in African-American history, this theme embodies the major premise of all Lawrence's work, namely, that people can build a better society. (The *Builders* also differ from his other works in series in that they are not narratively related. Numbers are used to differentiate works with the same title made within a particular year, not to designate sequence within a story.)

In *Builders No. 1*, compositional elements underscore psychological and moral aspects of the painting. The bold shapes suggest the strength needed to fashion an object or fight for a cause. The clarity of the forms parallels the man's clarity of purpose, entirely focused on his task. Though his body seems massive, his hands are sensitive, capable of precision work. The curves of his back and arms form a perfectly harmonious unity with the curving piece of wood. Bright colors convey a sense of optimism, the idea that the worker's determination will result in a contribution to society. Since the primary colors—red, blue, and yellow—are considered the building blocks of color theory and practice, their use enhances Lawrence's theme of the builder. Additionally, by framing the image on the top and sides with horizontal and vertical bands that look like structural elements, Lawrence stressed that this image is a construction, and that the same creative energy animates art, carpentry, and social change.

AF/JW

257

Late Afternoon

1972
Philip Guston (1913–1980)
America
Oil on canvas
67 x 79 ¼ inches
Bequest of the Estate of Musa Guston
1992.60

Yes—I too puzzle over "meanings"—I mean the linkage of images when they are together in a certain way and then how all changes, when in another combination on the wall.

Philip Guston in a letter to Bill Berkson, January 19, 1976[1]

Enormous shoes supported by an improbable pair of rubbery, spindly legs sprout amidst the detritus of an artist's studio. The ghost of a rejected idea appears on the right. In his visceral, stream-of-consciousness approach to painting, Philip Guston often retained partially effaced images of ideas that he had tried and dismissed. The painting's highly simplified forms, so quiveringly alive, project a powerful presence.

By the 1970s Guston had developed an allusive, highly personal vocabulary of symbols that became the grammar of his ambiguous, non-narrative visual statements. While ideas from literature, poetry, philosophy, and religion influenced his work, most of his imagery came from art historical sources. Guston constantly developed and refined this iconography until it became his own. For instance, the airless, claustrophobic ambience of *Late Afternoon* reflects his early and abiding admiration for the remote silence of Giorgio de Chirico's metaphysical paintings. Compressed space and the upside-down figure derive originally from Max Beckmann's *The Departure*. The nail studded shoe first appeared in his work in 1947. It reemerged in the 1970s to become a recurrent image, carrying with it such disparate connotations as the artist himself, the inexorable passing of time, or man's inhumanity to man—he had seen photographs of the piles of shoes at Auschwitz.

Guston's language, like that of a cartoonist, is stripped to the bare essentials. His resonant vision was often macabre, sometimes apocalyptic. At the same time, though, he never mired himself in hopeless cynicism, but lifted his imagery with the buoyancy of humor.

DA/JW

1. Robert Storr, *Guston* (New York, London, Paris: Abbeville Press, 1983), 108.

259

1978
Sarah Charlesworth (b. 1947)
America
Forty-five black-and-white prints
Approximately 20 x 24 inches each
Museum purchase with funds provided by the
 National Endowment for the Arts and the
 members of the Birmingham Museum of Art
1990.19.1–.45

On March 16, 1978, after a bloody gun battle
that left five policemen dead, terrorist members
of the Red Brigade (*Brigate Rosse*) kidnapped
Italy's Prime Minister Aldo Moro. With Moro
captive, the Red Brigade engaged in a series of
communications with *Il Messagero*, a major Italian
newspaper, that effectively publicized its leftist
agenda through news services worldwide—only

too happy to report every detail of such a real-
life thriller. On April 21, after rumors of Moro's
death, the Red Brigade sent a photograph of its
prisoner (holding that day's newspaper to prove
the date) to *Il Messagero*, a photo that played on
front pages of nearly every major newspaper in
the world. Weeks later, Moro finally turned up,
dead in the trunk of an abandoned car.

April 21, 1978 is the centerpiece of
Charlesworth's epic Moro trilogy, the first
of which examines newspaper reports of the
prior day when, in response to rumors, helicopters
combed the countryside in search of Moro's body.
The final piece, entitled *Osservatore Romano*, traces
the entire Moro saga as reported by the Vatican
newspaper. In a broader sense, all three works
stem from Charlesworth's *Modern History* series,

an examination into the iconography of newspaper imagery. According to Charlesworth, "Each piece examines a specific perspective, a particular event, or the dispersal of a given image within the international sphere. . . . Each piece, likewise, follows an exact 'game plan' or formula and the specific newspapers included as well as the placement of photos, reflect the relative import of daily events within each news context."[1]

In *April 21, 1978*, the "game plan" was to photograph the front page of forty-five different international newspapers, reproducing the masthead of each accompanied by that day's illustrations: in size and placement they appear exactly as in the original. In each case, however, Charlesworth eliminated the headlines and text, thus forcing viewers to ponder the strategies and assumptions underlying the dissemination of visual information. It "deconstructs" news, and by the very differences between each newspaper's size and placement of the Moro photograph reveals the relativity of media truth. The *New York Times* called it a "classic but rarely seen artistic investigation of editorial decision-making and happenstance."[2]

JW

1. Two other versions of *April 21, 1978* exist: one at the Stedelijk Van Abbemuseum, Eindhoven, Holland, and the other at the Museum of Contemporary Art, Los Angeles.
2. *New York Times*, August 13, 1989.

Tuba

1981–1982
Anthony Caro (b. 1924)
England
Steel
73 x 94 x 75 inches
Museum purchase with funds provided by the Bluff
 Park Art Association in honor of Sally Johnson,
 Mr. and Mrs. Jack McSpadden, Mrs. Lucy Durr
 Dunn, Miss Pauline Tutwiler, Mr. and Mrs. Don
 Logan, and the Hess Endowed Fund for the
 Museum through the Greater Birmingham
 Foundation
1989.3

Anthony Caro uses welded metal to create abstract assemblages that rely on suggested associations and internal references rather than on specific subject matter. In *Tuba*, Caro has assembled pieces of steel, shipyard debris that includes part of a buoy and chain. A natural layer of rust provides the sculpture's coloring and surface texture. When Caro constructs a sculpture, he does not sketch and plan the work ahead of time but instead physically manipulates the separate pieces to find the relationships between them.

Caro considers the placement of his sculptures to be extremely important for their proper viewing. He prefers that his works be placed on hard surfaces, often in an architectural setting, so that the viewer can approach the work within a context that is familiar and also related to human scale (that is, the scale of the surrounding architecture). Because Caro's work relies on abstract relationships of part to part, scale is a crucial element of the work and is also the reason for its success. *Tuba*, although not anthropomorphic,

can still be related in size to the human body. At approximately six feet, it is just taller than an average adult. Thus, the viewer can look at the work in terms of its parts without its size becoming dominant (or threatening). The work is composed of a large vertical plane with a cutout section at the center that acts as a frame for the disc of the buoy; these pieces are punctuated by smaller rolling forms and the curvature of a chain link that supports a corresponding horizontal plane. The shifting planes and curves create a dialogue among the separate elements.

This work, along with others from this series, has been associated with music. According to Caro's long-time dealer, Andre Emmerich, "Caro has said that he wanted to use less treble and more bass in his sculptures [from this series]."[1] The large planes of steel and the curving mass of the buoy convey a sense of weight and could be considered lower in "pitch" than the more linear, or melodic, table pieces for which the artist is known. Because of the use of large vertical planes, the work appears significantly different as it is viewed from various angles. The rhythm and variety experienced by walking around the sculpture add to its musical quality.

SVS

1. *Tuba* is listed in the catalogue raisonne by Dieter Blume, *Anthony Caro* (Cologne: Galerie Wentzel, 1985), catalogue 1632, 5: 207, 320. The quote by Andre Emmerich comes from the introduction to an exhibition catalogue that included works from the same series. The catalogue is "Anthony Caro: An Exhibition in Honor of the Artist's 60th Birthday," May 24–June 29, 1984, Acquavella Galleries and Andre Emmerich Gallery, New York.

Clay I Am, It Is True

1982–1983
Robert Arneson (1930–1992)
America
Glazed ceramic
83 x 25 x 25 inches
Museum purchase with funds provided by Louise
 and Jack McSpadden
1992.32.1 and 1993.32.2

Following the tradition of Goya and Daumier who employed sardonic humor and irony to reveal profound truths, Robert Arneson reflected on the human condition with self-deprecating wit. He brought a raucous brand of low-brow humor to high art, which he further undermined by his use of ceramics, a medium usually associated with craftsmen. (He once said clay allowed him to be serious without being taken seriously.) An iconoclast at heart, he specialized in satirizing the art establishment and its sacred icons. For instance, he mocked the Renaissance ideal of man as "the measure of all things" by illustrating himself in the guise of Leonardo's perfectly proportioned *Vitruvian Man*—now middle-aged, pot-bellied, and balding.

The project that brought him to national attention was *Portrait of George* (1981), a memorial dedicated to slain San Francisco Mayor George Moscone. Commissioned for the newly built Moscone Convention Center, the sculpture is a portrait bust with a pedestal bearing graffiti-like references to the mayor's life. Among the innocuous biographical statements, Arneson included painful references to the assassination—particularly the infamous "Twinkie defense" that won murderer Dan White a ridiculously reduced sentence—prompting the city to reject the work. The following spring, it went on exhibition at the Whitney Museum, only to be condemned by the cognoscenti as well.

Clay I Am, It Is True was conceived after the disheartening Moscone debacle and after Arneson fell victim to the cancer that would kill him nine years later. This sculpture, and a similar piece, *Ass to Ash*, are modeled after an Etruscan cinerary urn surmounted by a portrait of the deceased. Arneson's robust, skillfully accurate likeness is grotesquely disfigured, as though struck by the figurative fist of his critics. The fire on the column turns the whole into a frightening pyre, with rats gnawing at the base in reference to his illness and to human mortality, and, with words inscribed on the head and urn, the sculpture speaks: "CHALLENGING THE TRADITIONS OF CONFORMITY AND SELF-SACRIFICE," "ALL DAY LONG," "IT SHOULDN'T HAPPEN TO A DOG," AND "CLAY I AM, IT IS TRUE, BUT SCORN ME NOT, FOR SO ARE YOU."

DA/JW

Robert Arneson, Vitruvian Man, *1979. Ceramic, diameter: 18 1/4 inches. Gift of Frank Fleming in memory of Jim Morgan, 1986.646.*

264

Reclining Nude

1984
Fernando Botero (b. 1932)
Columbia
Bronze
48 x 109 x 61 inches
Museum purchase with funds provided by Mr.
 and Mrs. Charles W. Ireland in memory of his
 sister, Countess Colleen Ireland DeTigny; the
 Acquisition Fund, Inc.; the 1985 Museum Dinner
 and Ball; and other funds
1985.292

Fernando Botero's monumental works portray voluminous figures derivative of the religious, social, and artistic traditions of his native Columbia. Born in the isolated city of Medellin, where conservative traditions dating back to medieval European Catholism prevailed, Botero developed an early interest in international art, inspiring him to travel and study in Europe, Mexico, and the United States. Though strongly influenced by Diego Rivera's boldness, Matisse's simplification, and Goya's directness, Botero remained fiercely independent. His wit, combined with the folklore and Spanish Baroque artistic tradition of his native Columbia, resulted in a personal style where bulk became beautiful. With their mixture of childlike innocence and sensuality, Botero's figures celebrate joyous and beautiful life, exhibiting the oddest phenomenon of Columbian art—a kind of beauty that both attracts and repels.

Although Botero's career began with two-dimensional paintings, his inflated creations seem best executed in heroic, three-dimensional scale. In *Reclining Nude*, Botero paraphrased and animated the serene pose of the traditional odalisque, merged with the primitive fertility goddess of ages past, the figures of Rubens or Renoir rendered with sensual voluptuousness. Botero's interest in the proportional evolution of the historic nude—from Giorgione to Titian, Goya, Manet, and others—led to his own unique creation called the "Boteromorph." Rather than being anatomically proportioned, Botero's human forms concentrate weight at the center to attain the highest degree of three-dimensional expression. Boteromorphic space allows the artist's work to expand and take on volumetric massiveness, redefining the artistic canon of figural representation, at least according to his own signature style.

AH/DA/JW

Pictorial tapestry

Mid-1980s
Isabel John
Navajo people
America (Many Farms, Arizona)
Handspun wool and aniline and vegetal dyes
44 x 77 ½ inches
Museum purchase in memory of Richard Kenneth
 McRae with funds provided by family and friends
1991.710

This textile woven by Isabel John depicts a Navajo woman in traditional dress kneeling before a partially woven pictorial on her loom. The landscape from which she takes her inspiration can be seen through the vertical white warp threads. A basket holding balls of yarn is to her left, and her baby is to her right.

The landscape pictorial is a fairly recent development in Navajo weaving, coming into popularity in the 1970s.[1] References to pictorials can be found in the literature of the mid-1800s, but the first documented example was not collected until 1864, a blanket that belonged to a Cheyenne chief.[2] Representational weavings from the early to mid-twentieth century were frequently of sacred nature, showing the ceremonial sand paintings. Contemporary pictorial weavings are often secular, portraying scenes from everyday life on the Navajo Reservation. Popular imagery includes logos, road signs, animals, buildings, automobiles, trucks, wagons, and trains. The whimsical quality of these tapestries is suggestive of American folk painting.

Today pictorials are made by a few specialists and are relatively rare due to the complex technical abilities required. In 1980 it was estimated that Navajo weavers earned only $2 an hour.[3] Currently weaving plays an important part in Navajo economy. Many weave full time and have waiting lists of prospective buyers. Large tapestries may take as long as a year to complete. Recently weavers have begun signing their works, as in this case with the IJ in the lower left corner. This indicates the increasing respect for these as art objects, the recognition of named artists, and the growing self-esteem of the weavers.

Although commercial yarns and dyes are available, Isabel John still shears the sheep and cards, washes, spins, and dyes the wool. Navajo weaving is still done completely by hand, often outdoors on an upright loom, as is depicted on this textile. The weaver usually has an image of the finished product in mind and only rarely draws designs before weaving.

The products of the Navajo loom are visual recordings of the history and traditional way of life of the people and testify to their ability to adapt to change through innovation.

MMV

1. Alice Kaufman and Christopher Selser, *The Navajo Weaving Tradition: 1650 to the Present* (New York: E. P. Dutton, Inc., 1985), 106. "The term 'pictorial' . . . designate[s] any blanket or rug in which naturalistic motifs or intelligible lettering are used for their decorative or expressive qualities rather than for their ritual connotations or the sole purpose of permanently recording ritual designs such as in sandpainting rugs"—Dorothy Elizabeth Boyd, "Navajo Pictorial Weaving: Its Past and Its Present Condition" (M.A. thesis, University of New Mexico, June 1970).
2. Kaufman and Selser, *The Navajo Weaving Tradition*, 106.
3. Ibid., 106.

Control Chair

1986
Rodney Alan Greenblat (b. 1960)
America
Painted wood, leather, lights, electrical
 outlets, and casters
39 x 26 3/4 x 27 1/2 inches
Museum purchase with funds provided by an
 anonymous donor
1987.23

This chair catches the eye of most who view it because of its fanciful decoration, which represents the artist's own lexicon of alphabetical pictographs, cartoon characters, and vibrant color schemes. Rodney Greenblat not only produces individual pieces of furniture, but also creates total environments covered with this whimsical and colorful embellishment. Somewhat like the work of Frank Lloyd Wright and the Memphis Group, Greenblat's furniture calls for its own interior or "cartooniverse" as the artist calls it, although his pieces can also stand alone as a sculptural entity. This chair was originally a part of a large roomful of Greenblat's furniture with similarly decorated walls and floors called *Rodney's Room*.

The *Control Chair* reflects a vision of happiness translated from television cartoons and children's book illustrations. The artist says, "I always liked to watch sitcoms on TV and then I'd draw them myself. I'd come home from school and see all the reruns."[1] In addition to incorporating images from Disneyesque fantasies, his art also redefines and updates the tradition of such Pop artists as Roy Lichtenstein, Claes Oldenburg, and Richard Hamilton. He says that these stylized characters of cartoon life are "important in our lives. If we took everything seriously, without humor, we wouldn't be able to function. The world is so full of trouble, we have to laugh in order to live."[2]

Greenblat builds the objects himself and then "Rodneyizies" the surface with his dense pattern of signs, symbols, and images. The central face on the back of the chair is a representation of Milo from the children's book *The Phantom Tollbooth*.[3] Around the skirt of the chair are creatures and castlelike scenes, which may also relate to the book. The chair is outfitted with switches and lights that, like the seat on an airplane, should control the universe around you. This chair, however, suggests one of the ironies of modern life—you sit in the control chair yet you control nothing.

Rodney Greenblat was born in Daly City, California; his mother is an artist and his father an educator. Early in his youth they moved to Bethesda, Maryland, where he created his own world around trains in the attic of the house. He graduated from the New York School of Visual Arts in 1982, and then moved to the East Village where gallery owner Gracie Mansion became his mentor and promoted his work. Recognized as one of the young ingenious artists of the 1980s, he has had group and solo exhibitions throughout the world and is represented in many museum collections.

EBA

1. Paul Gardner, "Rodney Alan Greenblat's Candy-Colored Cartooniverse," *ARTNews*, vol. 5, no. 1 (January 1986): 105.
2. Ibid., 107.
3. Milo, a sad and discouraged little boy, is magically whisked away to a mythological land of castles, wizards, and other strange creatures. Through a series of adventures Milo realizes that life is indeed exciting. Norton Juster, *The Phantom Tollbooth* (New York: Random House, 1961).

#2 Birmingham Alabama

1987
Robert Frank (b. 1924)
Switzerland/America
Collage: four gelatin silver prints on two panels
One panel: 15 1/8 x 22 3/8 inches
One panel: 12 x 53 5/8 inches
Gift of the *Birmingham News*
1988.3.2

In 1987, the *Birmingham News* invited six prominent photographers to Birmingham to make a record of the city in celebration of the newspaper's 100th anniversary. The *News* presented the photographs to the Birmingham Museum of Art as a gift to the community. Photographer-filmmaker Robert Frank was reluctant to accept the invitation to join the *Birmingham News* Centennial Photographic Project because he did not wish to repeat his earlier work and because, at this point in his career, he had turned almost exclusively to filmmaking, which he believed encapsulated time more meaningfully. Nevertheless, Frank proceeded to create this complex image in which he exposes dualities present in his life and work and in the lives of his audience. By grouping a series of images together to create a single work, Frank successfully integrates his expertise in both film and still photography. With this method of photographic collage, Frank is able to bridge the gap between the static single image of still photography and the continuum of film.

Frank continues his exploration and illustration of the dual aspect of human life with his choice of subject matter. He was obsessed with loneliness and alienation, emotions he believed most Americans refuse to confront, and he embraces these themes by juxtaposing a sequence of three grey, rainy cityscapes with an equally dismal interior scene. The photograph of the interior of a vacant lounge is placed above the three images of lonely roadways. In the center of the lounge's

wall hangs what appears to be a mirror reflection of the dreary passages featured in the images below. By bringing the exterior inside, Frank erases any boundaries between the two, leaving no imaginative relief from the depressing nature of this composition.

Finally, Frank exploits the inherent contradictions between ideas and reality as he provides a tiny clue for the viewer about the particular time of year that these gloomy images were captured. Frank visited Birmingham to make these photographs the week before Christmas in 1987. The season is barely evident in the empty lounge, in which a Christmas tree can be seen outlined by a string of unlit holiday lights. The festive spirit usually associated with this time of year is called into question by the overt despair of the deserted lounge and barren roadways in this collage.

Though Frank felt reticent about participating in this project, ultimately he was pleased with its outcome. He felt that the body of work that he produced in Birmingham was a successful expression of his state of mind at the time.

CH

276

Margaret Gresham Livingston

1987
Larry Rivers (b. 1923)
America
Oil on canvas mounted on foam-core
70 ½ x 63 inches
Museum purchase
1987.32

In keeping with its customary tribute to out-going chairmen, the Trustees of the Birmingham Museum of Art voted in 1986 to honor Margaret Gresham Livingston for her ten years of service by commissioning her portrait. It would not, though, be the expected kind—the idealized, formulaic representation so ensconced in commemorative tradition. Instead, a call went out for the best contemporary artist, one whose independent reputation stood on its own. No longer destined for the back-room walls of the boardroom, the portrait was to become a museum piece itself. This would not be easy. The Birmingham Museum approached a spectrum of the established avant-garde, most of whom refused to work on commission, reserving for themselves the liberty to choose their own subjects. Not so Larry Rivers.

Rivers already enjoyed an established reputation as a seminal figure in the Pop Art movement of the 1960s, a visionary who had successfully offered a representational alternative to Abstract Expressionism. His humorous though poignant multi-imaged canvases had reintroduced narrative and history to art: subjects such as Napoleon, Rembrandt's *Dutch Masters*, and the Last Confederate Soldier had given focus to his irreverent vision. His methods could accommodate portraiture as well. He was a personality, too, originally a jazz musician who remained a performer, his flamboyant personality carrying him onto game shows, movies, and across a continuing, unpredictable wide range of work.

Rivers portrayed Margaret Livingston in a blurred montage of images related to her life.

She shared with Rivers her family photo album and a packet of materials from the Birmingham Chamber of Commerce. She sat for photographs, recounted personal stories, and explained her passion for the arts. According to Mrs. Livingston, Rivers strained to learn the "symbolism of [her] life, the family iconography" to combine with more public elements relating to the museum and to the city of Birmingham.

Foremost in the painting is the full-length figure of Mrs. Livingston, dressed in a well-tailored red suit (Rivers accompanied her to buy it). She leans on a table topped with a plant and draped with a handmade quilt, chosen because "it looked Southern." Her face is blurred on one side, a device characteristic of Rivers suggesting movement or action—in this case, symbolizing her vision of the changing world. Mrs. Livingston believes Rivers blurred her face to show that "he's not through yet . . . that the whole story isn't told."

Other images speak to significant aspects of her past: a black-and-white photograph of her mother with siblings and their nanny, the Sloss Furnaces (her grandfather was president), and her family home. In the center, two Maryland chairs stand beside a cubistic mass of dots, a recreation of a watercolor by Italian Futurist Gino Severini in the Birmingham Museum's collection (and a broader allusion to Mrs. Livingston's involvement in the local art community). Rivers pulled together these figures of past and present in a layered montage of time and a collaged spattering of composition, offering a range of evocation and insight far beyond portraiture's traditional formula.

WE/DA/JW

Pepper Table

1988
Craig Nutt (b. 1950)
America (Northport, Alabama)
Curly maple and lacquered wood
30 x 35 x 17 inches
Museum purchase with funds provided by the
 Harriet Murray Memorial Fund
1989.19.1

Airborne Acorn : Whirligig

1987
Pine
27 x 24 x 14 inches
Museum purchase with funds provided by Southern
 Research Institute, by exchange
1989.19.2

Craig Nutt relies on his rural background as the inspiration for his works of art. A designer of sculptural furniture and whirligigs, he is a man full of laughter who also has a great care for function in our commercial environment. "I want to make things that are substantial," he says, but "I'm also trying to give furniture a sense of humor."[1]

The *Pepper Table* encompasses all of Nutt's aforementioned concerns. Designed and constructed by the artist, the table has cabriole legs, which were carved in the form of red peppers with green stems. The legs support the trapezoid top of lacquered curly maple, inlaid with dyed green and red wood simulating olives. While the materials and construction of the piece conform to Nutt's standards for fine craftsmanship, the vegetable motifs lend humor to the table yet convey his feel for nature.

His interest in furniture began in the 1970s, with his work primarily in the restoration and reproduction of antique furniture. In the 1980s, as a more experienced cabinetmaker-artist, he embarked on his own designs. Nutt's use of mortise and tenon joinery combined with the fanciful giant vegetable motifs brings a new dimension to contemporary furniture design.

He notes that "a piece of furniture may take weeks or months to execute . . . it is challenging to capture an element of spontaneity in a process which is often anything but spontaneous."[2]

The vegetable idiom came from a number of sources in Nutt's life, the first being his experience as a member of the Raudelunas Marching Vegetable Band in a 1973 University of Alabama homecoming parade. This avant-garde group dressed like vegetables and used primitive "junkyard" instruments. Nutt says he has "an affinity to vegetables because like furniture, they're functional."[3] He admits, however, "I, too, approach vegetables aesthetically, as both a consumer and a producer. I began carving two-foot-long vegetables, especially carrots and peppers, and they started to look like table legs. And then I thought, well, if only they could fly . . . so I started doing the vegetable whirligigs."[4]

The whirligig of a propellered acorn squash flies atop a rocket-silo with "Queen Anne serpentine feet."[5] For balance and spontaneity, a gardener's trowel is attached to the end of the squash. The theme of the flying vegetable came from a speech by President George Bush in which Bush said, "I'll never use food as a weapon." This statement led Nutt to his series of vegetable bombs, with the rocket-silo stand illustrating one of Nutt's favorite themes: "Our ironic attitude that bigger, brighter, chemical-fed vegetables and more devastating weapons are better."[6]

EBA

1. Laura C. Lieberman, "Craig Nutt," *Southern Accents* (September-October, 1988): 86.
2. Statement of artist, accession file 1989.19.1, Birmingham Museum of Art.
3. Lieberman, 86.
4. Ibid., 91.
5. Ibid.
6. Gary Weisenberger, "Craig Nutt: Combining Humor and a Bit of Cayenne," *Fine Woodworking* (January-February, 1991): 92.

The Sigh of the True Cross

1988
Mel Chin (b. 1951)
America
Wood, mud, steel, gut, teff
102 x 63 x 25 ½ inches
Museum purchase with funds provided by the
 National Endowment for the Arts and the
 Acquisitions Fund, Inc.
1990.8

In the artist's own words:

"*The Sigh of the True Cross*, 1988, was constructed as a response to news (June 8, 1988) of Mengistu Haile Mariam's expulsion of the International Red Cross when they desired to aid millions of Eritrean drought victims in northern Ethiopia. It was an expected move on Mengistu's part (then losing ground to Eritrean Communist rebels) to utilize, as he had in the past, famine, drought, and corruption to maintain control over the people of Ethiopia. If his use of food and natural disaster as a weapon was especially repugnant, then his extravagant multimillion dollar celebration of the Tenth Anniversary of the Ethiopian Socialist Revolution [was] equally disturbing. This anniversary occurred just before the Mescal, or Festival of the True Cross, which commemorates the Coptic belief that the True Cross was not found in a Roman well by Constantine's wife, but instead fell in a hail of fire and light on a mountain top in the Wollo province of northern Ethiopia. It is during this feast that the masingo, a single-stringed bowed, spike fiddle, a popular and normally a secular instrument, may be heard playing tunes for the occasion. . . .

"To fashion the work I chose materials and methods consistent with the manufacture of a masingo and materials which have a significant symbolic or indigenous association with Ethiopia . . . e.g., bull gut treated with garlic in the traditional fashion (tugging at the roots of braided eragrotis teff, a grass grain used as food), olive wood for the tuning peg, found wood from crates, scraped timber, handmade tools to hack out parts of the work. . . .

"The bow that is used to play the instrument is not present, but its form is mimicked in a sickle, emerging from the neck broken off to serve as its handle. Its cutting edge is the outline of the boundaries of Ethiopia, and the blade covered with the parched earth is a commentary on the drought and a misguided and totalitarian form of Marxism (imported from East Germany) used as a tool against starving thousands. The hammer/tuning peg is in perverse concert with the sickle. To tune the work would allow its empty bull gut strings to tear at the roots of an indigenous food. The faint, dusty "Red Cross" and the sound box are the targets of the tool/weapon sickle. Piercing the sound box (already muted with drought) further removes its voice from the capacity of complaint."[1]

JW

1. Mel Chin donated a portion of the purchase price of this sculpture to the Gulelie Children's Home, a sanctuary for some eight hundred teenage survivors of disasters in Africa. The full text of the explanation above, dated 1989, is in the Birmingham Museum's file.

Untitled

1989
Cindy Sherman (b. 1954)
America
Cibachrome print
41 ½ x 33 inches
Museum purchase with funds provided by the
 Acquisitions Fund, Inc., and Rena Hill Selfe
1990.15

This photograph, presumably fashioned after a portrait of Sir Thomas More by sixteenth-century German artist Hans Holbein (ca.1460–1524), is one of a series of "History Portraits" by artist-photographer Cindy Sherman. The "History Portraits," produced in 1989–1990, set a new precedent in Sherman's already successful career. Prior to this series, Sherman's subject matter was almost exclusively devoted to the representations of women in popular culture. In this particular artwork and others like it, Cindy Sherman delves deeper into our Western cultural heritage, using old master paintings as her vehicle for exploring and exposing societal stereotypes.

Here, borrowing from such masters, Sherman investigates issues of portraiture by recasting the pose as clearly artificial and misleading. The garish makeup, absurd false eyebrows, and harsh stage lighting all undermine the reverence these paintings usually evoke. By upsetting the aura of the original masterpiece, she allows us to begin to question the pictorial conventions that shape our understanding of the age depicted and the identity of the people who lived in it.

The scale and presentation of the image mimic the artwork that is its source. Sherman takes on the impact and currency of paintings head to head, competing with them in the use of size and color. Though photography can be a medium of illusion, it is also built from reality. In this photograph, the play between the exact description the camera allows and the complete fancy of the image make for a delightful updating of sixteenth-century practices.

Sherman further demystifies the power of images, especially cultural icons, by making herself their subject. She takes this to an extreme by cross-dressing; the fact that she is female questions the posturing and aggrandizement of the male in traditional representations. She stares past the frame with the steely-eyed assurance of a brilliant poseur. Her actions return a sense of silliness to the seriousness of hallowed art. We are reminded that the culture from which the original portrait was issued was made of individuals, real men and women, as struck with vanity and concern for the status quo as today's image-conscious society.

Though she maintains that her photographs are not self-portraits, Sherman is the model for this and most of her work. The obviously fake lips, eyebrows, and forehead pasted to the face of the artist-model are comic in their crude application. This lack of subtlety in her aggressive use of props, lighting, and makeup draw attention to the tangible artifice of this image and act as a metaphor for the inherent paradoxes of portrait making at large.

Sherman was still an art student in Buffalo, New York, when in the mid-1970s, performance art emerged on the forefront of the New York's art scene. The process of gathering the props and costumes, creating the setting, preparing the proper lighting, and so on are all a part of the process of Sherman's artistry. This method of creating images parallels the efforts that are needed to stage a theatrical production. With this in mind, Cindy Sherman's photographs seem to be capturing a moment of performance.

CH

Object Index

Asian Art

Cambodia
Ganesha, 36

China
Landscape Album, 166
The Pure Land of Amitabha, 50
Sakyamuni as an Ascetic, 44
Tang horse, 26
Yuan plate, 42
Yuhuchun bottle, 41

India
Uma-Mahesvara, 38

Japan
Jomon Jar, 18
Kasuga Deer Mandala, 54
Kenzan dish, 87
Quail Feeding by Moonlight in Susuki and Kikyo, 150
Set of tea shelves, 112

Korea
Buddha, 28

Thailand
Avalokitesvara, 33
Buddha, 24

Tibet
The Wheel of Existence, 142

Decorative Arts

America
Airborne Acorn: Whirligig, 278
Chair, 219
Control Chair, 271
Dress, 149
Liberty Giving Sustenance to the Eagle, 146
Pepper Table, 278
Quilt, 172
Silver punch bowl, ladle, and cups, 220
Sofa, 164
Window, 217

England
Britannia Triumphant, Wedgwood, 141
Chair, 131
Chest with drawer, 79
The Four Quarters of the Globe, 120
Silver basket, 104
Silver centerpiece, 144
Silver stand, 104

France
Acanthus vase, 234
Cabinet, 114
Chest of drawers, 137
Drop-front desk, 122
Lamp, 198
Mantel clock, 135
Pair of armchairs, 132
Pair of console cabinets, 96
Pair of firedogs, 90
Perfume fountain, 88
Tureen and lid with stand, 117

Germany
Charger from the Swan Service, 101
Harlequin and Colombine Dancing, 107

Italy
Four stained glass windows, 170
Gros point lace, 76

Prussia
Cast-iron busts, 163
Cast-iron casket, 163

Traditional Arts

African
Community power figure, Zaire, 193
Funerary vessel, Ghana, 224
Headdress for Epa masquerade, Nigeria, 241
Headdress in the form of an antelope, Mali, 243
Helmet mask, Zaire, 231
Reliquary guardian figure, Cameroon, 222
Standing figure, Mali, 176

Artist Index